Essential
MONET

This is a Parragon Publishing book
This edition published in 2001

Parragon Publishing
Queen Street House
4 Queen Street
Bath BA1 1HE, UK

Copyright © Parragon 2000

Created and produced for Parragon by
FOUNDRY DESIGN AND PRODUCTION,
a part of The Foundry Creative Media Co. Ltd
Crabtree Hall, Crabtree Lane
Fulham, London, SW6 6TY

ISBN: 0-75255-517-0

Printed and bound in China

Essential
MONET

VANESSA POTTS

Introduction by Dr. Claire O'Mahony

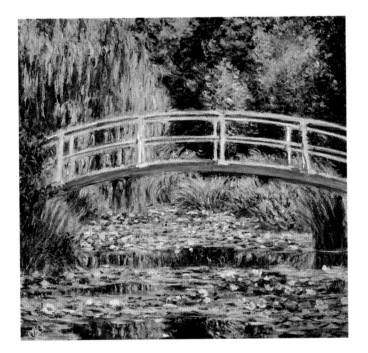

p

CONTENTS

❦ CONTENTS ❦

INTRODUCTION

*C*LAUDE OSCAR MONET is in many senses the quintessential Impressionist painter. The spontaneity and vivacity of his painting technique and his devotion to the close observation of nature have been the focus of most discussions of his art. However, the range of his subject matters, the complexities of his exhibiting strategies and his responses to the variety of artistic and socio-historical transformations experienced during his long lifetime are fundamental to understanding his unique contribution to the history of art.

Born in 1840 in Paris, where his father was a wholesale grocer,

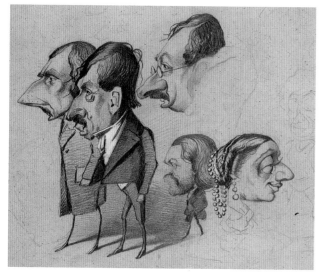

Monet lived in Le Havre from the age of five; the Normandy region was to be a vital influence on him throughout his life. His earliest artistic reputation was as a caricaturist, but by the mid-1850s Monet, with the encouragement of the atmospheric landscape painter Eugène Boudin (1824–98), had begun to paint from what he saw in the open air.

Monet's artistic career began in earnest with his first trip to Paris in 1859. On his arrival in the capital he was befriended by a number of painters associated with the Realist movement, most notably the Barbizon painter Constant Troyton (1810–65) and the young Camille Pissarro (1830–1903). He also received his first formal training, becoming a pupil for two years in the studio of the academic painter Charles Gleyre (1808–74). It was there that he made a number of artistic friendships that were to have a formative influence on him; he met Pierre Auguste Renoir (1841–1919), Frédéric Bazille (1841–70), and Alfred Sisley (1839–99).

Despite legends stating the contrary, Monet had a degree of success at provincial exhibitions as well as at the annual state-sponsored art exhibition held in Paris each year in May, the Salon. In 1865,

having made painting trips to the forest of Fontainebleau and the Normandy coast at Honfleur and Le Havre, where he met the Dutch open-air landscape painter Johan Barthold Jongkind (1819–91), Monet sent two of his seascapes to the Salon exhibition, and they were accepted. A portrait of his mistress, Camille Doncieux, and a landscape were also accepted in 1866, and another seascape in 1868.

Inspired in part by the controversial paintings produced by Edouard Manet (1832–83) in the last years of the 1860s, Monet began to wrestle with subjects derived from the modern life of Paris. The capital had been undergoing a process of extraordinary transformation on the initiative of Emperor Napoleon III's prefect, Baron Haussmann. "Haussmannisation" cut a series of huge boulevards, lined with large-scale, expensive apartment blocks and arcades of shops, through the city's labyrinthine medieval streets, so beloved of an earlier generation of Romantic poets and artists. These changes necessitated the transplantation of the workers of Paris—who had lived in small upper rooms of the old buildings above the more lavish apartments of wealthier Parisians—to a new region of suburbs beyond the city walls. Monet, like many artists of the Impressionist circle, became fascinated with both the new phenomena of boulevard culture and the suburban districts, in which many pleasure spots blossomed alongside the factories on the banks of the river Seine.

Monet's technique and style reflect a wonderful awareness of the achievements of his teachers and contemporaries while also creating a unique and constantly transforming personal vision. The young Monet synthesized the open-air techniques practiced by Boudin and Jongkind and theorized by the drawing master Lecoq de Boisbaudran with the controversial subject matter of modern experience. The more abrupt handling and traditional palette of his earliest works were derived from the manner of Realist painters such as Gustave Courbet (1819–77) and followers of the Barbizon School. In the following decades, Monet moved away from the traditional modeling in black and white, known as *chiaroscuro*, to a sense of depth and volume created entirely through color relationships. Rather than using the dark, reddish-brown

underpainting typical of the nineteenth century, Monet began to paint on canvases primed in white or light beige tones to enhance the brilliance of his colors.

Monet experimented with varying degrees of finish throughout his career, although it was not until the 1880s that he would exhibit his most sketchy works publicly. (Sketches such as the famous paintings of La Grenouillère and the beach at Trouville, now in the National Gallery, London, were almost certainly intended as private notations rather than as works for public exhibition.) However, his practice of building up a work was to be fairly consistent throughout his life. He

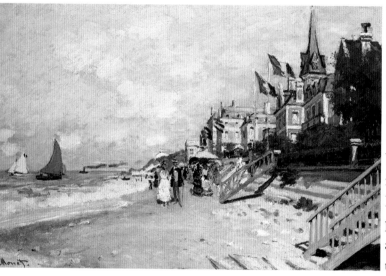

would first lay in the main elements of the composition in the appropriate colors in a loose underpainting, and he would then work up all these areas in a range of broad contours and small surface brushstrokes, as fitting to the feature being described. Despite his protestations in later life, this process of elaboration was not always performed in front of the subject, but rather over a period of days or often months in the studio, as Monet's letters of the 1880s to the dealer Durand-Ruel testify.

Many of Monet's views of Paris from the 1860s adopt unusual viewpoints and incorporate ambiguous hints of narratives about the relationships of the tiny figures evoked through his summary brushstrokes. The overall effects of these compositional devices had many precedents, not only the unusual perspectives typical of the Japanese prints of which Monet was an avid collector, but also his awareness of the world of the *flâneur* described with such verve in Charles Baudelaire's *The Painter of Modern Life*. This delightful and influential essay, which nominally describes the achievement of

Constantin Guys (1802–92), a draftsman who evocatively captures the fashions and social types of the Second Empire, articulates the unique freedom and anonymity available to the young man as he wanders around absorbing the spectacle of the new Paris. Monet eloquently captures this mood of exploration and mystery in his aloof aerial views of the manicured public gardens, bridges, and boulevards at the heart of Paris and the chance encounters of its suburban fringes.

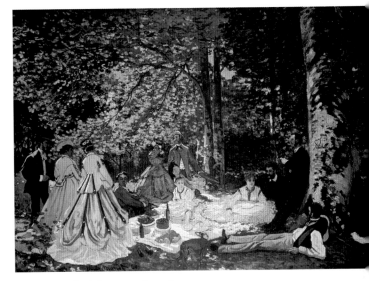

In 1866, Monet began his response to Manet's scandalous painting *Déjeuner sur l'Herbe*, which had been rejected by the Salon of 1863 on the grounds of indecency, with a monumental painting of a picnic enjoyed by elegant Parisian men and women. Regrettably, it never came to fruition, and only a sketch and a few fragments survive. Monet did complete a second large-scale painting of fashionable women at play, *Women in the Garden*, which he executed entirely in the open air. However, it was rejected by the Salon of 1867. This was a period of some personal and professional strain for Monet. His mistress, Camille, was pregnant with their son Jean and, although Monet's father had been supportive of his son's artistic career, he would not tolerate this romantic alliance. Suffering financial difficulties, Monet returned to the family home in Le Havre and left Camille in Paris. However, they were reunited after Jean's birth, living first at Etretat and then in Bougival, where Renoir and Pissarro were frequent visitors and colleagues on sketching trips around suburban pleasure spots such as the floating restaurant, La Grenouillère.

In 1870, Monet and Camille were married and made a honeymoon trip to Trouville, a resort on the Normandy coast. With the outbreak of the Franco-Prussian War in July of 1870, the Monets took the decision to flee to London. A number of other artistic figures

had also left for London, including, most significantly for Monet, the leading art dealer Paul Durand-Ruel, who soon became a vitally important and lifelong patron for Monet and the Impressionist circle. During the nine months the family spent in London, Monet painted numerous views of the city's parks and of the River Thames. After traveling through Holland in the summer, where he painted at Zaandam near Amsterdam, the Monets returned to France and settled in a suburb to the west of Paris called Argenteuil. Monet remained there until 1878, and many of his friends—Renoir, Sisley, Gustave Caillebotte (1848–94), and Manet—joined him there to paint the life of the River Seine, a site of pleasure boating, swimming, and river cafés, as well as a burgeoning industrial town.

Durand-Ruel had been an avid buyer for these paintings, but in 1873 he suffered financial losses. Monet and his friends had to find a new set of patrons, and they embarked on planning an independent exhibition to draw attention to their work. On the Boulevard des Capucines in the studio of Nadar, a leading photographer of the day, the *Société Anonyme des Peintres, Sculpteurs, et Graveurs* held its first exhibition in April of 1874. A contemporary critic coined the term "Impressionism" in response to Monet's unusually sketchy view in grayish-blue and orange of the industrial harbor at Le Havre

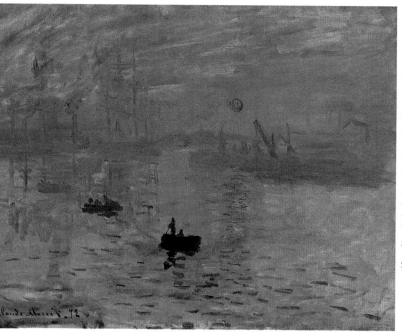

enshrouded in fog entitled *Impression, Sunrise.* This exhibition achieved a certain notoriety, although it did little to raise the prices that the artists could ask for their works, as proved by the 1875 auction of the Jean-Baptiste Fauré collection of works by Berthe Morisot (1841–95), Renoir, and Sisley. Monet also showed paintings at the second, third, fourth, and

seventh of the eight exhibitions mounted by the Impressionist group between 1876 and 1884.

Monet met Ernest Hoschedé and his wife Alice in 1876, and they were to play an important role in his later life. Hoschedé commissioned Monet to paint four paintings to create a decorative ensemble for the main receiving-room at his home just outside Paris, the Château de Rottembourg at Montgeron. After Hoschedé's bankruptcy and the birth of Monet's second son, Michel, in 1878, the two couples and their eight children decided to form a joint household in Vètheuil. However, Camille, who seemingly had a disease of the womb, died in the fall of the next year. Alice Hoschedé and Monet were to form an open, rather unconventional relationship that may have contributed to Monet's gradual distancing from his Parisian painter friends and their exhibitions.

Though intimate, the couple lived largely autonomous lives. Although Ernest Hoschedé had created a separate life for himself in the 1880s, Monet and Alice did not marry until after Ernest's death in 1892. After a brief sojourn in Poissy, the family moved to their now-famous house in Giverny. They rented this house until Monet was able to purchase it in 1890, due to a new-found affluence achieved in a large part by Durand-Ruel's adept and financially rewarding cultivation of American collectors interested in purchasing Monet's works. The family were to spend the rest of their lives at Giverny.

With Alice caring for his children, Monet embarked on a period of frequent painting trips to picturesque corners of France throughout the 1880s. He returned several times to the Normandy and Brittany

coasts, as he had always done, but now he chose to paint the more remote sites rather than the tourist-filled resorts. The Parisians at play in Trouville and Ste.-Adresse, celebrated in his canvases of the 1860s, gave way to the lonely, tempest-tossed shores and rock pools of Fécamp and Pourville and the majestic isolation of the hilltop church at Varengeville in 1881 and 1882. He found a favorite motif in the dramatic cliffs and needles of Etretat (a subject made famous a decade before by Courbet). He returned there in 1883, 1885, and 1886, when he also painted many views of Belle-Ile off the southern coast of Brittany. In 1886, Monet also began to explore more distant regions within France and even the tulip fields of Holland. His life-long fascination with the cool light and coastal storms of the north was coupled with new explorations of the warm brilliance of the Mediterranean. He visited the southeastern tip of France, painting Bordighera, Antibes, and Juan-les-Pins in 1884 and 1889. He also traveled to the Creuse Valley in the heart of France in 1889.

The 1880s and '90s saw a shift of focus in Monet's life on many levels, in the kind of subject matter he explored, the venues he selected for exhibiting his works and the huge success and fame that he achieved. Like so many artists and writers at the end of the nineteenth century, he became dissatisfied with the themes of modernity and urban experience. His art became much more focused on a world of personal sensation before the wonders of nature. A monumental, decorative quality creeps in to his late works. Rather than the external spectacle that delighted Manet and Baudelaire, these paintings offer private spaces of contemplation that engulf the viewer in their gentle color harmonies and bold compositions. These paintings achieve a world of escape and private reverie which was analogous to the artistic ambitions championed by the Symbolist painters and poets, and Art Nouveau designers.

These new subjects not only widened Monet's own experience and modes of expression but they also attracted keen buyers and dealer-patrons. After the acceptance to the Salon of a painting of an ice floe in 1880, Monet embarked on a new cycle of one-man and

group exhibitions with several of the leading private art dealers of the day. In 1883 Monet held a one-man show at the gallery of his old friend and supporter Durand-Ruel. He participated in the group shows organized by Georges Petit in 1885, 1886, and 1887. This relationship with Petit culminated in a retrospective of Monet's work in 1889 which confirmed the popularity and sales of his work. On his return from the trips to Antibes, Monet also exhibited 10 paintings with the dealers Boussod and Valadon, which their manager, Theo van Gogh, had purchased. Interestingly, Monet ended this hugely successful exhibition by refusing one of the highest accolades from the French state, the *légion d'honneur*. While rejecting honors for himself, he sought a place in the nation's museums for his mentor Manet by orchestrating a campaign of subscriptions to pay for the purchase of the famously scandalous and innovative painting of a Parisian courtesan, *Olympia*, of 1865.

The artistic explorations undertaken on Monet's many painting trips of the 1880s were essentially preliminary work for his great series paintings of the 1890s. In the series, Monet would select a particularly resonant site and subject, such as grainstacks, poplar trees on the River

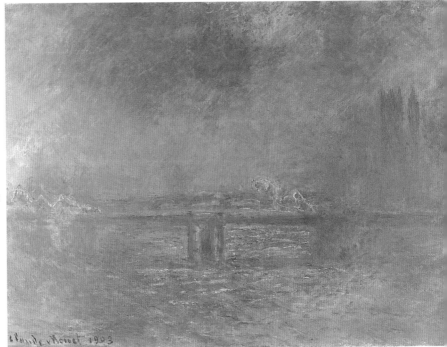

Epte or the façade of Rouen Cathedral, and paint suites of paintings portraying the motif under various different conditions of light and season. These series lay at the heart of Monet's public exhibiting career in the last decade of the nineteenth century. In a one-man exhibition held in Durand-Ruel's gallery in 1891, Monet included 15 paintings

from the grainstack series. He also created single-theme exhibitions
for subsequent motifs throughout the following years. He showed
the poplars at Durand-Ruel's gallery in 1892, the façade of Rouen
Cathedral in 1893, the first water-garden series in 1900, the London
views in 1904 and a series of 48 water lily paintings, known as
"waterscapes," in 1909. The views of Pourville and of early mornings
on the Seine were included in his one-man exhibition at the Georges
Petit Gallery in 1898, and the Venice views were shown at the
Bernheim-Jeune Gallery in 1912.

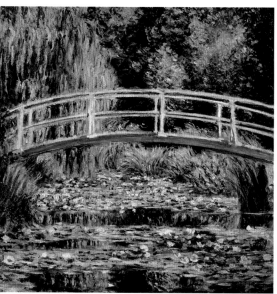

Monet's other great artistic project of the 1890s was the creation
of his water garden at Giverny. As soon as he had
purchased the house, he began to create an
elaborate flower garden incorporating every
shade of color and variety of bloom—a palette
made of flowers. In 1893, he had the opportunity
to buy a second plot of land on the opposite side
of the road and railway track that run through
the property to this day. Monet elaborated on the
indigenous pond and stream by gaining planning
permission to alter the flow of water entering the
stream and by repeatedly enlarging the pond in
1901 and 1910. Perhaps his most dramatic
addition was a bridge, of typical arched Japanese
design, which he built at one end of the pond.
This peaceful idyll of his own devising was to be Monet's final subject,
which he painted daily for 20 years.

The water lily series paintings led Monet to his last, great
project: the decorations for the Orangerie. Decorative painting had
witnessed an extraordinary revival in the last quarter of the nineteenth
century in both official and more esoteric artistic circles. In a speech at
the awards banquet for the Salon of 1879, Jules Ferry, Minister of Fine
Arts and Education, had called for the decoration of all France's public
buildings. Town halls, schools, churches, and museums throughout
France were decorated with vast mural schemes celebrating the Third

Republic. This revival of decorative art was paralleled among a set of wealthy patrons who commissioned numerous decorative paintings to ornament the salons of their villas. Similarly, many leading restaurants, such as Maxime's and Le Train Bleu, the latter built at the Gare de Lyon for the World Fair of 1900, sought sympathetic decorative schemes to enhance the Belle Epoque elegance of their diningrooms. Leading artists from every aesthetic camp of the day were commissioned to create these decorations, from the members of the Nabis group, such as Pierre Bonnard (1867–1947) and Edouard Vuillard (1868–1940), to leading Salon painters such as Albert Besnard (1849–1934) and Henri Gervex (1852–1929).

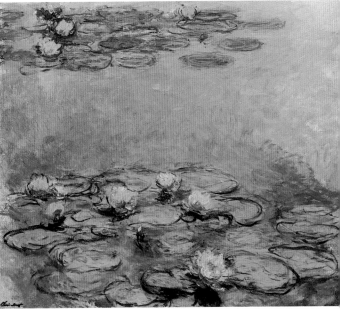

The powerful Republican politician Georges Clemenceau was a close friend and a vociferous champion of Monet's painting. Concerned at his friend's gloom after the death of both his beloved wife Alice in 1910 and his elder son Jean in 1914, Clemenceau cajoled the old painter to embark on a colossal decoration inspired by the water garden. Monet built a special studio in his garden so that he could work in comfort on such monumental proportions. In 1918, he decided to donate the work to the French state. Despite suffering from cataracts in both eyes, Monet worked on the project continuously until his death in 1926. Initially, the ensemble was to be housed in a specially built pavilion in the grounds of the Hôtel Biron (now the Musée Rodin), but in 1921 it was announced that the murals would be housed in the Orangerie in the Tuilleries Gardens near the Louvre. The architect Camille Lefèvre designed two oval rooms at ground level to house the paintings, and they were opened to the public on May 16, 1927.

Dr. Claire O'Mahony

DANDY AU CIGARE (c. 1857–58)
Dandy with a Cigar
Musée Marmottan. Courtesy of Giraudon

MONET started his artistic career as a caricaturist in his home town. His caricatures were displayed in the local frame shop, where they attracted much attention because he frequently used well-known and therefore recognizable people from Le Havre as his subjects. Thanks to the success of these caricatures, Monet was able to save enough money to study art in Paris.

The frame shop manager also displayed landscapes by the then more famous artist Eugène Boudin (1824–98). This effected an introduction between the two artists, and Boudin took Monet painting with him on many occasions. Boudin believed that an artist should have a full experience with his art and complete the entire landscape outdoors. This was unheard of before Boudin and became known as *plein-air* technique. Monet embraced this concept wholeheartedly, and it became an important feature of his work throughout his career.

Dandy au Cigare is a typical caricature, complete with exaggerated features and the recognizable accessories of a dandy. The oversized cigar distorts the face, rendering the man ridiculous. In the more serious *Portrait de Poly* (1886), Monet retains some sense of the caricature that is especially obvious with the treatment of the sitter's large red nose. Notice this dandy has a similar affliction.

Portrait de Poly (1886)
Portrait of Poly
Musée Marmottan. Courtesy of Giraudon. (See p. 148)

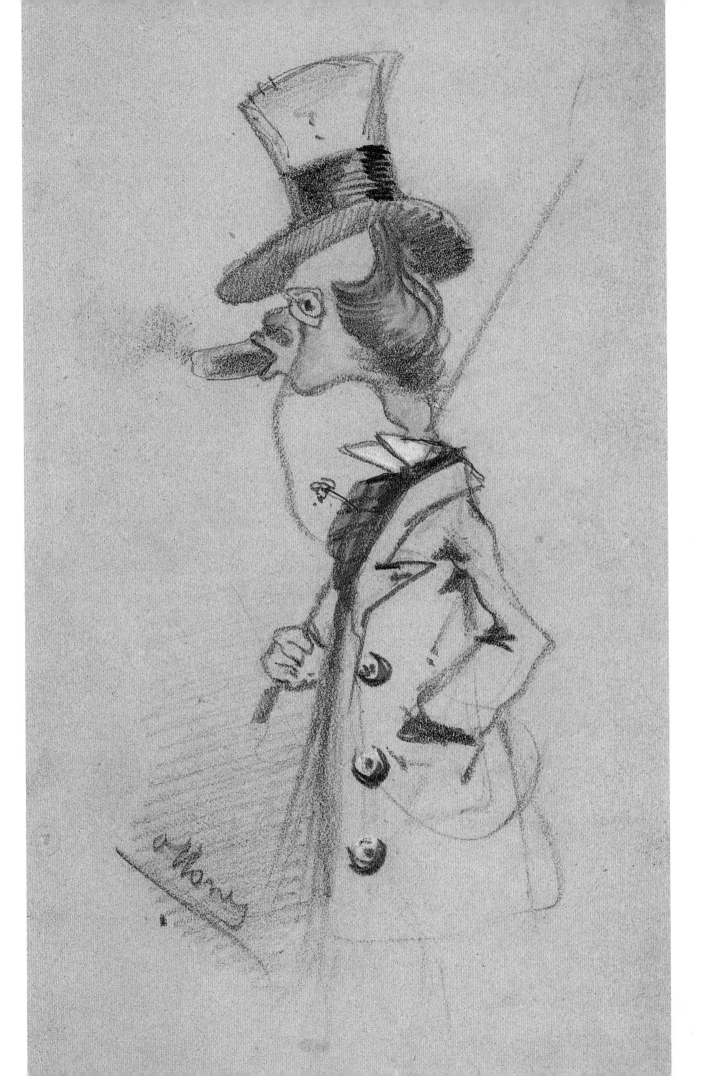

PETIT PANTHÉON THÉÂTRAL
(c. 1857–60)
LITTLE THEATRICAL GROUP
Courtesy of Giraudon

THE object of a caricature is to exaggerate the features that make an individual identifiable for humorous purposes. This unfinished picture demonstrates Monet's abilities in this field to great effect.

In particular the nose of each person best illustrates Monet's skill. He does not appear to have a stock of funny noses that he simply applies to the face; each person in the picture has a different nose from the others. These range from a gallic monstrosity on one gentleman to a tiny button of a nose on another. Their eyes, lips, and foreheads are also uniquely individual. The whole effect is to create a face that the viewer can "read" in order to understand the character of the person portrayed. Thus each man could appear intelligent, mean-spirited or kind, depending on how Monet has drawn his characteristic features.

What this picture does show is the quickness of eye that Monet had. He notes the details of the features and then interprets them in a new way. This is the approach he takes with other more serious paintings where the subjects he chooses to paint are not an exact replica of reality but his response to it.

Trophée de Chasse (1862)
Sporting Prizes

Musée d'Orsay. Courtesy of Giraudon

*T*ROPHÉE *de Chase* is unusual when compared with Monet's later work. However, what cannot be overlooked is his determination to succeed as an artist: this led him in the early years to paint what can be considered conservative paintings. His choice of subject matter was frequently based on what would be acceptable to the art community.

The colors used here are true to life and lack the brilliance that was to emerge later in Monet's life. They are blended together to create a more traditional palette. Still life was never to be a priority in his career, and this is one of the rare examples of it. However, he took two still lifes with him to Paris to show round the art schools.

The elaborate composition and detailed treatment of the birds demonstrate how Monet was growing in confidence about his abilities at that time. The quality of execution shows how determined Monet was to understand the basics behind good art through traditional training. This level of detail would not be of such great concern in his later career, when the general impression became more important.

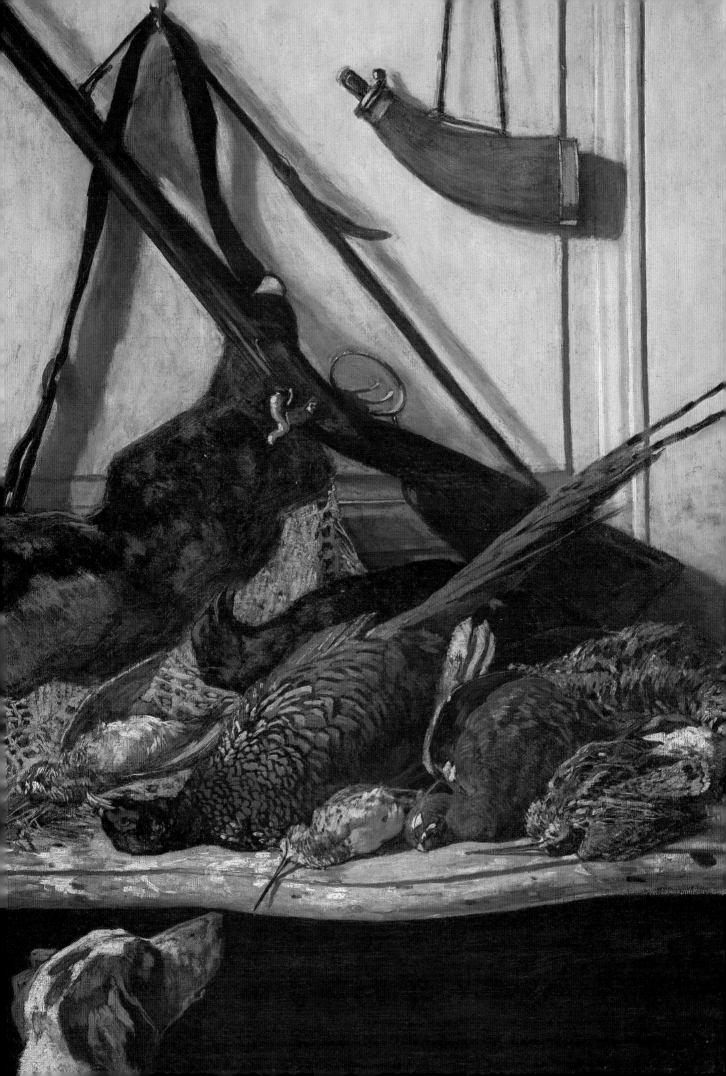

La Rue de la Bavolle, à Honfleur (c. 1864)
Bavolle Street, at Honfleur

Mannheim Stadtische Kunsthalle. Courtesy of Giraudon

*T*HERE is some confusion over the exact date in which *La Rue de la Bavolle, à Honfleur* was painted. However, it is definitely an early piece and one that is distinctly unusual for Monet.

Honfleur has many buildings dating from the sixteenth century, making the village very picturesque. For this reason it is an unusual subject for Monet to pick, as he normally veered away from the picturesque, particularly when it came to buildings. His preference was for modern subjects, such as St. Lazare Station. The painting *Le Pont de l'Europe, Gare St Lazare* (1877) has all the hallmarks of the sort of city scene that Monet liked. There are modern buildings in the background, a new bridge built in contemporary materials and, most impressive of all, a steam engine. The street scene from Honfleur lacks all of these attributes— its old-fashioned buildings and quiet street are lacking in the bustle and action characteristic of the later painting.

There is no sense of urgency; the scene has the tranquility that Camille Corot (1796–1875), one of Monet's artistic predecessors, would have been proud of. There is no hint at the style that was to become synonymous with Impressionism.

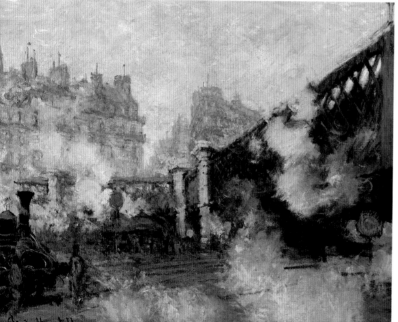

Le Pont de L'Europe, Gare St-Lazare (1877)
Europe Bridge, St Lazare Station
Musée Marmottan. Courtesy of Giraudon. (See p. 96)

LE DÉJEUNER SUR L'HERBE (1865)
THE PICNIC ON THE GRASS
Pushkin Museum, Moscow. Courtesy of Giraudon

THE subject-matter of this painting is not controversial, but Monet's treatment of it is. Monet started work on this massive canvas with the intention of submitting it to the Salon exhibition of 1866 and causing a sensation. The sheer scale of the work meant it was not ready in time, and Monet abandoned it.

The unfinished canvas reveals a conventional scene of picnickers in the forest. However, Monet is attempting to treat the people as a natural part of the landscape. There is no story to the painting, and this is emphasized by the uncentered composition: the eye is not drawn to any one point, and the people are simply a part of their surroundings. Monet wanted to create a sense of spontaneity with this painting, as if it were the capturing of a moment. This is underlined by the casual actions of the figures. One woman is caught in the act of touching her hair; another is about to put down a plate. This realism was very unusual in art of this period. Manet's influence is felt in the painting, but Monet hoped to avoid the moral judgement that Manet suffered with *Olympia* by not using controversial subject matter such as nude figures.

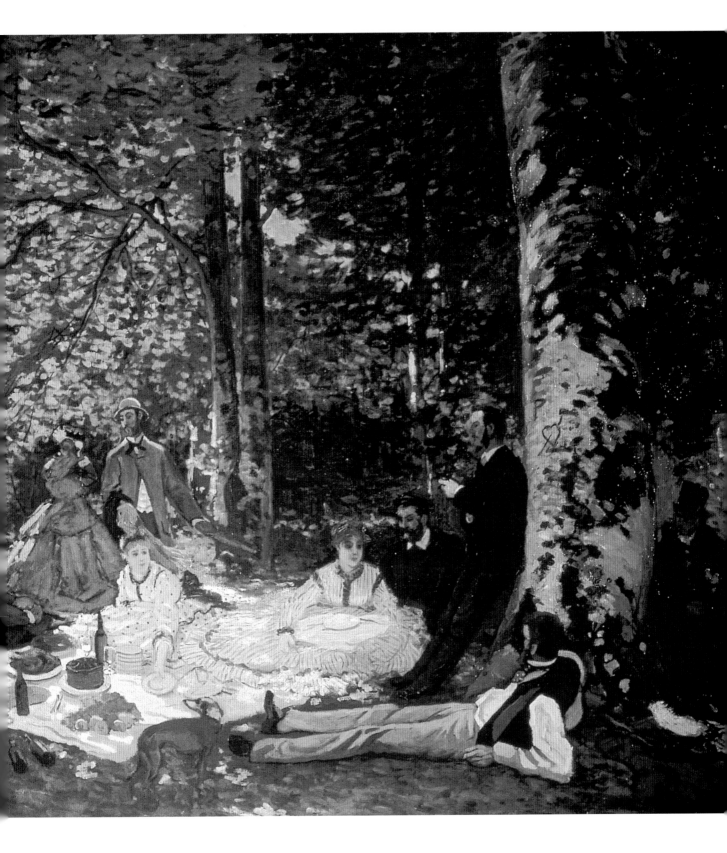

CAMILLE OU LA FEMME À LA ROBE VERTE (1866)
CAMILLE (WOMAN IN THE GREEN DRESS)

Bremen Kunsthalle. Courtesy of the Visual Arts Library, London

C AMILLE Doncieux, Monet's mistress and later his wife, was the artist's favorite model and he used her repeatedly in his work. Here she is posed in an attitude that is relatively informal.

The most striking aspect of this painting is the green of the skirt. Monet's love of color and his desire to paint modern subjects probably prompted the choosing of this dress for the painting. The skirt dominates to the point where the woman's personality is secondary. Camille as an individual in her own right is not captured.

The lack of background detail is quite deliberate so that the woman is the only focus of attention. By not providing a setting, her character remains mysterious, with only her clothing hinting at her background. Camille has been painted as if captured mid-action, a spontaneous reaction on the part of the artist to the aesthetic picture her image makes.

Monet submitted this painting to the Salon exhibition and was successful in it being chosen. The Salon was the state-run exhibition, which had a strict and traditional selection process for inclusion in one of its exhibitions. An unknown artist could expect to achieve some notoriety from being selected, and with notoriety often came financial reward.

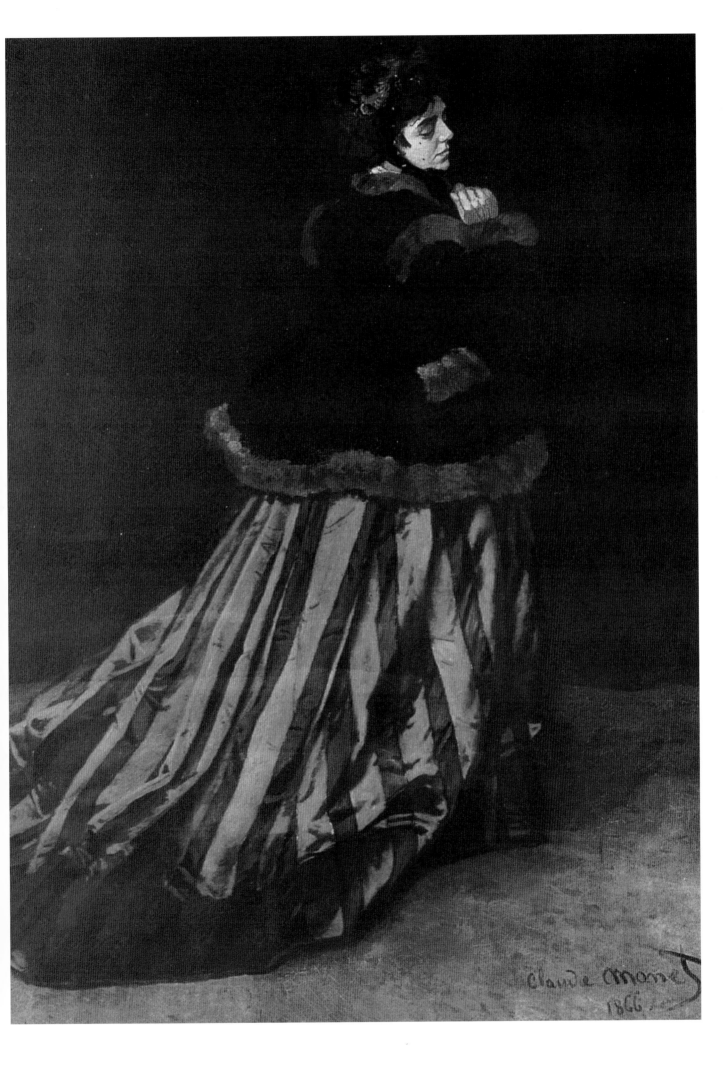

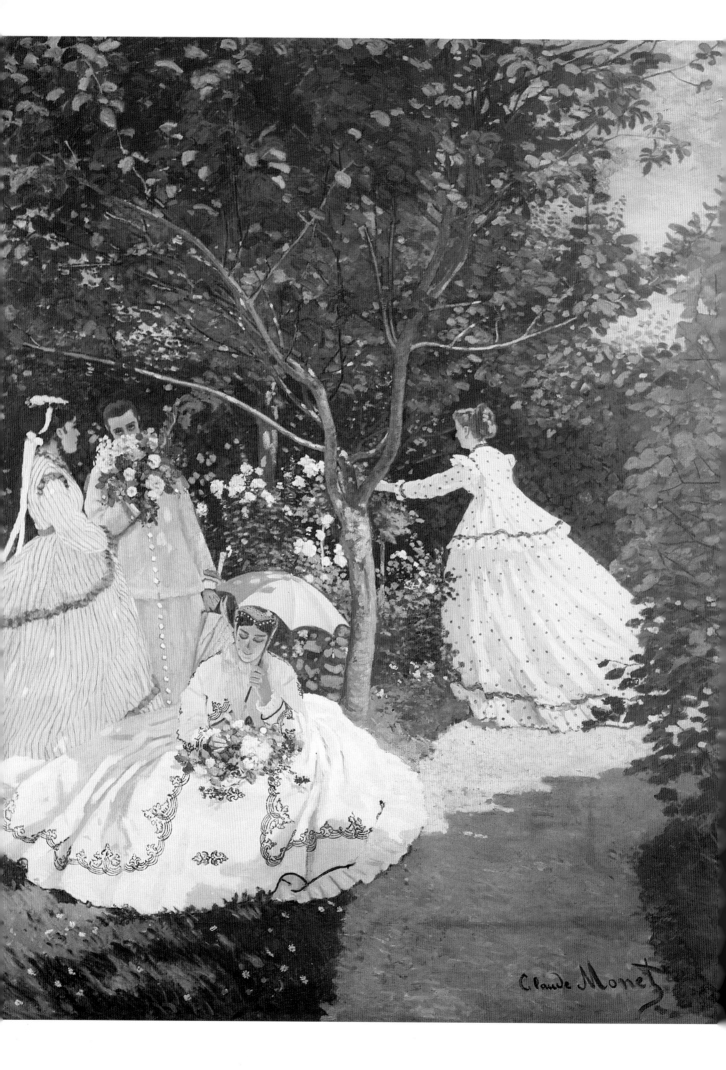

FEMMES AU JARDIN (1866)
WOMEN IN THE GARDEN
Courtesy of Topham

*C*AMILLE Doncieux posed for all four women in this painting, wearing hired dresses: the impoverished Monet could not afford clothes like these. Monet submitted the painting, which was painted at Ville d'Avray, to the 1867 Salon, but it was rejected. Artists such as Daumier and Manet also criticized the picture.

Monet was aiming to make two significant points with *Femmes au Jardin*. This large canvas was traditionally reserved for historical or religious paintings that carried a moral message for the viewer. By painting an unremarkable, modern scene, Monet was declaring that these everyday moments, painted in a realistic manner, were just as important in the art world as esteemed historical or religious subjects.

His second point was concerned with the spontaneity of art and painting exactly what was in front of the artist. Instead of sketching the scene and then completing it in a studio, Monet painted the entire work in the open air. This was the *plein-air* technique that Eugène Boudin had introduced him to. So determined was he to make this painting seem real that he dug a trench in the garden in order to have the canvas at the right level.

JEANNE-MARGUERITE, LE CADRE AU JARDIN (1866)
JEANNE-MARGUERITE, THE IMAGE IN THE GARDEN

The Hermitage, St Petersburg. Courtesy of Topham

ANOTHER work that was inspired by Manet's artistic style, *Jeanne-Marguerite, le Cadre au Jardin* completes the isolation of the individual that Monet had attempted to capture in *Femmes au Jardin* (1866). In the slightly earlier work, although the women form a group, they seem removed from each other. Here Monet finalizes that isolation by leaving a lone female in the garden.

Her isolation is further completed by placing her to the far left edge of the canvas, so that she is removed from the main focus of the picture. This gives an unsettled feel to the composition that is similar to that achieved in the earlier work. In *Femmes au Jardin* three of the women are placed left of center, and the eye struggles to find a main focal point between the women. This is achieved in *Jeanne-Marguerite, le Cadre au Jardin* by patches of color. The viewer is drawn repeatedly from the yellow to the red flowers and then across to the white dress.

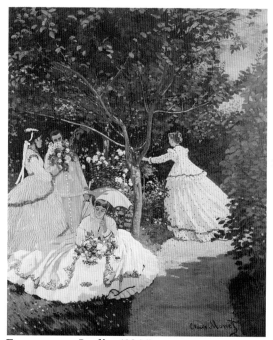

The technique of using blocks of colors employed in *Femmes au Jardin* is repeated here with more vigor. The sky is almost a solid patch of blue, the dress a block of white and the grass a strip of green. This gives a flat effect to the picture.

Femmes au Jardin (1866)
Women in the Garden
Courtesy of Topham. (See p. 29)

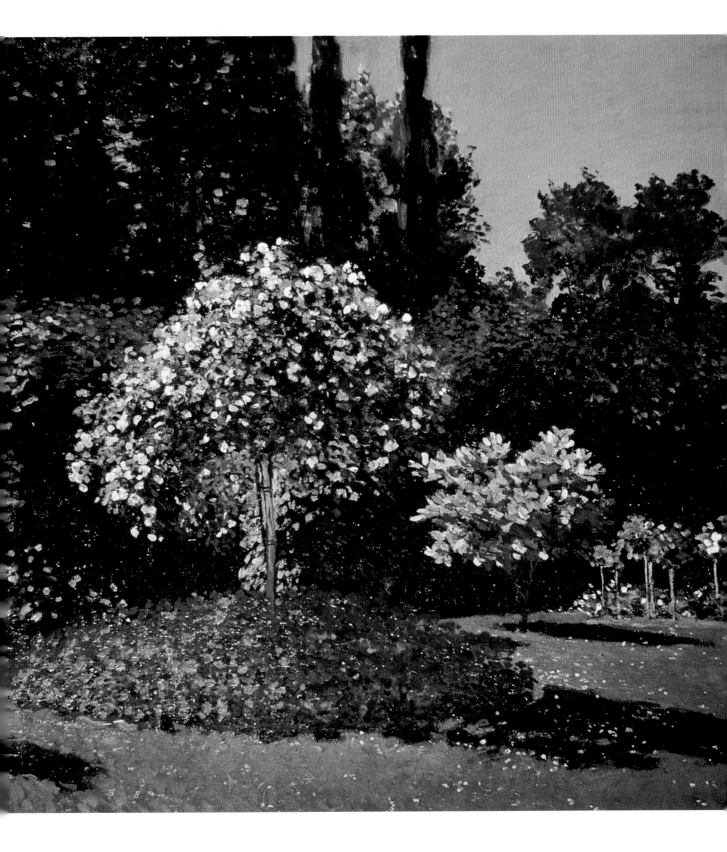

CAMILLE AU PETIT CHIEN (1866)
CAMILLE WITH A LITTLE DOG

Private Collection, Zurich. Courtesy of Giraudon

*T*HIS intimate portrait is one of the few that shows Camille in a formal pose. Although not shown face on, her features have been recorded in the kind of detail lacking in many of the paintings she posed in for Monet as a model.

The difference in his attitude to the woman between this painting and *La Liseuse* (1872) is interesting. In the main picture his aim is to create a portrait of Camille: there is no vivid background to distract the eye and she is definitely the center of attention. Her profile is emphasized by being painted against a dark color. The quick brushstrokes representing the shaggy dog, contrast with the careful work on Camille's face, and underline that Monet was trying to make Camille the only subject of interest. This is not the case with *La Liseuse*. Here the background, and even Camille's dress, are perhaps more important than who she is. She is painted as part of the scenery, almost an incidental feature of the landscape.

By posing Camille with her face turned down toward her book, her features are not easily distinguishable. In *Camille au Petit Chien*, she looks steadily forward, and some sense of her character can be gleaned from the attitude of the head and the quiet pose.

La Liseuse (1872)
The Lover of Reading
Walters Art Gallery, Baltimore. Courtesy of Giraudon. (See p. 62)

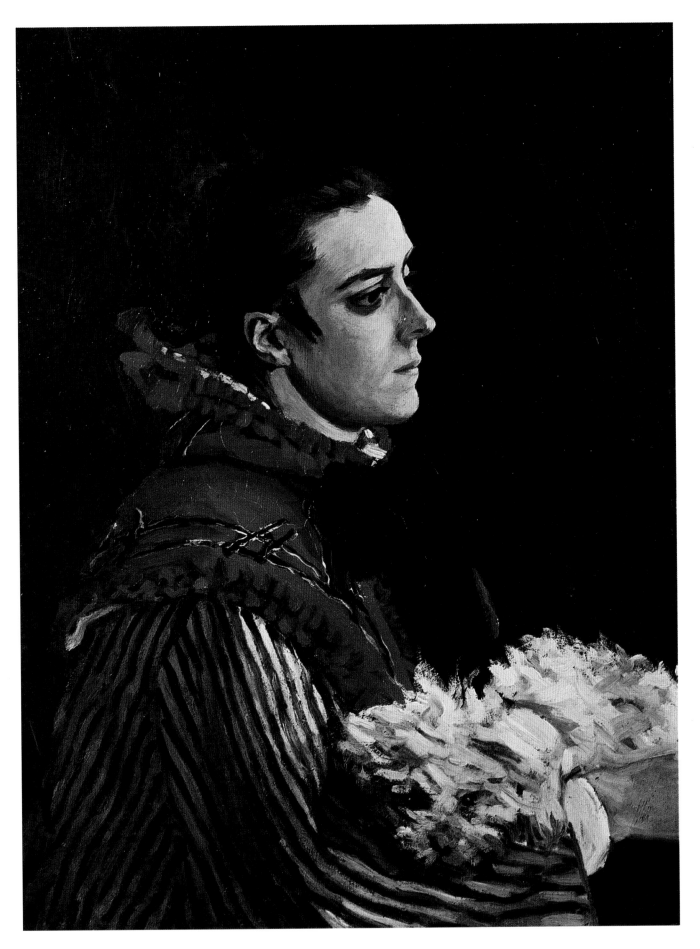

LA CHARRETTE, ROUTE SOUS LA NEIGE À HONFLEUR (1865) THE CART, ROUTE THROUGH THE SNOW AT HONFLEUR

Louvre, Paris. Courtesy of Giraudon

IN 1865, Monet successfully exhibited two paintings, including this one, at the Salon in Paris for the first time. This was an important breakthrough in his career. One of the pictures exhibited was a marine scene painted at Honfleur.

La Charrette, Route sous la Neige à Honfleur shows the town as seen from the approach road. It is a winter's day, but the painting is not dark and gloomy as Monet's snowscapes often are. Instead there is a light in the sky that seems to be generated by the sun, which is not yet visible. The white of the snow is not diluted by too much darkness from the buildings or the cart. The overall effect is quite bright.

Although this is an early work, some elements of Monet's later technique are evident within it. There is some short brushwork, using contrasting shades of white, on the snow on the road. Also, Monet is conscious of the parallel lines formed by the cartwheels in the snow and the ditch by the side of the road. This use of lines and shapes in the landscape would become very important in his later work.

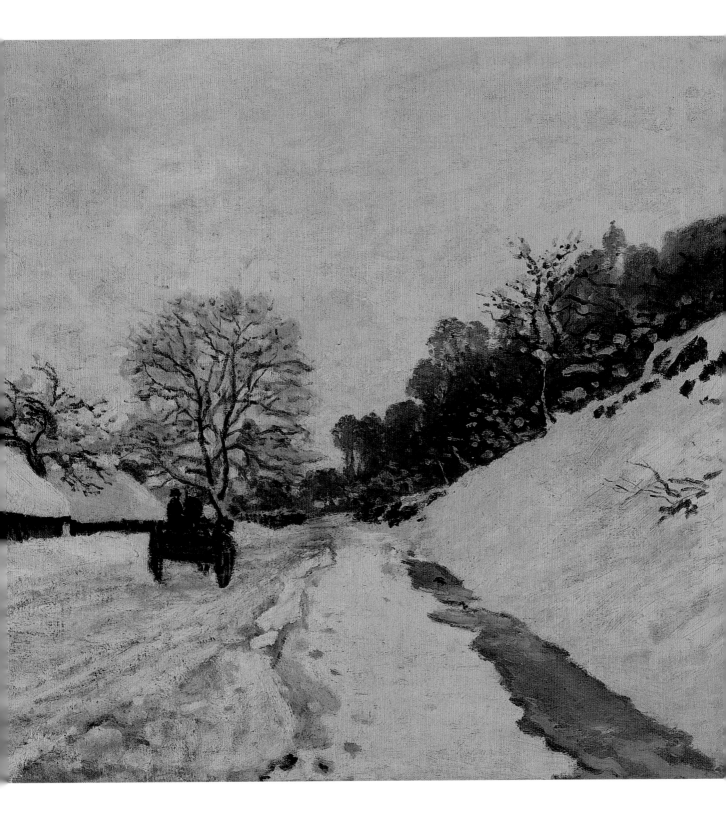

PORTRAIT D'HOMME (1865)
PORTRAIT OF A MAN

Kunsthaus, Zurich. Courtesy of Giraudon

*T*HIS is a portrait of Victor Jacquemont, a watercolorist and engraver who worked for several newspapers at the time. However, the picture has been repeatedly cataloged with varying titles and it is difficult to confirm which is the correct one. As a result, it is known simply as *Portrait d'Homme*.

Manet's influence can be seen in the picture, as it can be in other paintings by Monet from this period; the lack of detailed shading on the figure means he has been painted with solid contrasting colors. Working up the body, Monet starts with white only for the shoes. He then switches to gray for the trousers, with only a little shading around the knees and ankles, brown for the jacket and waistcoat, and flesh for the face. The colors are not varied in tone, so that the figure seems very flat on the canvas. The effect of sunlight or the shadow from the umbrella is not painted in.

A similar technique was used in *Camille sur la Plage* (1870–71). However, in the latter, Monet has taken it to its logical conclusion. The brushstrokes have become thicker and the paint is laid on heavily. He concentrates purely on color, so that Camille's face does not have any features. The sky is one solid color, and even the sea has little variety.

Camille sur la Plage (1870–71)
Camille on the Beach
Courtesy of Giraudon. (See p. 48)

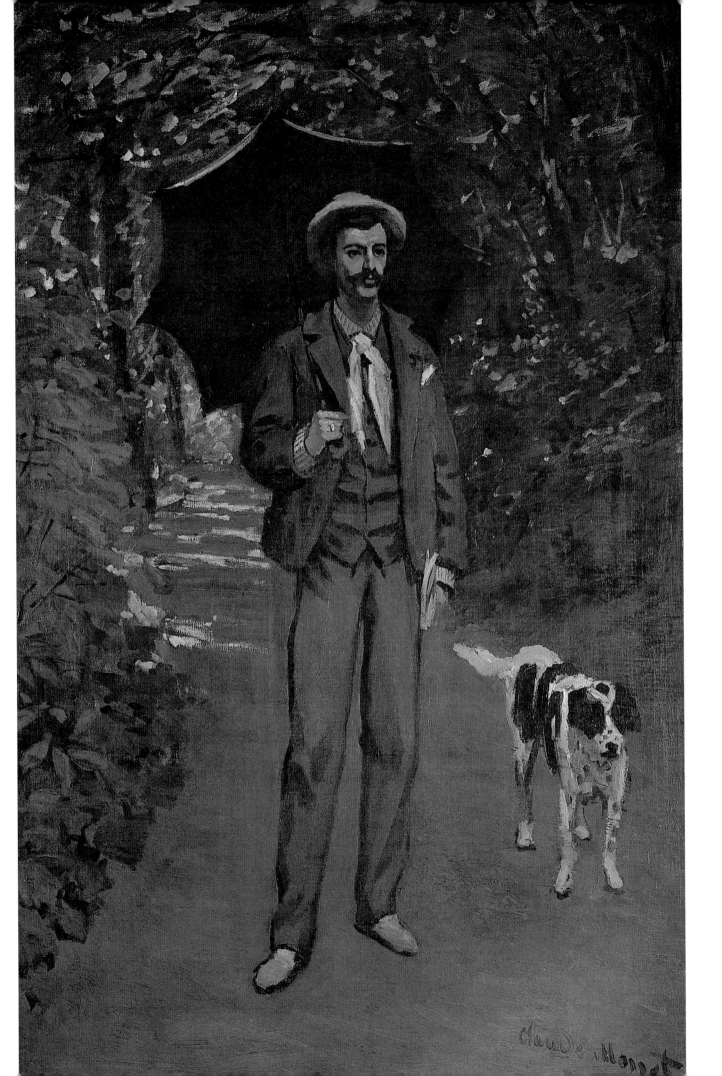

LA ROUTE DE LA FERME,
ST.-SIMEON EN HIVER (1867)
THE ROAD TO THE FARM,
ST.-SIMEON IN WINTER

Private Collection. Courtesy of Image Select

SNOW interested the Impressionist painters because of the effects it created with light and because of the way it changed the shape of the landscape. Like other snowscapes that Monet painted, this one contrasts the white of the snow with dark patches. This is a very different treatment of color from that used in *Norvège, les Maisons Rouges à Bjornegaard* (1895), where the white emphasizes the red of the buildings and the blue of the sky.

The contrast between white and dark in the St.-Simeon painting makes the picture seem somber. The figures on the road are alone in their surroundings, their isolation echoed in the birds in the sky. Both form dark patches against a light background, and each seem equally unconnected to their companions. The sky and snow are painted in the same colors, giving the painting a timeless quality. In contrast, the Norwegian buildings are caught with the sun falling on them, giving the painting some specificity of time.

The Norwegian painting is not as stark as the earlier work. The snow reflects pink from the sun, and the blue sky is more welcoming than the gray in the St-Simeon picture. The paint is laid on with quick brushstrokes, whereas the earlier picture has an air of precision to its brushwork.

Norvège, les Maisons Rouges à Bjornegaard (1895)
Norway, the Red Houses at Bjornegaard
Courtesy of Giraudon. (See p. 196)

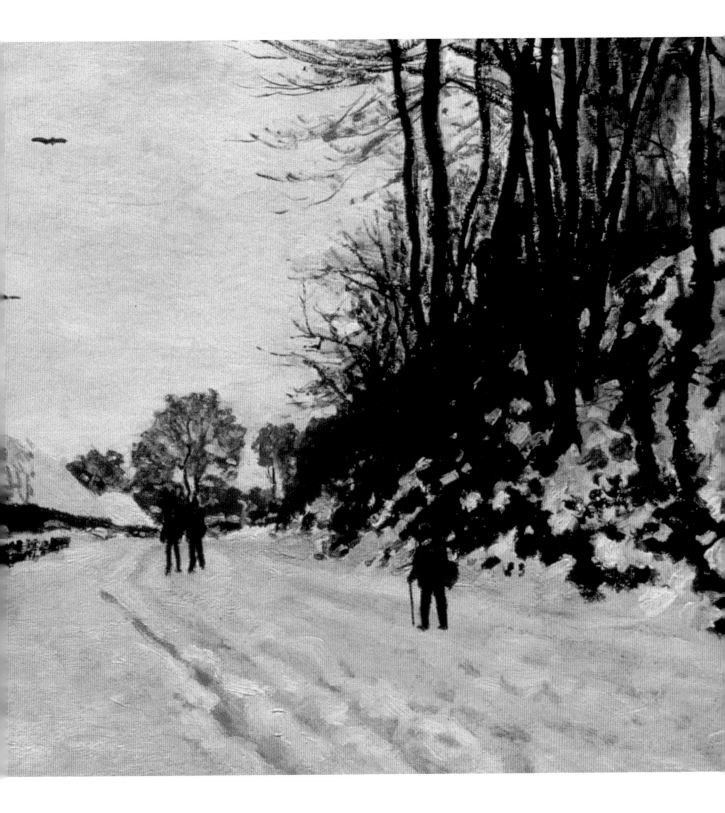

❀ LA ROUTE DE LA FERME, ST.-SIMEON EN HIVER ❀

GLAÇONS SUR LA SEINE À BOUGIVAL (1867)
ICE FLOES ON THE SEINE AT BOUGIVAL

Musée d'Orsay. Courtesy of Image Select

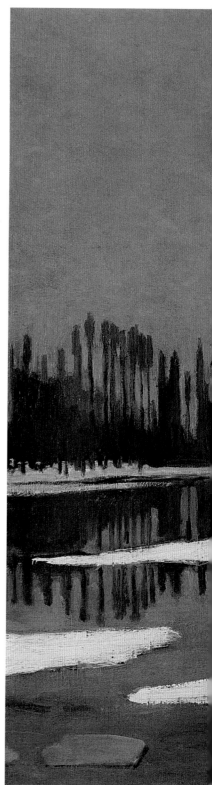

*T*HE composition of this painting, and its date, suggest that Monet was still interested in the same techniques that he had been using while in Normandy. Three years earlier, he had been engrossed in painting snow scenes, but not in the same style as this.

Monet uses an almost monochromatic color scheme with little variety between the gray and white of the palette. This seems suitable for recording a dull winter's day. It is in contrast to his later treatment of the Seine in winter as depicted below. In *La Seine a Bennicourt, Hiver* (1893) the color scheme is more varied, and the touches of yellow and light blue help to give the picture a warmer tone. In addition, he is preoccupied with laying on small brushstrokes of individual colors to create an all-encompassing atmosphere. In *Glaçons sur la Seine à Bougival*, however, the technique is more concerned with toning brushstrokes in to create a solid block of color.

The trees to the left are painted as vertical lines that form a screen that is reflected in the water. This is reminiscent of contemporary Japanese art. The use of color and the decorative and simplistic interpretation of the landscape are all in keeping with Japanese art, which was very popular at this time.

La Seine à Bennicourt, Hiver (1893)
The Seine at Bennicourt in Winter
Courtesy of Christie's Images. (See p. 186)

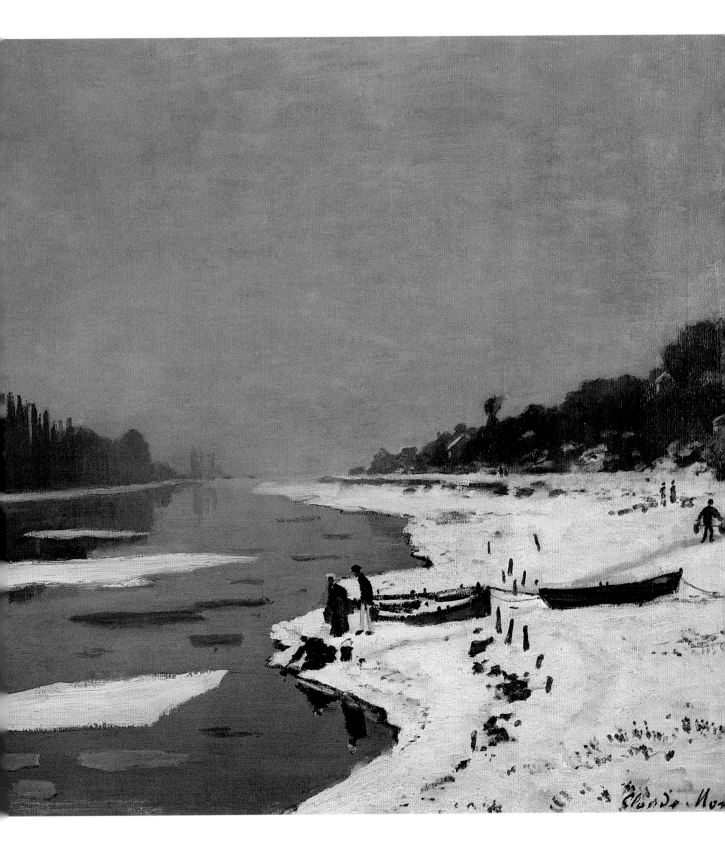

Terrasse à Ste.-Adresse (1867)
Terrace at Ste.-Adresse
M.O.M.A., New York. Courtesy of Giraudon

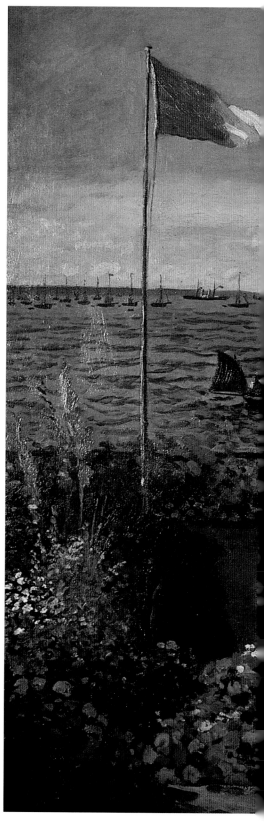

*P*OVERTY forced Monet to return from Normandy to the family home around 1867, and while there he painted this view from one of the upstairs rooms. The man seated is Monet's father. Monet's stepson commented later that the abundance of flowers on the terrace suggests that Monet's love of flowers was inherited from his parents. The painting appears composed and almost artificial when compared with some of the earlier works, which are deliberately given a spontaneous feel.

Monet later referred to this painting as the "Chinese painting with flags." At that time the words "Japanese" and "Chinese" were often interchanged. He owned some Japanese prints, and their influence is seen in this work. The flags that dominate the picture dissect the three horizontal bands of the painting—the terrace, the sea, and the sky—providing a vertical balance.

The composition itself is unconventional, with the faces of the people turned away from the viewer. The boats and ships in the background emphasize the modernity of the scene, as they were vital to trade in the town. Their shapes on the horizon are sharply geometric, contributing to the oriental tone of the painting. While Monet's treatment of the sky is flat, the sea shows signs of his fascination with its every changing color, a fascination that emerges strongly in later works.

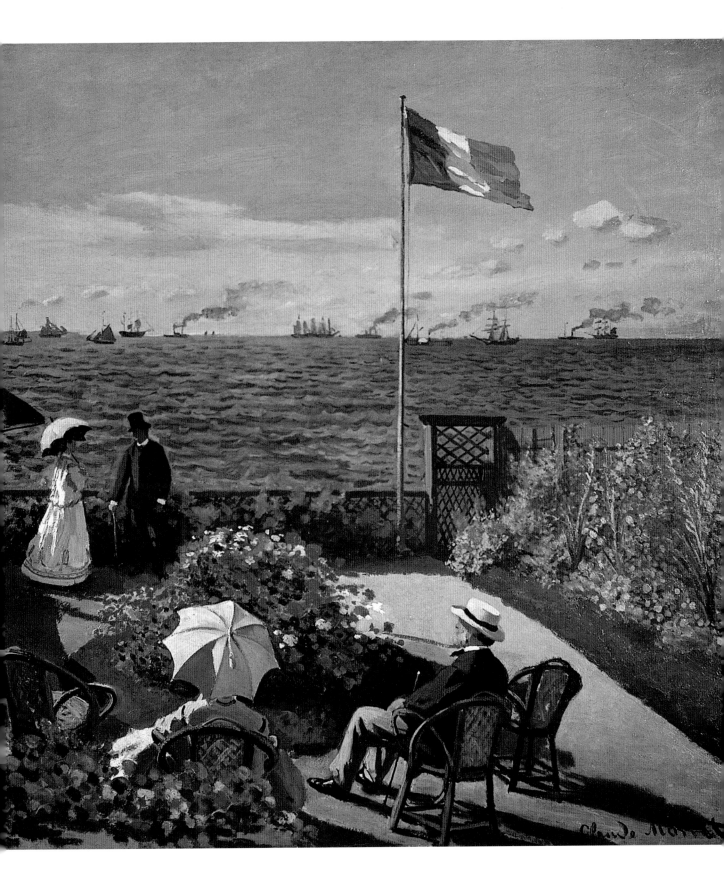

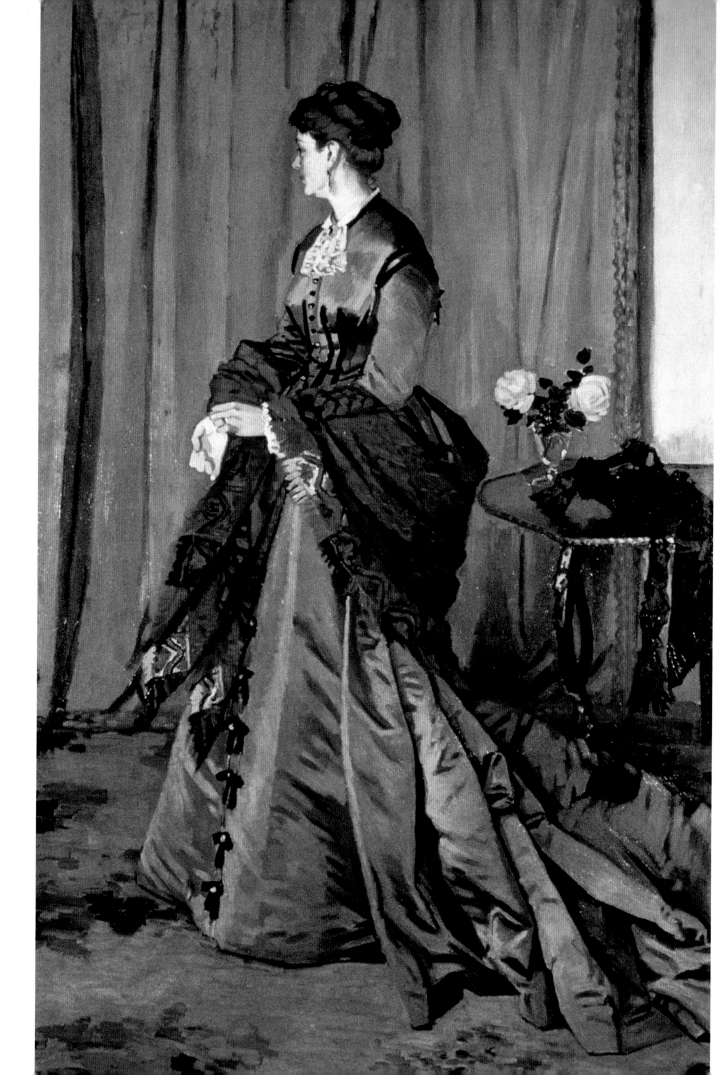

PORTRAIT DE MADAME GAUDIBERT (1868)
PORTRAIT OF MADAME GAUDIBERT

Musée d'Orsay. Courtesy of Image Select

MADAME Gaudibert was the wife of one of Monet's patrons, who commissioned this life-size portrait from him at a time when he was in desperate financial straits.

Monet had painted portraits earlier in his career. In particular, *Camille, ou la Femme à la Robe Verte* (1866) was especially successful. However, this slightly later work, while mimicking the pose of the earlier portrait, has advanced in technique; the composition is more complex. The averted face is intriguing, particularly as this was a commissioned portrait. As can be seen in the later work *Essai de Figure en Plein Air* (1886), this pose was one Monet favored greatly. The head turned to one side turns the woman into an anonymous figure. Monet has painted a fashionable woman of society rather than a detailed individual portrait.

The later painting reveals how Monet takes the anonymity of the figure to new levels. In *Portrait de Madame Gaudibert*, the face of the woman may not be shown fully, but the features that are revealed can be discerned easily. In the secondary image, the face is not averted as far as Madame Gaudibert's, yet the features are blurred and unidentifiable. As the title of the painting suggests, the later work was concerned entirely with aesthetic composition.

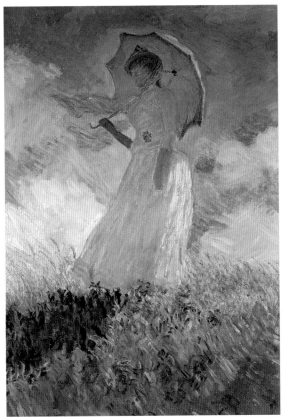

**Essai de Figure en Plein Air
(Vers la Gauche) (1886)**
Study of a Figure Outdoors (Facing Left)
Courtesy of Giraudon. (See p. 160)

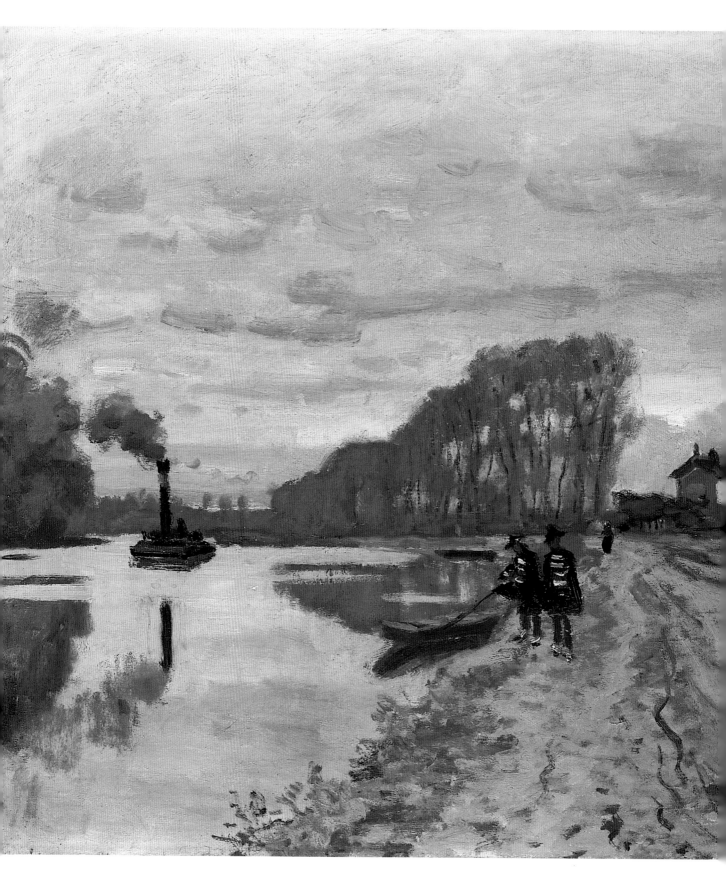

VOLTIGEURS DE LA GARDE FLANANT AU BORD DE L'EAU (1870)
SOLDIERS STROLLING BY THE RIVERSIDE
Courtesy of Christie's Images

THE steamboat on the water and the guards patrolling the riverbank give *Voltigeurs de la Garde Flanant au Bord de l'Eau* a modern element, preventing the rural setting from being timeless. Similarly *Prairie de Limetz* (1887) relies on the dress of Alice Hoschedé to date the painting to contemporary times.

The figures in both pictures are treated in a similar cursory technique that does not allow for any detailed paintwork. However, they do draw the eye toward them. Alice achieves this by her prominent position in the painting and the pink splash that her dress makes. She is, however, just another aspect of the landscape. The guards in this painting also attract the eye through the bright color they make against a dusty, brown background. The eye then moves from them to the woman seen further along the road. Monet creates a depth in both paintings by using two distinct groups of people with a distance between them. In *Voltigeurs de la Garde Flanant au Bord de l'Eau*, the road running straight ahead into the distance adds to the depth.

Prairie de Limetz (1887)
Limetz Meadow
Courtesy of Christie's Images. (See p. 166)

Monet's treatment of light on the surface of the water is interesting. He shows an incomplete reflection of the steamboat as a result of light reflecting strongly off the water and cutting the boat off from its reflection. Water, light, and reflection become increasingly important elements in his work.

CAMILLE SUR LA PLAGE (1870–71)
CAMILLE ON THE BEACH

Courtesy of Giraudon

THE treatment of the subject in this painting is simplistic. The figure poses on the beach facing toward the viewer and in close proximity, yet she has no features to her face, with the merest hint of an outline for her nose and eyes. She is an anonymous woman without identity.

Monet's formal portrait of Camille (*Camille au Petit Chien* (1866)) is in stark contrast to this work. It depicts Camille in profile but with careful attention paid to her features, so that her face is revealed in detail. Her clothes are treated to the same level of care, and she would be recognizable as the subject in reality. Part of Camille's lack of detail in *Camille sur la Plage* may be due to the unfinished nature of the work— in places the canvas shows through. While this alone does not necessarily indicate that

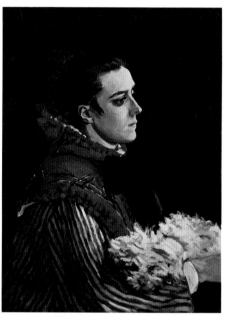

Camille au Petit Chien (1866)
Camille with a Little Dog
Private Collection, Zurich.
Courtesy of Giraudon. (See p. 32)

a work is unfinished, the lack of a signature adds weight to the assumption. Monet did not sign all his finished work, but in this case it seems certain he had not finished the painting.

The brushstrokes are laid on thickly and are clearly visible to the viewer. The work has an air of spontaneity that is especially evident when examining the sea, which is painted in with a few brushstrokes using only three colors.

SUR LA PLAGE À TROUVILLE (1870–71)
ON THE BEACH AT TROUVILLE

Musée Marmottan. Courtesy of Giraudon

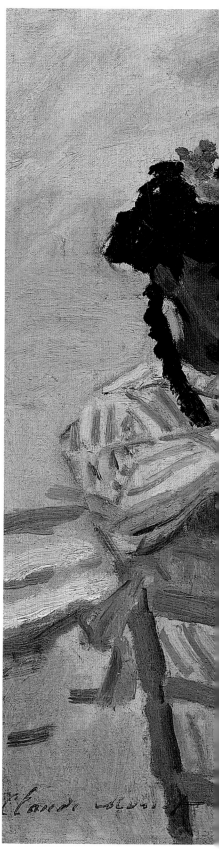

*P*AINTED while on vacation with Boudin, this picture depicts both Camille and Boudin's wife on the beach at the popular French tourist spot of Trouville. Monet's choice of subject again reflects his desire to record modern scenes. He chose to show this familiar resort in an untraditional way.

First the viewer is thrust in very close to the two women. This is the opposite technique to that used in *La Plage à Trouville* (1870). The result is to make the viewer slightly uncomfortable, as if he were invading an intimate scene. This discomfort is furthered by the relationship between the two women. The central space between them is empty; neither woman acknowledges the presence of the other. Their features are not detailed, so there is an air of anonymity about them. Similarly, the people walking in *La Plage à Trouville* are not painted in detail.

In the background other tourists can be seen, also devoid of identifiable features. This, combined with the quick, heavy brushstrokes, adds to the spontaneity of the painting. In both works Monet is advocating the *plein-air* technique of painting.

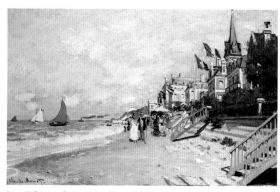

La Plage à Trouville (1870)
The Beach at Trouville
Courtesy of Christie's Images. (See p. 52)

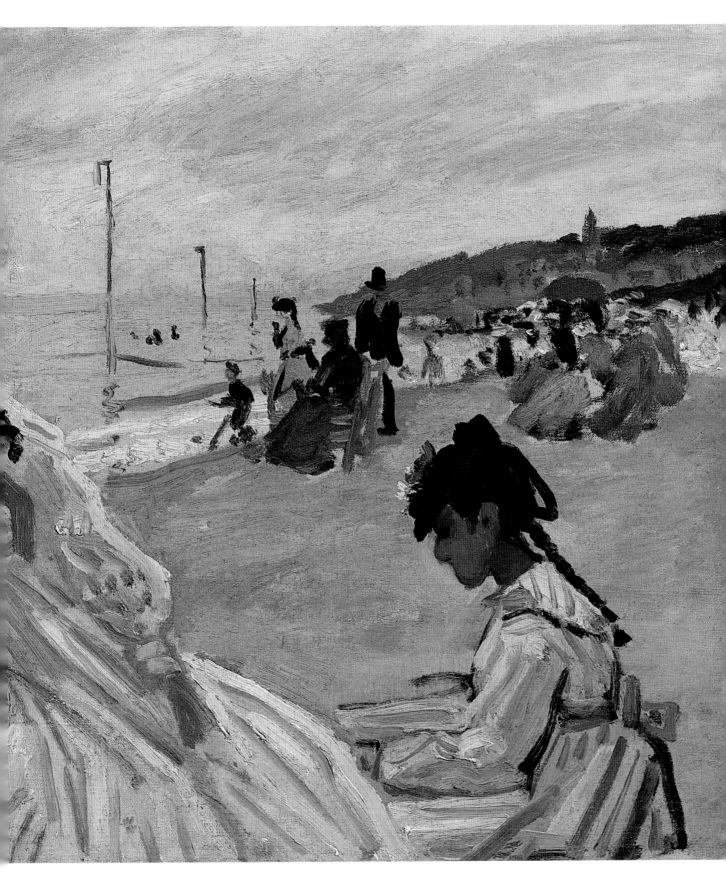

LA PLAGE À TROUVILLE (1870)
THE BEACH AT TROUVILLE

Courtesy of Christie's Images

IN both *La Plage à Trouville* and *Barques de Pêche devant la Plage et les Falaises de Pourville* (1882), Monet sought to perpetrate the concept of *plein-air* painting. The cursory depiction of the figures and the quick dashes of paint on the canvas add to the idea that these are works of spontaneity. Each depicts leisure activities being carried out.

However, the Trouville painting shows a number of people walking along the beach. In contrast, the Pourville work depicts a solitary individual, the lack of buildings in the picture adding to his air of isolation. In *La Plage à Trouville* the viewer becomes the isolated person. A strip of sand at the front of the painting is empty of people, and the viewer is facing the approaching tourists, which means the viewer has the sensation of walking against the general flow of people. Despite the fashionable location, the viewer is removed from the main action.

The colors used in this work are brilliant. The flags give the painting a lively air, and the luminosity of the sunshine makes the whole picture warm. In contrast, the colors used in the Pourville painting are more muted. The sky is nearly filled with cloud, and the palette used is less jewel-like.

Barques de Pêche devant la Plage et les Falaises de Pourville (1882)
Fishing Boats in front of the Beach and Cliffs of Pourville
Courtesy of Christie's Images. (See p. 124)

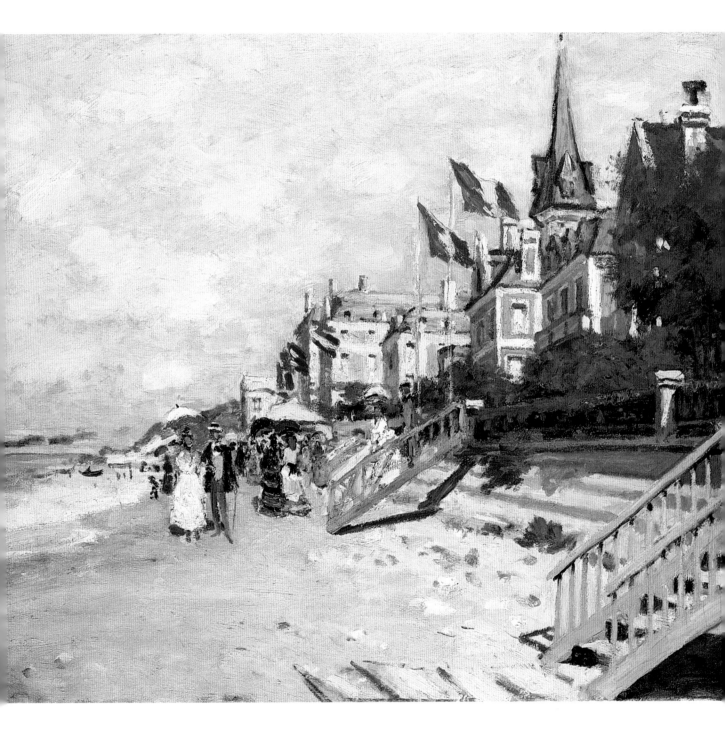

CHASSE-MARÉE À L'ANCRE, ROUEN (1872)
FISHING BOAT AT ANCHOR, ROUEN
Louvre, Paris. Courtesy of Giraudon

*T*HERE is an overwhelming feeling of
loneliness to this painting. The stillness that
surrounds it adds to that sensation. The lack
of movement in the water and on land, and the
non-specific time of day, give it a timeless quality.

The figure on the ship is isolated in his
environment by the sheer size of the boat and its
masts thrust up into the sky. The straight lines formed
by the masts mimic the lines of the poplars, which
pierce the sky behind the ship on the banks. The
sky itself covers a large part of the canvas, adding to
the timeless nature of the painting. The vastness of
the sky is exaggerated by its becoming almost one
with the water, so that the painting is dominated by
their blueness.

Against this background, the ship stands out.
Her masts dissect the sky, preventing it from
completely overwhelming the picture. The detail of

the ship's rigging is a
complex arrangement of
lines that contrast with
the restful simplicity of
sky and water.

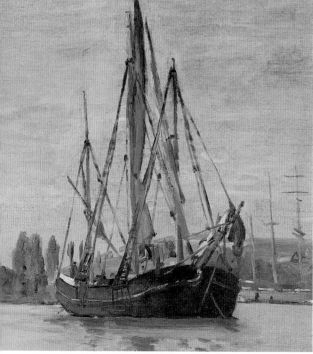

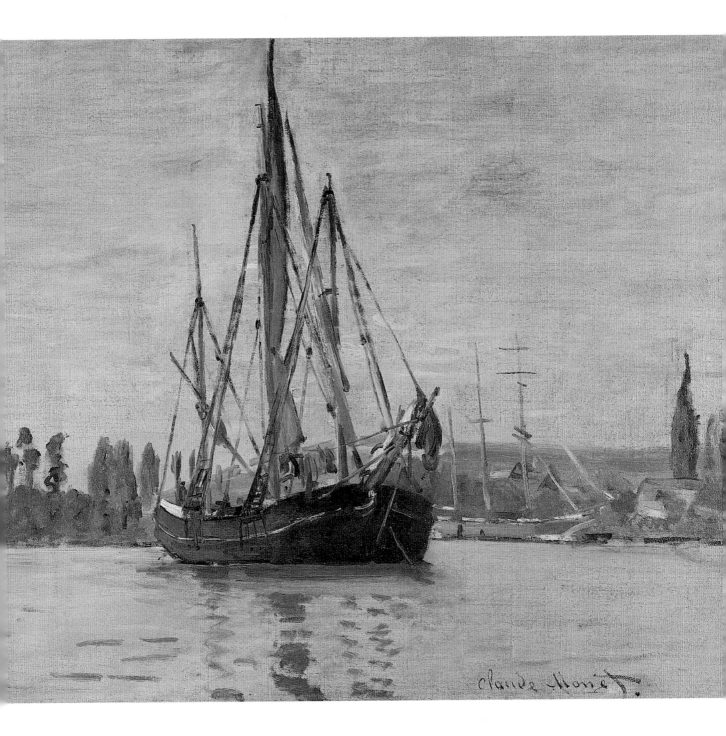

BATEAUX DE PLAISANCE (1872)
PLEASURE BOATS

Musée d'Orsay. Courtesy of Giraudon

BOATING as a hobby and pastime became very popular in France in the nineteenth century. At the time many people worked long days in the city, choosing the weekends to either visit the country or seaside, where many went aboard the pleasure boats.

For Monet, his boating scenes represented the attempts by a typical Frenchman to enter into a dialog with nature. For this reason the paintings are frequently empty of people and seem to be very isolated moments. In this picture there are only a couple of people on the bank, and their features are indiscernable. In *Chasse-Marée à l'Ancre* (1872) there is only one man on board the ship, and his isolation is exaggerated by its size. Both paintings devote a lot of space to the sky, which adds to the insignificance of the individuals.

Prior to his move to Argenteuil, Monet painted only merchant ships and working boats.

Chasse-Marée à l'Ancre, Rouen (1872)
Fishing Boat at Anchor, Rouen
Louvre, Paris. Courtesy of Giraudon. (See p. 54)

Chasse-Marée à l'Ancre shows such a ship. Once at Argenteuil, however, Monet rarely produced marine paintings that did not feature pleasure boats, and *Bateaux de Plaisance* is typical of those he painted at the time.

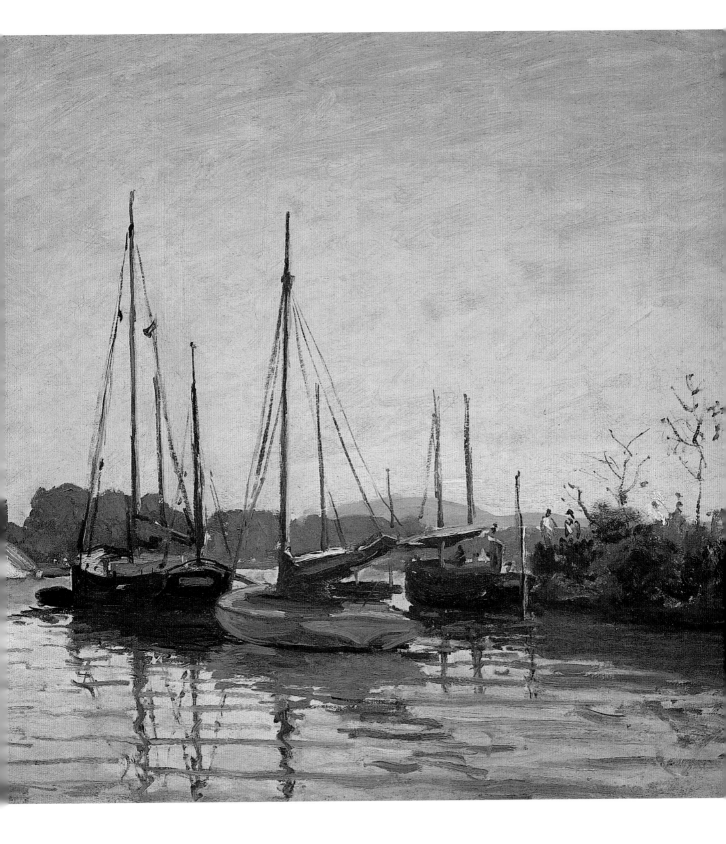

CARRIÈRES-ST.-DENIS (1872)

Courtesy of Giraudon

THIS landscape shows many of the traditional Impressionist trademarks. Some of the techniques within it can be traced to later landscapes, such as *Antibes, Vue de Cap, Vent de Mistral* (1888). Even though they treat contrasting subjects, one being a natural landscape, the other a town, there are some similarities.

Carrières-St-Denis has three broad horizontal bands going across the canvas. In the foreground is the water; above it is the town with its patchwork of roofs forming blocks of colors. To the left, some bushes and poplar trees break the horizontal created by the town. The poplars reach into the blue sky that forms the third band. In *Antibes, Vue de Cap, Vent de Mistral*, the banding is made up of four elements of land, sea, mountains, and sky. The presence of water in both was to become a common element in Impressionist work and appears repeatedly in later paintings.

The brushstrokes on the water form strong linear bands in places that disrupt the reflection of the poplars to the point where they disappear in patches. The later painting is concerned with capturing the color of the sea to such an extent that the strength of the blue prevents any reflections from appearing.

Antibes, Vue de Cap, Vent de Mistral (1888)
Antibes, View of the Cape in the Mistral Wind
Courtesy of Christie's Images. (See p. 170)

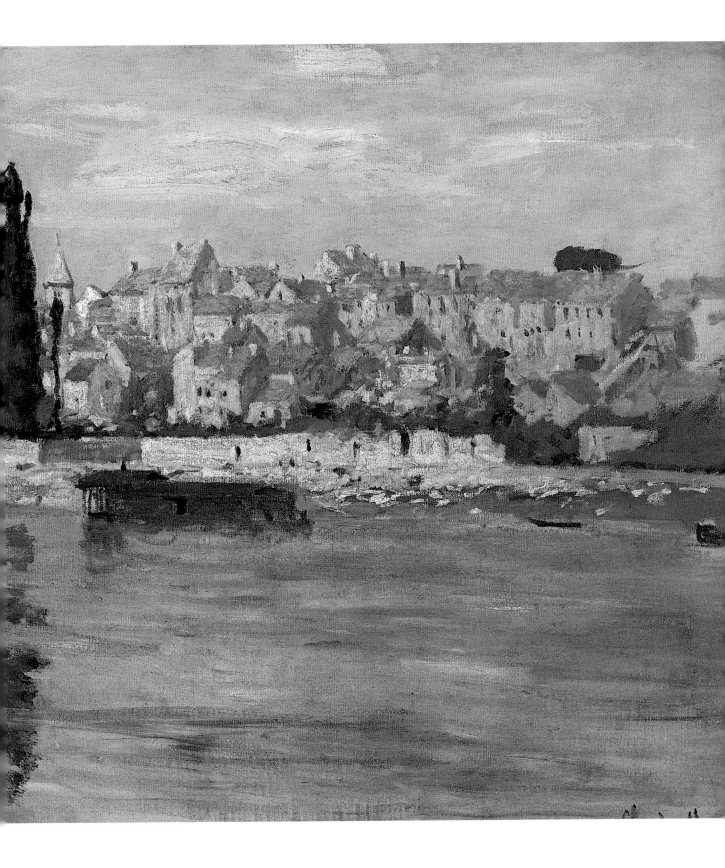

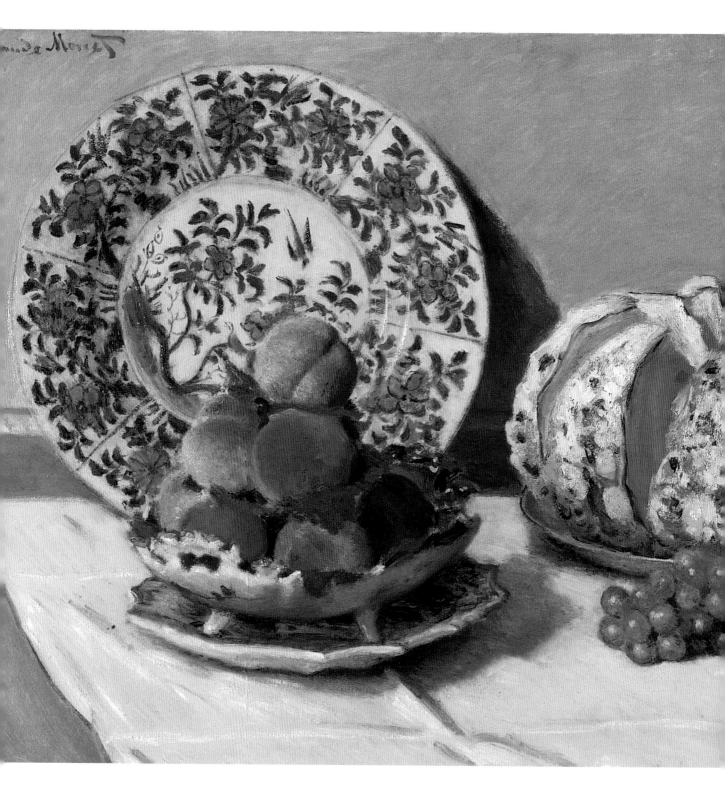

NATURE MORTE AU MELON (1872)
STILL LIFE WITH MELON

Courtesy of Giraudon

ONET painted very few still lifes. This study of fruit is treated in a similar manner to his landscape paintings, in the sense that the composition is structured around parallel planes. *Nature Morte au Melon* is not treated with the obvious banding approach evident in some of Monet's landscapes, although this compositional technique is present. The wall in the background forms one strip of color; the tablecloth creates another square of color that is prevented from reaching completely across the canvas by the strip of dark tabletop painted in the middle and side of the picture. These lines of varying color create strong geometric shapes on the canvas. It is easy to see a triangle in the right-hand corner where the wood meets the tablecloth and the frame. Similarly, the wall forms a rectangle.

These geometric shapes are disrupted by the fruit and plates used as the focal points of the composition. It is not by accident that Monet chose round fruits as his subject: the roundness of the melon, grapes, peaches, and the plate contrast with the geometric shapes of their

background. The treatment of varying color and light on these draw the eye away from the solid colors with which the backdrops have been painted in. As a result, the whole is harmonized.

LA LISEUSE (1872)
THE LOVER OF READING

Walters Art Gallery, Baltimore. Courtesy of Giraudon

*D*URING the eighteenth century, women often featured in paintings as allegories or with allegorical subjects. There would be a narrative context to the paintings that could be read by the symbolism included in the painting.

In *La Liseuse*, Monet has taken Camille and painted her in an attitude that is reminiscent of these earlier paintings. However, he has given the treatment a modern rendition and there is no symbolism or allegory to the work. Camille's face is shown in profile and her expression is serene. There is no story to be read into the work; as it is a painting of purely aesthetic purpose. The woman in her pink dress reflects the flowers around her. This association between nature and the female as a flower is evident in *La Barque* (1887), where the color of the women's dresses echo the color of the flowers on the bank.

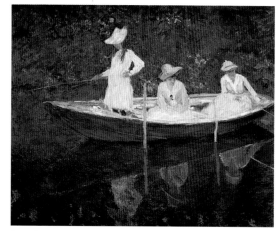

La Barque (1887)
In the Rowing Boat
Courtesy of Topham. (See p. 162)

La Liseuse was unusual in its time for posing the woman outdoors. This later became a common practice, but at the time it added to the originality of the painting. Both paintings celebrate the female in harmony with a natural background of flowers.

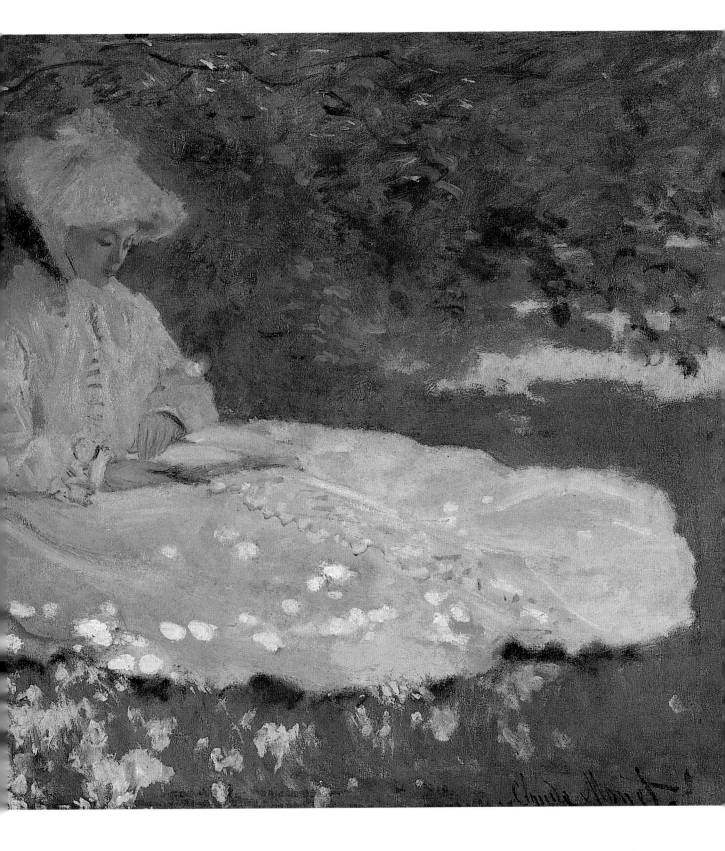

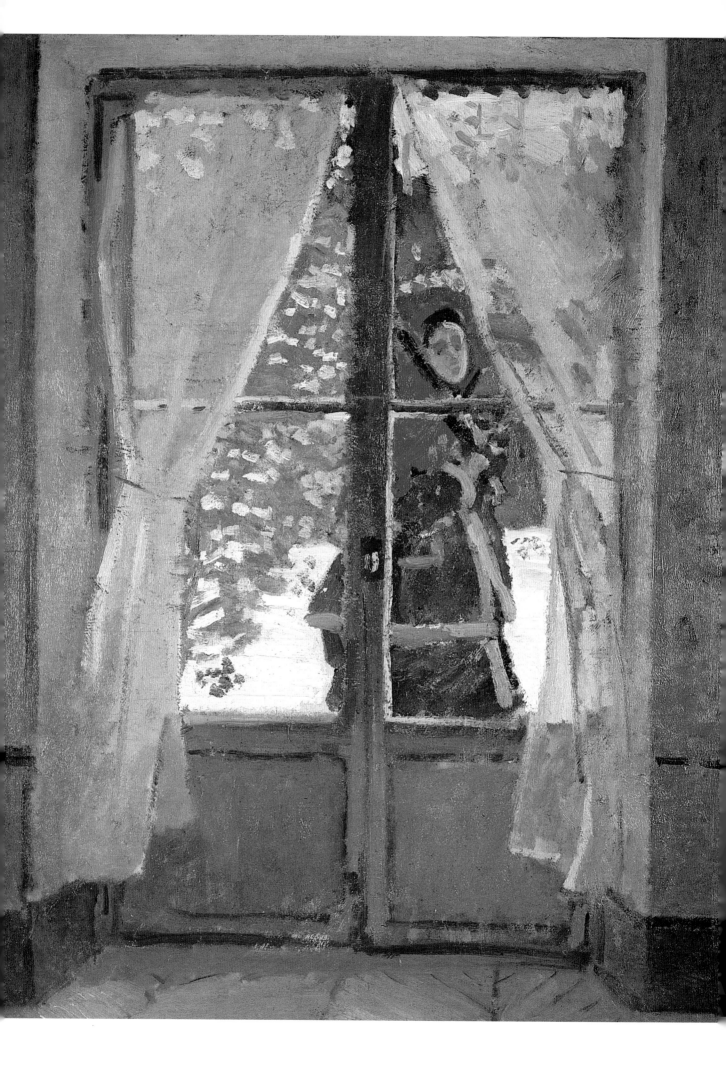

LA CAPELINE ROUGE,
PORTRAIT DE MADAME MONET (1873)
THE RED CAPE, PORTRAIT OF MADAME MONET

Cleveland Museum of Art. Courtesy of Giraudon

PAINTED at Argenteuil, this work depicts Camille Monet caught as she passes the window. The air of spontaneity about the picture contrasts strikingly with the more formal pose of *Femme Assise sur un Banc* (1874). The intimacy of Madame Monet's portrait is conveyed in the glance she throws over her shoulder at Monet as she passes.

Unlike the composition of *Femme Assise sur un Banc*, in *La Capeline Rouge, Portrait de Madame Monet* the artist uses a very obvious frame around his central subject in the form of the curtains and windowed doors. The frame invades that painting to the point of covering most of the canvas. In the secondary image the subject fills the canvas to the extent that all of her dress cannot be contained in the picture. In this painting the woman is set apart from her natural background. In Madame Monet's portrait, the outside and inside world are connected through the white of the snow and the white of the curtains.

Femme Assise sur un Banc (1874)
Woman Seated on a Bench
Courtesy of the Tate Gallery. (See p. 84)

The red hood draws the viewer's gaze to Madame Monet; her face turned toward the viewer is intimate. Her central position between the curtains, the bright hood and her inward gaze make her the focus of the painting. In a similar way the seated woman of 1874 is striking against her green background. Her eyes also form a connection between the viewer and the subject of the painting.

LA FALAISE DE STE.-ADRESSE (1873)
STE.-ADRESSE CLIFFS
Courtesy of Christie's Images

*I*N both these paintings Monet has restricted himself to the essentials only, his aim to create an overall impression. For this reason there is no detail on the sea or the shore of *La Falaise de Ste.-Adresse* but merely strokes of color. The difference between these two paintings lies in Monet's tension between land and sea in *Etreat, La Plage et la Falaise d'Aval* (1884) and the calmer landscape of *La Falaise de Ste.-Adresse*.

The horseshoe of land provides a balanced curve in the main painting. The curves and rounded ends to the cliffs give the whole picture a softer feel than in the later work. In this, the jagged point of the cliff end and the uneven beach and sea surface make for a more dramatic painting. *La Falaise de Ste.-Adresse* has a wash of yellow that encompasses the land and the beach, creating a warm glow that is reflected in the sky.

The paintings that Monet produced of the Normandy coast were exhibited in 1898 and proved very popular with the buying public. The combination of familiar scenes and aesthetic presentation meant that these pictures sold easily.

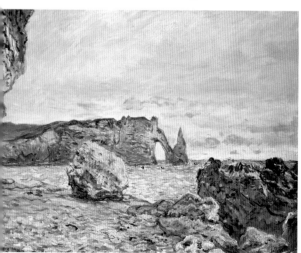

Etreat, La Plage et la Falaise d'Aval 1884
Etreat, the Beach and the Aval Cliff
Courtesy of Christie's Images. (See p. 140)

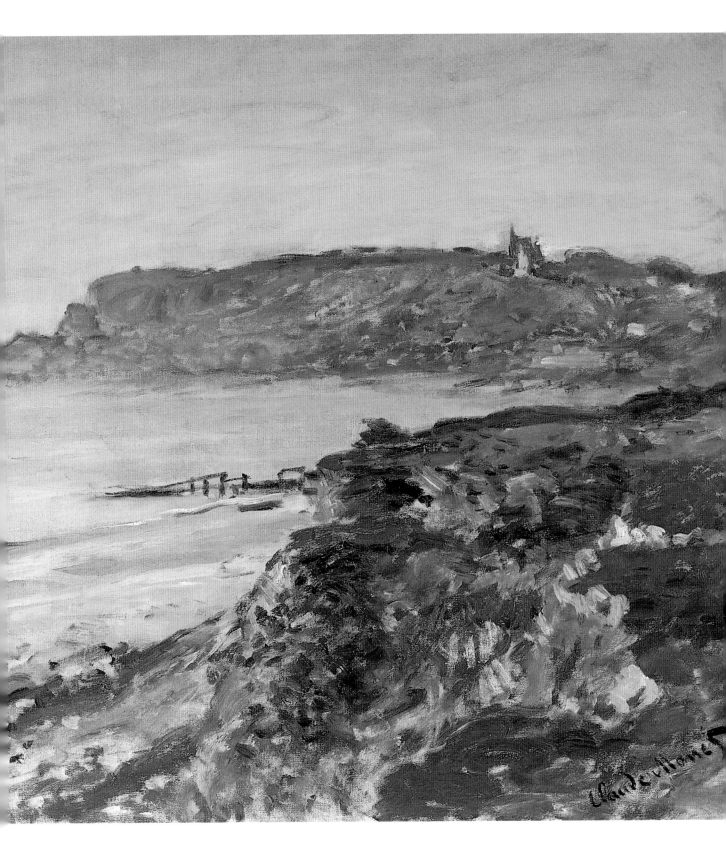

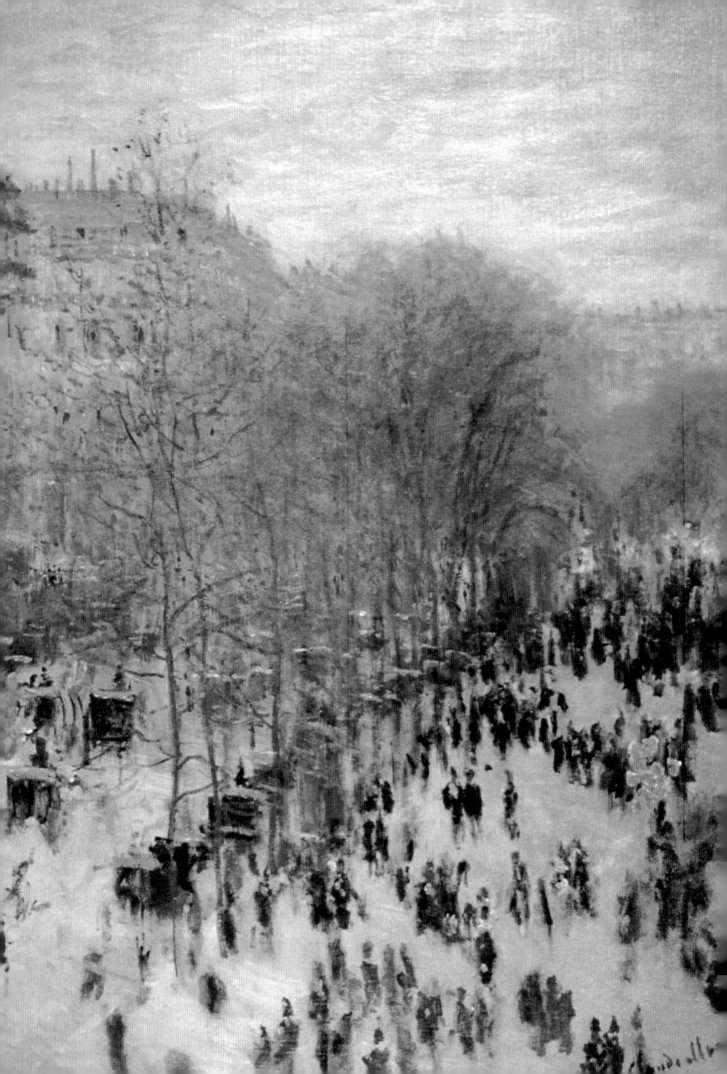

BOULEVARD DES CAPUCINES (1873)

Courtesy of the Visual Arts Library, London

*D*EPICTING a modern scene, Monet shows a Paris that is bustling and full of action. He has caught the fleeting nature of movement precisely by dabbing on paint to represent people, rather than dwelling on their detail. This technique is also used in *La Plage à Trouville* (1870) where the people are equally as lacking in detail. He also picks another modern subject; that of the tourist resort.

As well as creating a spontaneous painting that dwells on the instantaneousness of the moment, Monet is also investigating the effects of winter light in *Boulevard des Capucines*. This is the cause of the off-white glow in the sky which reflects on to the street below. Against this, the people seem like dark marks, and this earned them the description of "black tongue-lickings" from the critic Leroy. The different effects of sunlight would especially be understood by the contemporary viewer as the work was displayed with a companion piece depicting the street in summer.

In *La Plage à Trouville*, Monet paints on a level with his subject, so that everything is seen to scale and the numbers of people are camouflaged. In the main picture, his view is from above, looking down. This increases the impression of the people as a small, scurrying crowd in a city of wide boulevards and tall, modern buildings.

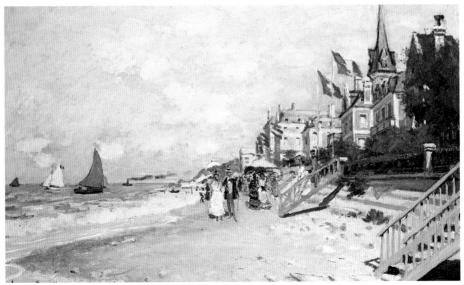

La Plage à Trouville (1870)
The Beach at Trouville
Courtesy of Christie's Images. (See p. 52)

ZAANDAM (1871)

Courtesy of Image Select

MONET visited Holland on his way back from England at the end of the Franco-Prussian War. While there, he painted 24 canvases in just three months. The combination of architecture and water in a flat landscape was what attracted him most. This combination appears again and again in his work.

This painting is reminiscent of some of the marine pictures from Argenteuil, particularly in the technique used on the water. The reflections of the buildings are sharp and the colors clear. *La Zuiderkerk, Amsterdam* (1872) has the same clarity of color but the surface of the water has been treated differently. It is not the mirror that the canal is in the main picture. The strokes used on the water are short flecks of varying colors. In *Zaandam* the water is painted with smooth brushwork. Long white lines are used to indicate where the water reflects light alone. The ripples of the water are also depicted by the wobbly reflection, particularly evident when looking at the reflected masts of the boat.

Both paintings use blocks of colors when it comes to the buildings. In *Zaandam*, a block of red is placed next to a block of blue, representing the house fronts. The architectural nuances are not detailed.

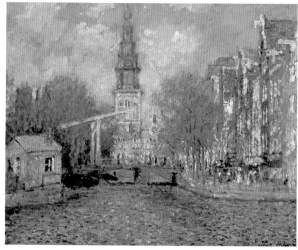

La Zuiderkerk, Amsterdam (1872)
Zuiderkerk at Amsterdam
Philadelphia Museum of Art. Courtesy of Image Select. (See p. 72)

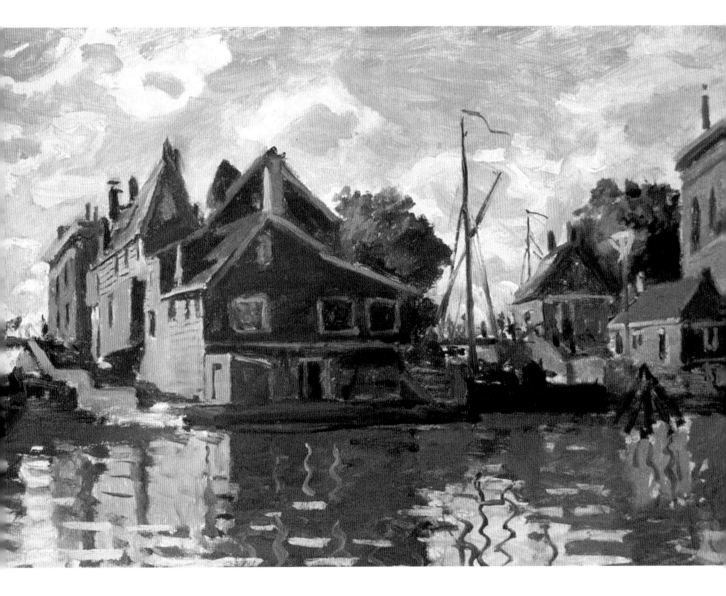

LA ZUIDERKERK, AMSTERDAM (1872)
ZUIDERKERK AT AMSTERDAM

Philadelphia Museum of Art. Courtesy of Image Select

*T*HERE is some confusion about the date of this painting. Monet visited Holland in the summer of 1871, yet this painting is dated 1872. It is now generally agreed that, despite the date, this and another painting, also dated 1872, are part of the 1871 series.

The composition of this painting is centered on the spire, with the canal leading up to it. On the right are the tall buildings of Amsterdam, with people moving along the pavement and over the bridge. These people are painted as flecks. The reflections of the buildings on the water are represented by yellow brushstrokes. This is the same as in *Le Parlement, Couchant de Soleil* (1904), where the buildings' reflection is identified only as a dark patch on the water.

A comparison of these two paintings reveals that by 1904 Monet was less concerned about observing the boundaries between building and water. It is difficult to identify where building ends and reflection begins. In *La Zuiderkerk, Amsterdam* the water is clearly separated from the buildings and there is no danger of building and reflection merging. The painting is in focus and uses strong blocks of color, whereas the London painting has a mist over it that prevents a detailed look at the subject.

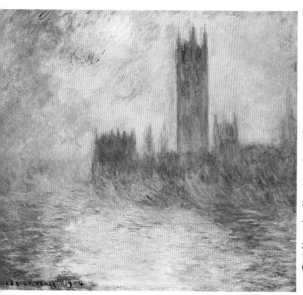

Le Parlement, Couchant de Soleil (1904)
Houses of Parliament, Sunset
Courtesy of Christie's Images. (See p. 224)

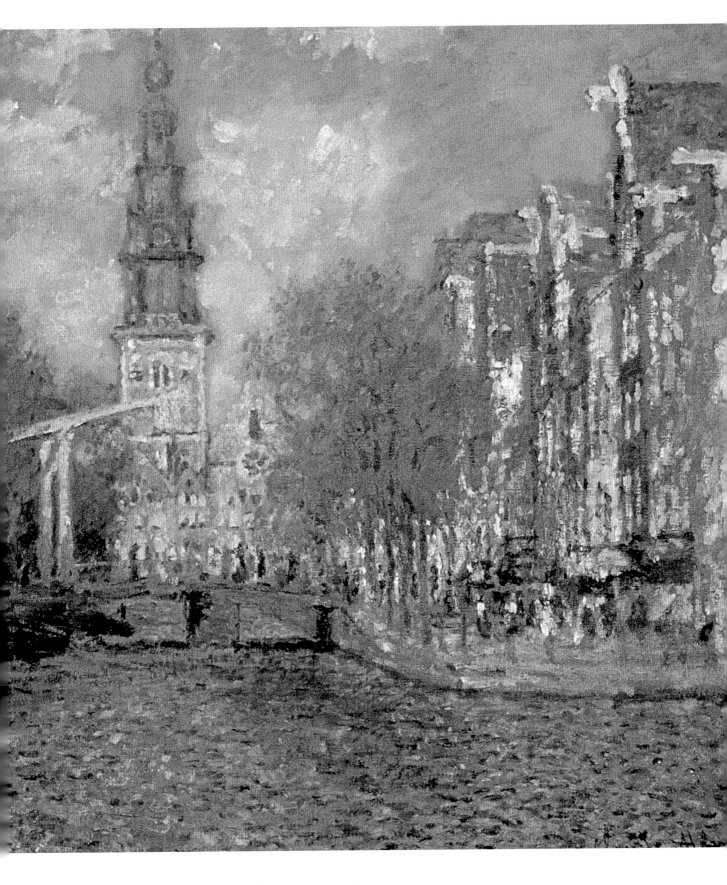

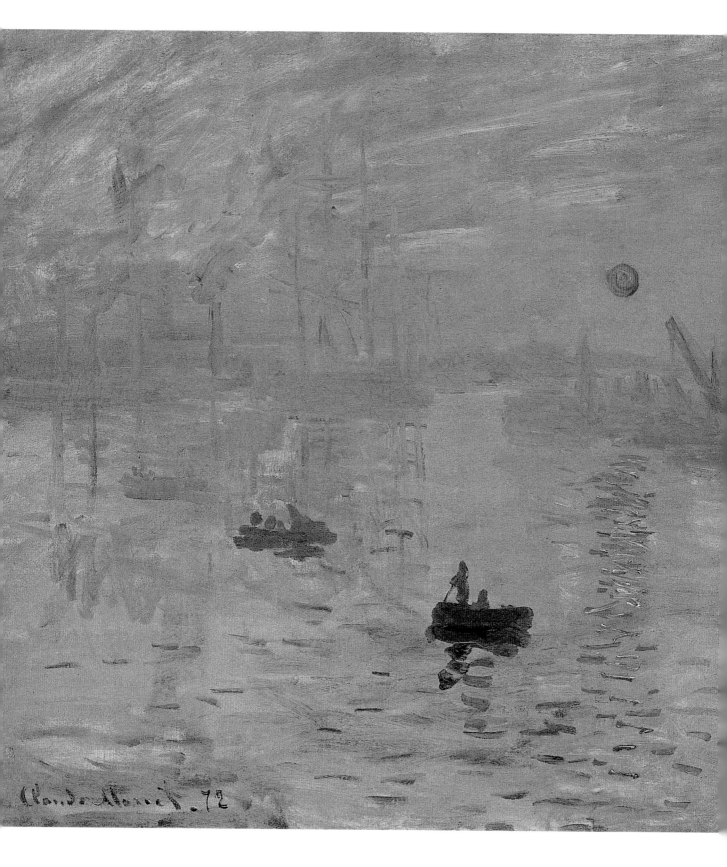

IMPRESSION, SOLEIL LEVANT (1872)
IMPRESSION, SUNRISE
Courtesy of Giraudon

*T*HIS painting is responsible for the birth of the term "Impressionist." It was included in the first exhibition held by the Society of Painters, Sculptors, and Engravers in 1874. Monet was a founding member of this society, which had originated from the express desire to end the artistic stranglehold of the Salon.

A critic who attended the exhibition, M. Louis Leroy, wrote a now famous article in *Le Charivari* in which he used the term "Impressionist" based on the title of this painting. Despite the fact that Leroy had used the word derisively, the group decided to adopt it and painters such as Renoir and Degas were happy to be called Impressionists. Impressionist art is concerned with capturing on canvas the light and color of a fleeting moment, usually with brilliant colors painted in small strokes, side by side, rather than blended together.

Ironically, *Impression, Soleil Levant* is not typical of Monet's work, although it does carry elements of his usual style. The horizon has disappeared and the water, sky, and reflections have merged. The buildings and ships in the background are only vague shapes and the red sun dominates the painting. As Monet himself commented: "It really can't pass as a view of Le Havre." His aim was not to create an accurate landscape, but to record the impressions formed while looking at that landscape.

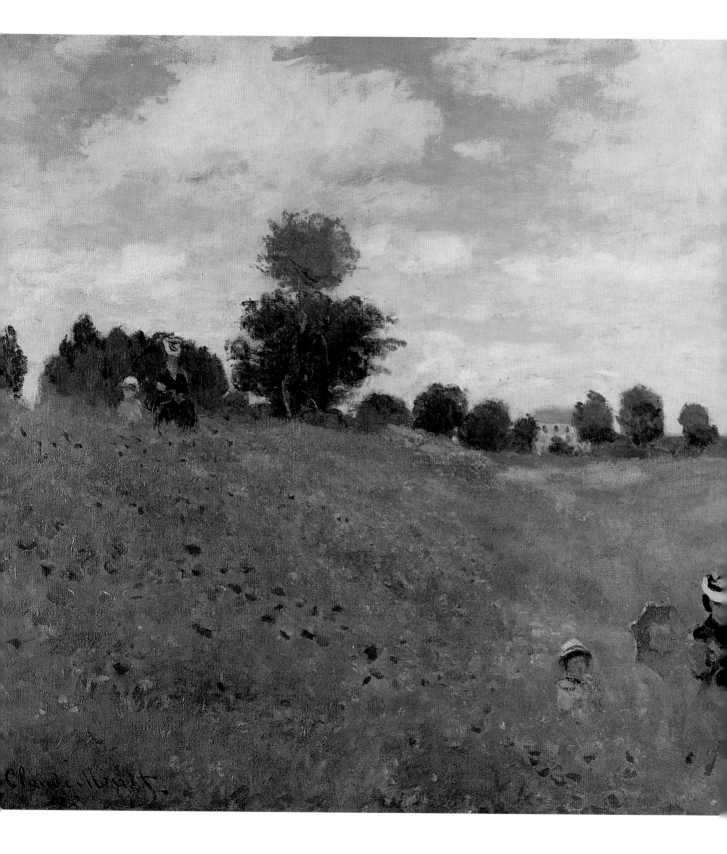

LES COQUELICOTS, ARGENTEUIL (1873)
POPPIES AT ARGENTEUIL

The Louvre, Paris. Courtesy of Giraudon

THIS scene from nature contrasts with the recent paintings that Monet had been doing, which were mainly of city subjects. Its soft tranquility reflects some of the warmth of a summer's day: the figures merge with their surroundings, almost melting into them; the body of the boy in the foreground disappears into the grass, and the dress of the woman matches some of the darker shades of grass on the right.

Figures that fade into a rural background are entirely appropriate to Monet's views on nature. He felt that nature was not there to serve man but that man was a part of nature. Hence, the figures in this painting are not the main focus. If it were not for the sloping edge of the poppies drawing the eye of the viewer back from the first group of people to the second on the horizon, the figures could be overlooked. The dominant force of this painting is without doubt the poppies.

Painted in an almost abstract style, the splashes of red draw the observer's eye at once, despite the fact that roughly half the canvas is given over to sky, creating a feeling of an airy summer's day. The blue of the sky contrasts with the red of the poppies and ensures that the landscape, as opposed to the people, leaves the strongest impression on the viewer.

LE PONT DE CHEMIN DE FER, ARGENTEUIL (1874)
THE RAILWAY BRIDGE, ARGENTEUIL

Musée d'Orsay. Courtesy of Giraudon

MONET was fascinated with painting this railroad bridge during his time at Argenteuil. For him it represented the coming together of modernity and nature. He always painted it with a train rushing across and billowing smoke. This explosion of energy was contrasted with the tranquility of the water. The bridge, which has contact with both, links the two different worlds.

This is in contrast with *Les Déchargeurs de Charbon* (1875), where the bridge appears to be a barrier separating the workers from the passers-by. The solid paint on the bridge in the main painting is contrasted with the colors used on the water. In places the brushwork is applied sketchily. However, when Monet wishes to illustrate the movement of light over the water he uses denser and more detailed strokes. This is especially evident on the water moving under the bridge.

Les Déchargeurs de Charbon has dark colors used repeatedly to give the whole painting a gloomy appearance. The main painting does not have one dominant color or tone; instead each section is given a color of its own that complements its neighbor and also separates it: for example, the greenish-yellow of the grass is not related to the gray of the bridge, but the tones manage to complement one another.

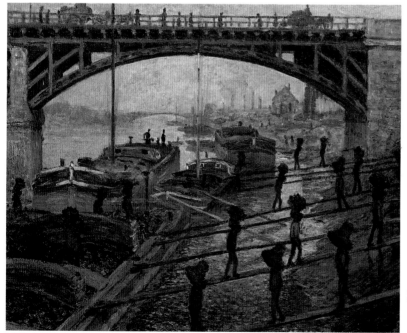

Les Déchargeurs de Charbon (1875)
Unloading Coal
Courtesy of Giraudon. (See p. 86)

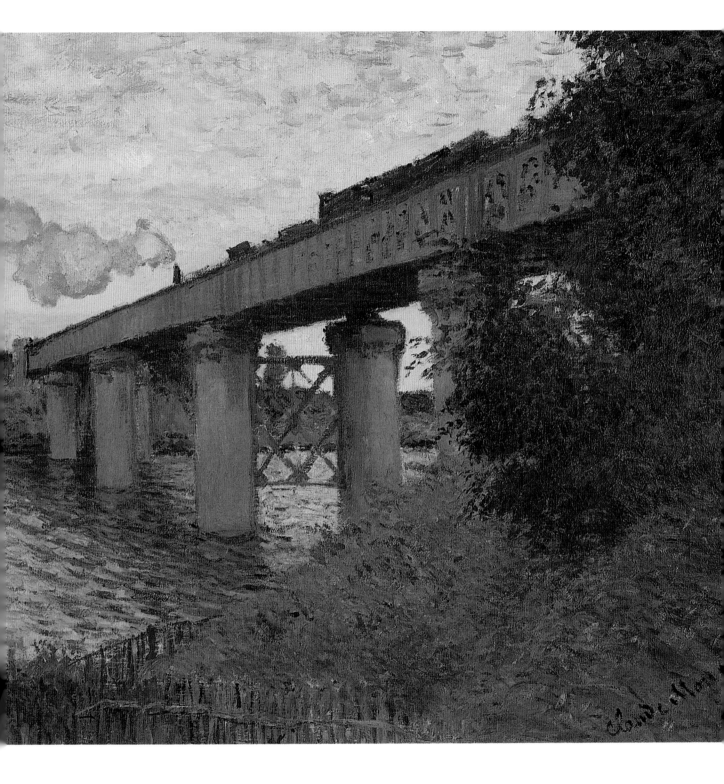

Au Pont d'Argenteuil (1874)
The Bridge at Argenteuil

Musée d'Orsay. Courtesy of Giraudon

A NUMBER of paintings from Argenteuil depict boats and this is a classic example. Monet had a very commercial mind and, as boating was a popular pastime for Parisians in the 1890s, his choice of subject matter was guaranteed to appeal to the buying public. The whole is a tranquil scene that has a translucent air to it.

The colors harmonize to help create an aesthetic view. Broken color is used where it is necessary to depict the surface of the water affected by light, and under the arches of the bridge where the light reflects off the water. By using adjacent lines, an almost translucent effect is created. The bridge to the right is another feature that Monet favored in paintings at this time. In this picture the lines and arches provide a geometric balance to the translucence of the water.

Les Déchargeurs de Charbon (1875)
Unloading Coal
Courtesy of Giraudon. (See p. 86)

Les Déchargeurs de Charbon (1875) is a contrasting vision both of the river and of a bridge. In this painting the river is a source of industry, not relaxation. The bridge is used as a dark frame across the top half of the painting and appears threatening. In *Au Pont d'Argenteuil* the river is peaceful and the bridge a complement to it.

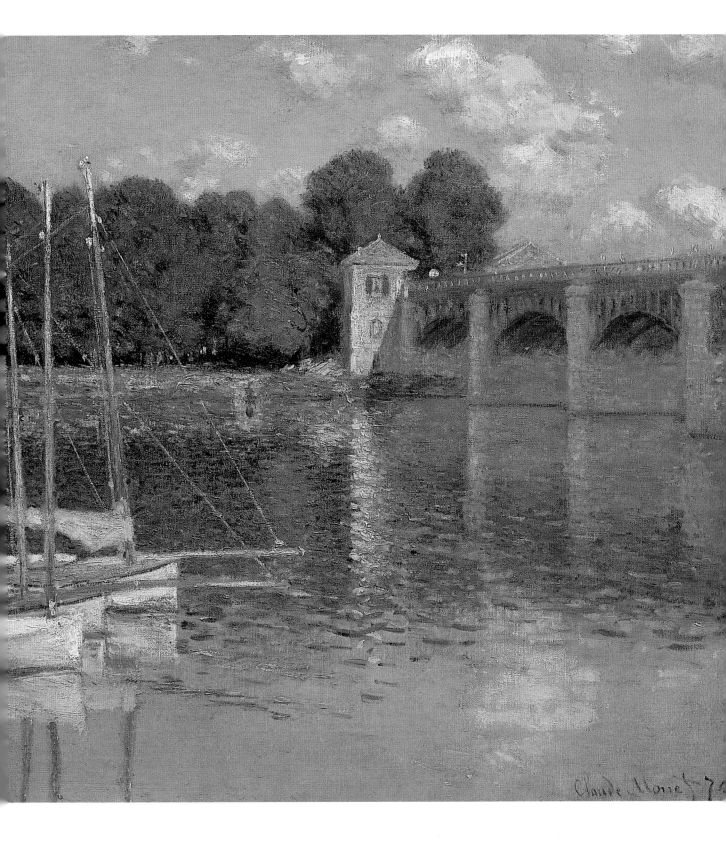

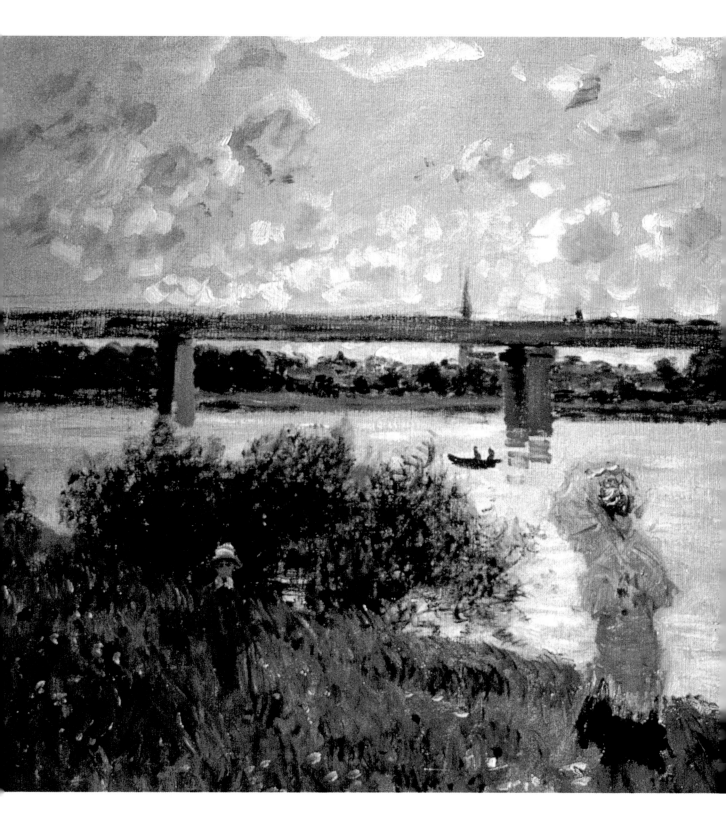

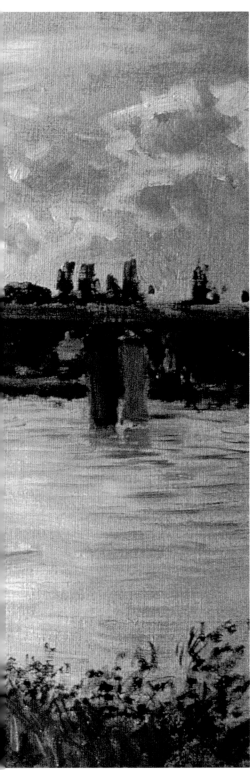

LE PONT D'ARGENTEUIL (1874)
THE BRIDGE AT ARGENTEUIL
Courtesy of Image Select

WHAT makes this landscape dramatic is the railroad bridge in the background. Its presence dominates the painting and forms a solid structure that spans the canvas.

Its solidness contrasts with the bushes and the woman—both of which are curved and rounded shapes—the antithesis of the straight lines of the bridge. Similarly the green of the grass is fresh and natural compared with the gray of the bridge. Monet is painting the meeting of modernity with tradition. The line of the bridge is echoed in the horizon. However, the natural world and modern are not harmonized in the same way as they are in *Waterloo Bridge* (1902). In this painting, bridge, water, and sky fuse. The focal point is the patch of sunlight on the water rather than the bridge. Even the smoking chimney stack in the background seems to be a balanced part of the painting.

It is interesting to note that in *Le Pont d'Argenteuil*, Monet deliberately chose this view of the bridge so that it did not include the factories that lay just to the left of where the canvas ends. He obviously felt that he could not harmonize industry into a natural background as he had learned to do when he painted *Waterloo Bridge*.

Waterloo Bridge (1902)
Courtesy of Christie's Images. *(See p. 220)*

FEMME ASSISE SUR UN BANC (1874)
WOMAN SEATED ON A BENCH

Courtesy of the Tate Gallery

*T*HIS woman is a striking presence on the canvas, in a dress of pink and white, against a backdrop of a green bench and green trees. She is deliberately placed out of harmony with her surroundings, and this gives her a commanding presence.

Her parasol, hat, and dress define her as a fashionable woman. Monet uses these to form shapes and solid lines that are geometric in

design. Little effort is made to shade her dress or to make use of any shadowing in the painting. The strong, solid shape of the woman is balanced by regular horizontal lines on the bench and vertical lines representing the foliage behind. This style has often been compared to Manet's.

The bench itself is flat and, were it not for the woman seated on it, would appear as a screen of green rather than with depth to it. Perspective and depth are not of importance in this painting. Monet is primarily concerned with creating an overall impression using strong shapes and lines.

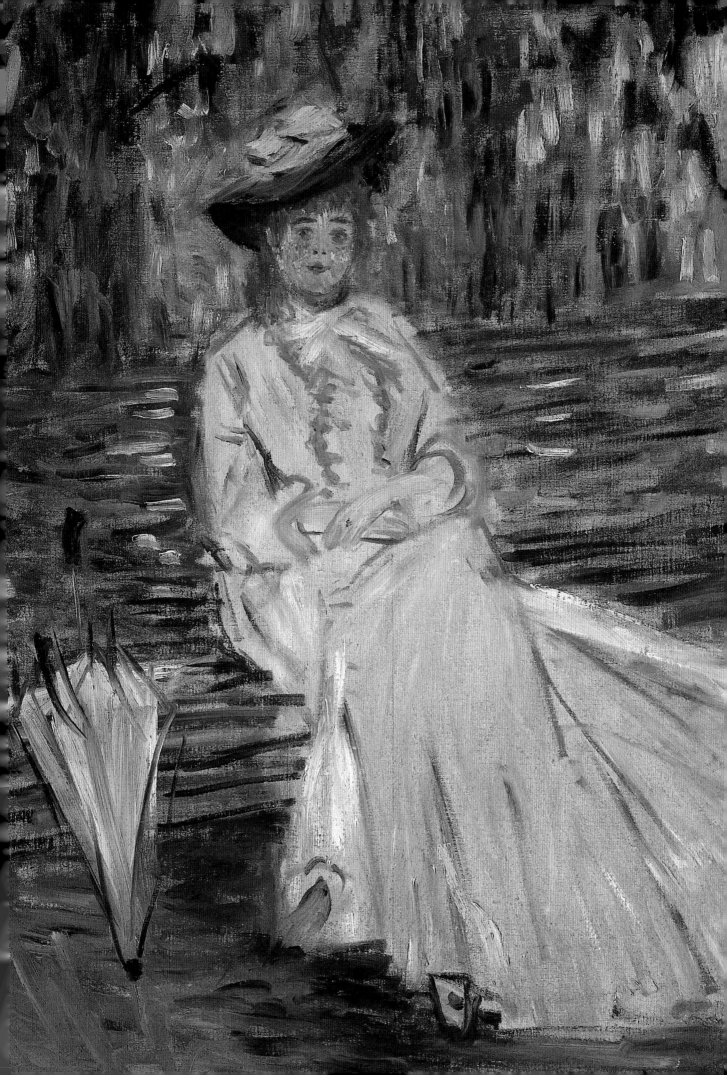

LES DÉCHARGEURS DE CHARBON (1875)
UNLOADING COAL
Courtesy of Giraudon

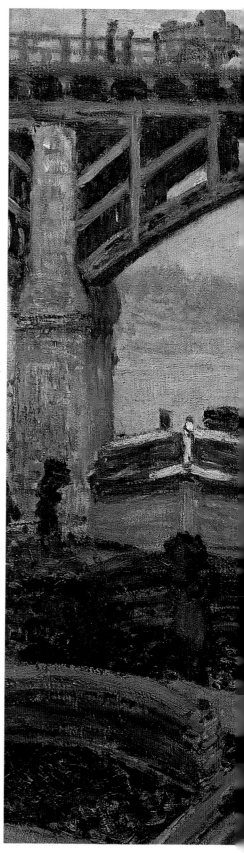

PAINTED just outside Argenteuil, this picture is unique in Monet's work: it is the only one of his paintings that depicts laborers at work. The result is a dramatic painting that has a schematic composition to it.

A sense of mechanization is achieved by the regular spacing and number of men walking up and down the planks. The men are a part of the machine. The regularity of their movement and the depiction of industrial work going on are countered by the casual passersby on the bridge. This subject is a very marked contrast to the idyllic boating paintings from the same period. The color scheme is dark and gloomy compared with the lighter tones of the boating paintings. However, although the subject matter is different, Monet's ability to create harmony and balance is not compromised and is achieved by his use of the vertical and horizontal. The bridge forms a strong network of grid lines that provides a frame over the picture.

The men moving across the planks are a strong vertical balance to the horizontal lines of the planks. The overall effect is to create an order within the painting that harmonizes the picture and adds to its machine-like qualities.

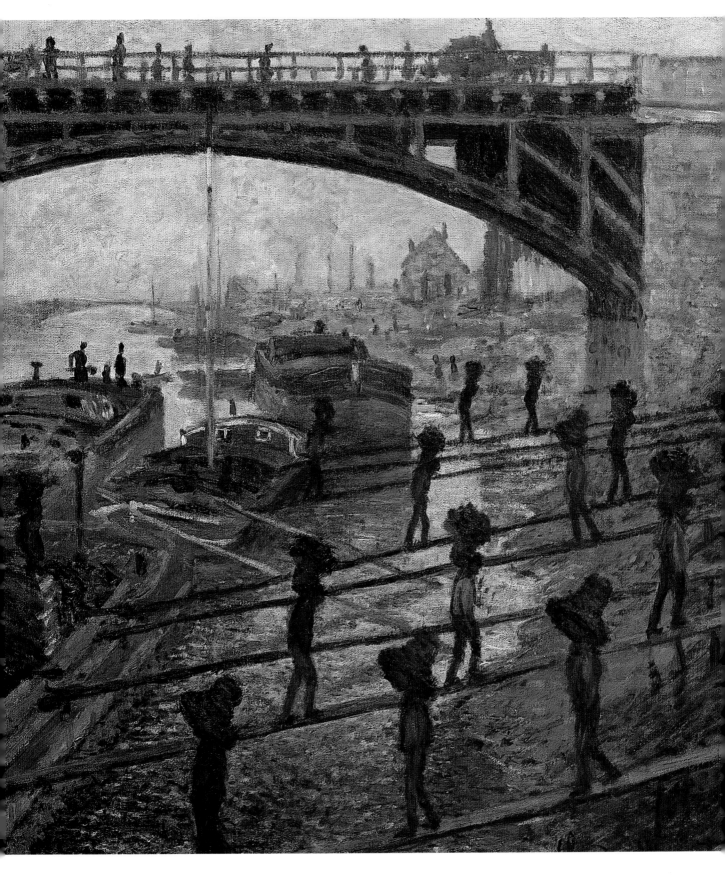

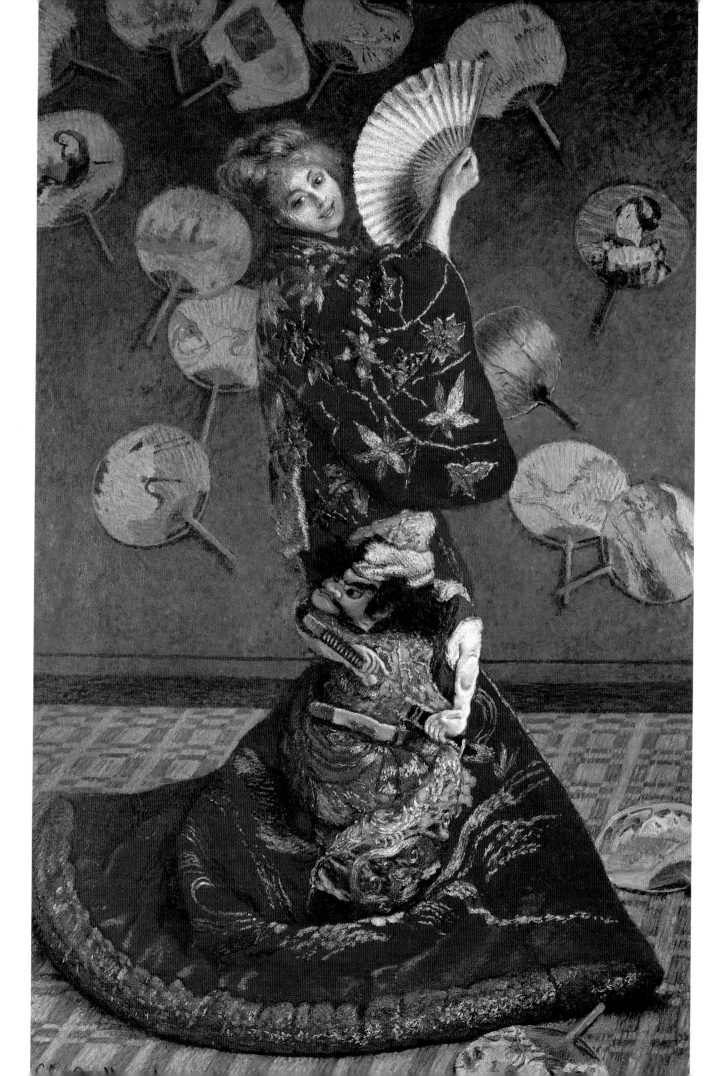

LA JAPONAISE (1875)
THE JAPANESE WOMAN
Boston Museum of Art. Courtesy of Giraudon

*I*NCLUDED in the second Impressionist Exhibition, this work was an abrupt departure from the style that Monet had been cultivating over the preceding decade. At the time the painting caused a sensation. One critic praised its "solid coloring" and "emphatic impasto."

It harks back to *Camille, ou la Femme à la Robe Verte* (1866), which was painted in a style that the Salon would appreciate. Monet was very poor at this time, and one theory holds that he chose deliberately to paint a conventionally posed painting that would have a high chance of selling, with perhaps the added benefit of attracting a new patron. Monet had a strong commercial instinct that lies behind some of his choices of subject matter and style.

The careful composition and posing of Camille in this painting lacks all the spontaneity that Monet had been looking to capture in other works. Camille is not true to life, as she is wearing a blonde wig. The robe itself is magnificent, and Monet's depiction of the samurai warrior contrasts with the sweetness of Camille's face. Monet's interest in Japanese art, an influence on some of his earlier work, was obviously still strong at this time.

Un Coin d'Appartement (1875)
A Corner of the Apartement

Courtesy of Giraudon

IN *Un Coin d'Appartement* and *Le Capeline Rouge*, Monet experiments with framing his subject. In *Un Coin d'Appartement*, he repeats the shape of the curtains and plants in the foreground in the curtains in the background. The frame has the dual purpose of drawing the eye into the painting and also focusing the viewer's perception of the subject. By making the frame well lit compared with the subject, Monet emphasizes the darkness of the room.

Monet is clearly experimenting with light and dark. In the earlier painting of 1873, Madame Monet is in contrast with the dark interior because she is well lit and wears a bright color. In the later picture, Jean Monet, who stands at the center, is one of the darkest

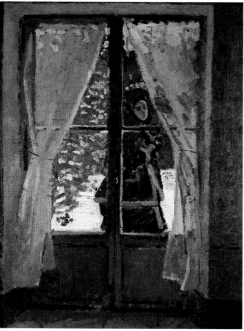

patches on the canvas; the light reflecting from the floor at his feet emphasizing his darkness.

Jean Monet is isolated in the room and is separated from the woman at the table. He makes a disturbing figure because he is painted so dark and because of the steady gaze he directs at the viewer. Madame Monet has a similar direct gaze, but hers is a more intimate, loving look. Jean Monet is also vulnerable; his size is exaggeratedly small when compared with the height of the plants, which appear to threaten to engulf him.

La Capeline Rouge, Portrait de Madame Monet (1873)
The Red Cape, Portrait of Madame Monet
Cleveland Museum of Art. Courtesy of Giraudon. (See p. 65)

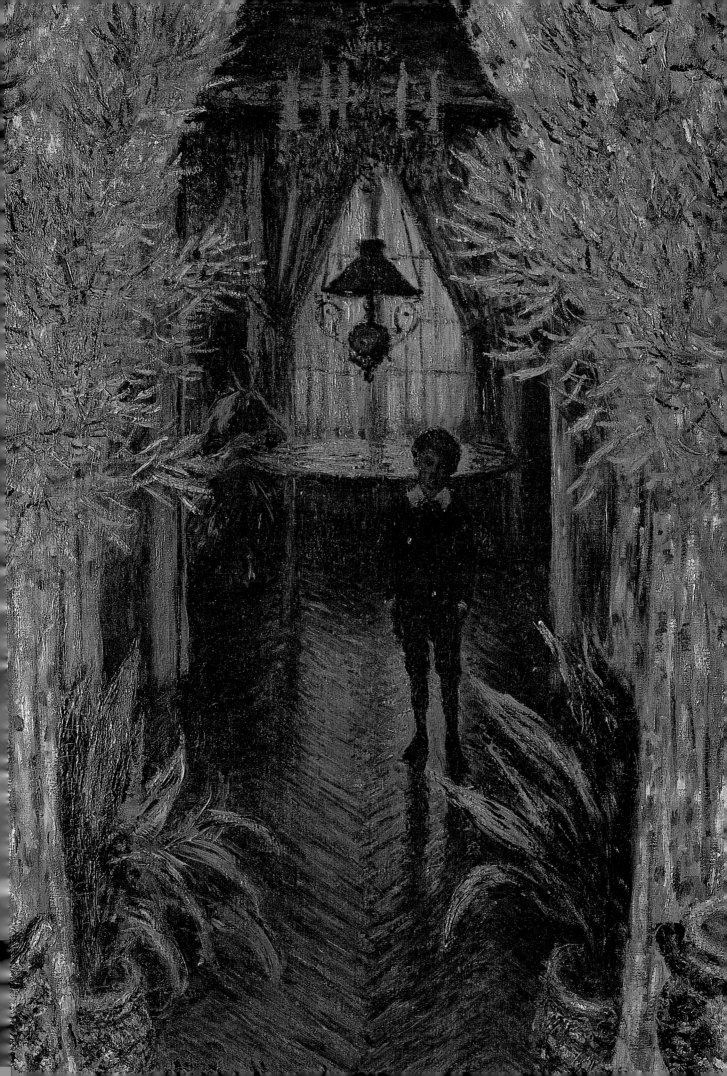

EN PROMENADE PRÈS D'ARGENTEUIL (1875)
WALKING NEAR ARGENTEUIL

Courtesy of Giraudon

MANY of Monet's paintings of summer days in the countryside around Argenteuil share an intensity about them. Both *Les Coquelicots, Argenteuil* (1873) and *En Promenade près d'Argenteuil* are concerned with capturing the essence of a summer's day. The passion with which Monet wanted to preserve this particular day is evident in the colors used.

Both paintings have a beautiful blue sky with soft, white clouds billowing across it, but the real color comes from the flowers. In the earlier painting, Monet concentrated on capturing the incredible strength of the red poppies. In the later painting, the poppies are again present, but other flowers also shine through so there are blues and whites as well as red in the grass. In both paintings the flowers are represented by a dash of color rather than a detailed presentation.

In *Les Coquelicots, Argenteuil*, the flowers appear to threaten to swamp and overwhelm the people. In *En Promenade près d'Argenteuil*, the figures stand out above the flowers and are seen full length. They are not dominated by their environment but form a family unit that is in harmony with the natural world around them. No buildings appear in this painting, adding to its pastoral tone.

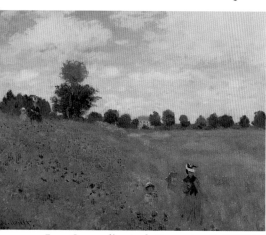

Les Coquelicots à Argenteuil (1873)
Poppies at Argenteuil
Louvre, Paris. Courtesy of Giraudon. (See p. 76)

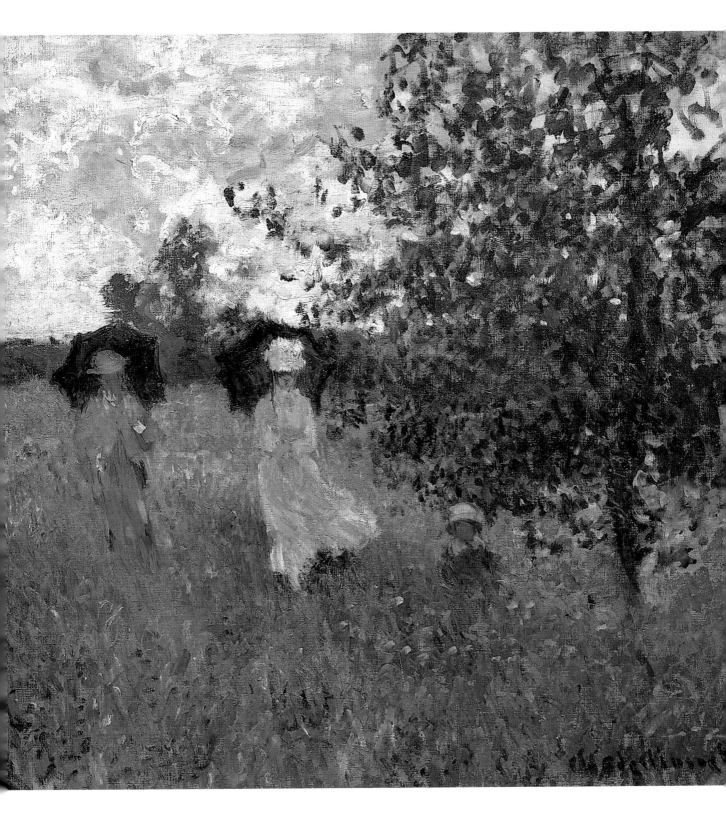

LES DINDONS (1876)
THE TURKEYS
Courtesy of Giraudon

*I*N 1874, Ernest Hoschedé invited Monet to stay on his estate and commissioned four decorative panels from him. This is one of them. While the subject matter itself is very traditional, Monet's treatment of it is not.

One can compare this with *Trophée de Chasse* (1862), which was created early in Monet's career, while he was still careful to follow the traditions of art. It depicts dead game birds in a conventional composition, the whole carefully arranged for the artist's benefit. The formality of this earlier painting is not in evidence in *Les Dindons*. The birds, painted realistically to life size, ramble across the painting at will. This has the result of making the composition seem asymmetrical. The carefully arranged triangular symmetry of the still life is not in evidence here. Monet even has the audacity to cut one bird off at the neck, unheard of in paintings of the establishment, adding to the spontaneity of the painting.

The viewer is placed on a level with the birds, as if he were lying on the grass. In *Trophée de Chasse* the distance is carefully maintained between subject and viewer. The different angle taken in the later painting adds to the informality of the whole picture.

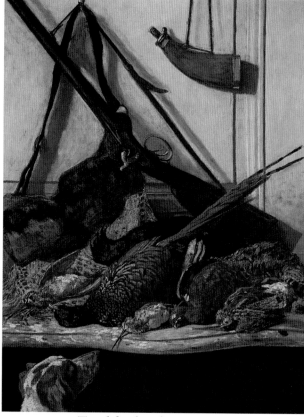

Trophée de Chasse (1862–63)
Sporting Prize
Musée d'Orsay. Courtesy of Giraudon. (See p. 20)

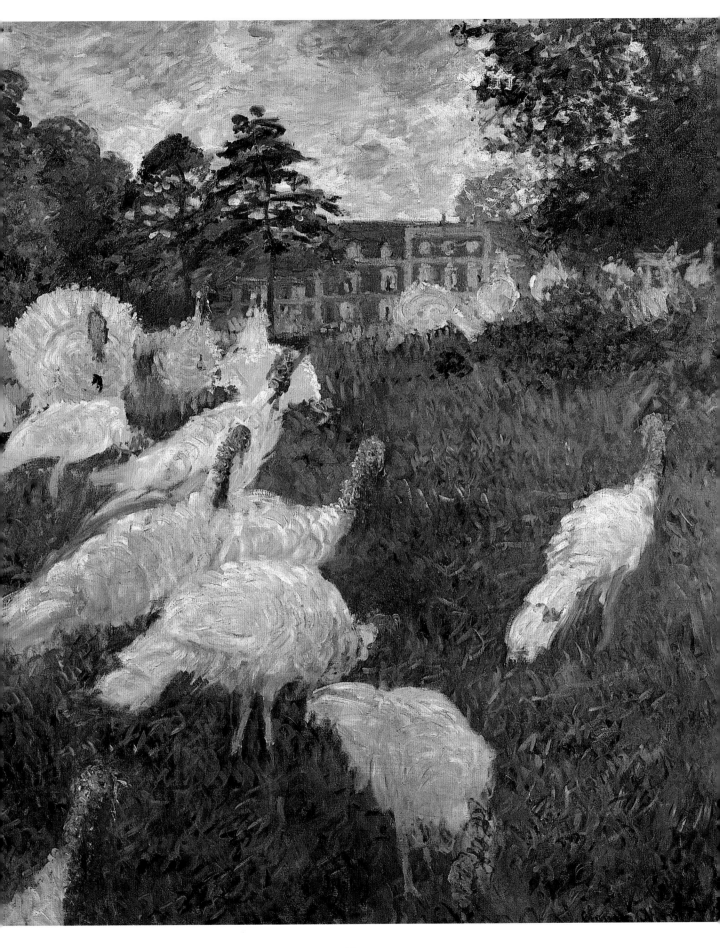

LE PONT DE L'EUROPE, GARE ST.-LAZARE (1877)
EUROPE BRIDGE, ST. LAZARE STATION

Musée Marmottan. Courtesy of Giraudon

BETWEEN January and April 1877, Monet painted 12 pictures of the Gare St. Lazare. Although these are sometimes referred to as Monet's first attempt at a series of paintings, they differ from each other too widely to justify such a title, although they do show his growing interest in using the same subject again and again. Monet's choice of a station as a subject reflects his desire to paint modern scenes. The author Emile Zola described them as "paintings of today."

Monet uses the smoke from the engines in a similar way to the fog in *Charing Cross Bridge, La Tamise* (1903): as a tool to distort light and color patterns. However, whereas this is made into a localized effect in *Le Pont de l'Europe, Gare St.-Lazare*, the later painting is dominated by fog, creating a haze over the setting. The architecture is not recreated in detail, as in the earlier work, but becomes shadowy as a result of the fog. Monet's aim with *Le Pont de l'Europe, Gare St.-Lazare* is to paint a modern subject. The buildings, the bridge, and the train are all synonymous with modern Paris. There is an air of bustle in this scene that is missing altogether from the serene Charing Cross Bridge painting.

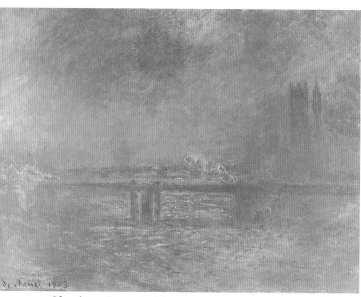

Charing Cross Bridge, La Tamise (1903)
Charing Cross Bridge, The Thames
Courtesy of Christie's Images. *(See p. 222)*

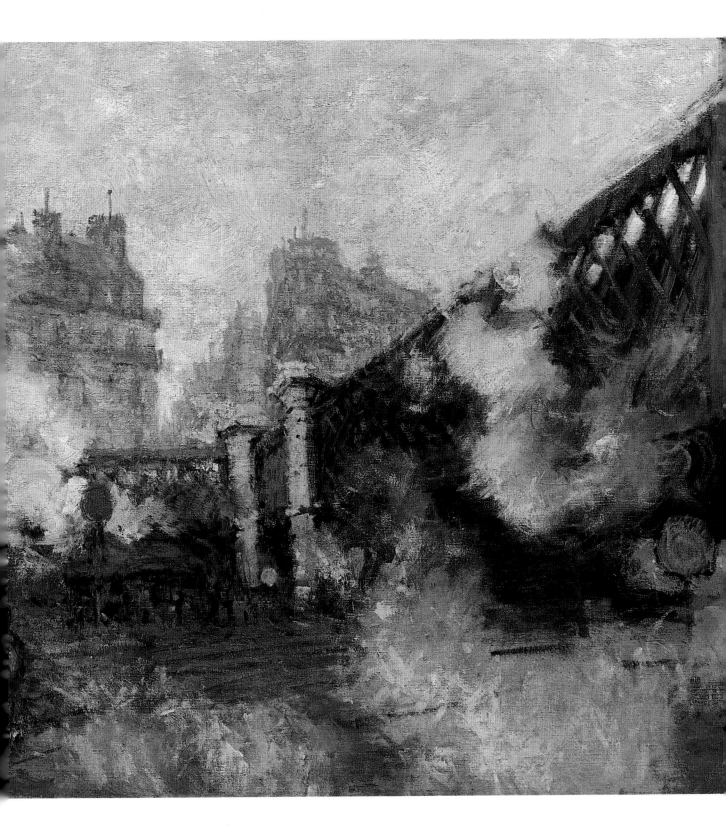

LA ROUTE À VÉTHEUIL (1878)
THE ROAD TO VÉTHEUIL

Phillips Collection. Courtesy of Image Select

*L*A ROUTE *à Vétheuil* is very similar in composition to *La Route de la Ferme, St.-Simeon en Hiver* (1867). Both show the broad sweep of a road approaching buildings in the distance; however, the two works are set in contrasting seasons and the effect of these different seasons is that the snow muffles the winter scene.

La Route à Vétheuil is dominated by geometric shapes and lines. The road in both paintings draws the eye in and forms two meeting diagonals on the canvas. However, although the snow markings in the St. Simeon painting underline this linear aspect, the concentration of white effectively dampens the overall impact. The road in the later painting is not only free of snow but has been painted using obvious vertical brushstrokes. The bank forms a triangle on the canvas, and the hills in the background also form a geometric shape.

Monet uses light to emphasize the geometry of the painting so that the dark hills in the background of *St.-Simeon en Hiver* contrast with the well-lit bank in the foreground. Similarly, the shadows of trees not visible in the painting fall across the road, creating parallel horizontal bands of darkness that contrast with the vertical band of the road.

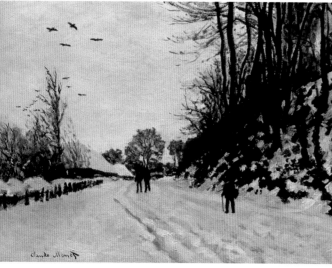

La Route de la Ferme, St.-Simeon en Hiver (1867)
The Road to the Farm, St. Simeon in Winter
Private Collection. Courtesy of Image Select. (See p. 38)

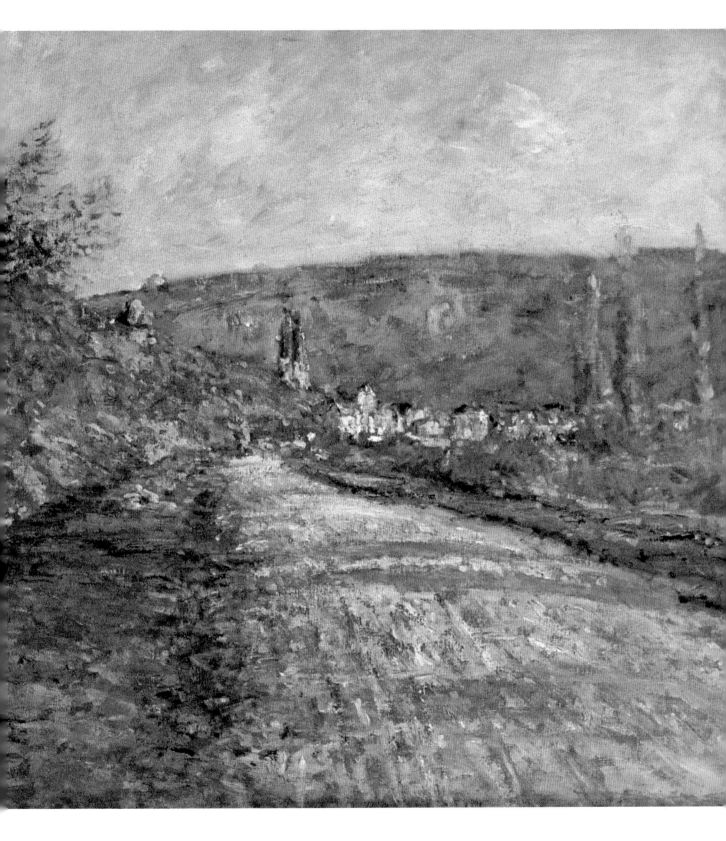

CHRYSANTHÈMES (1878)
CHRYSANTHEMUMS
Courtesy of Christie's Images

THE strange, almost three-dimensional effect of the flowers on the wallpaper is reminiscent of the Japanese fans in *La Japonaise* (1875). The flowers float in an uncomfortable way behind the basket of flowers. This effectively causes two different points of interest in the painting, so that the eye struggles between the wallpaper and the flowers to find a central focal point.

This is in contrast to *Les Roses* of 1925–26, where Monet's treatment of the flowers is based purely around the pattern they create. The flowers are painted without the detail afforded to the chrysanthemums. In *Les Roses,* Monet's aim is entirely decorative. Here the flowers do not float across the canvas but are given a strong background and are placed in an obvious domestic setting. Although not a conventional still life, this picture does depict flowers in a more traditional way.

The quick brushstrokes that cross each other create a blurring around the center of the flowers. Out of the mass of pink and white, the individual petals emerge to spiky effect. The roses are painted as dashes of color that have little definition. By this time Monet is more concerned with the impression of the flower than with the detail.

Les Roses (1925–26)
The Roses
Courtesy of Giraudon. (See p. 254)

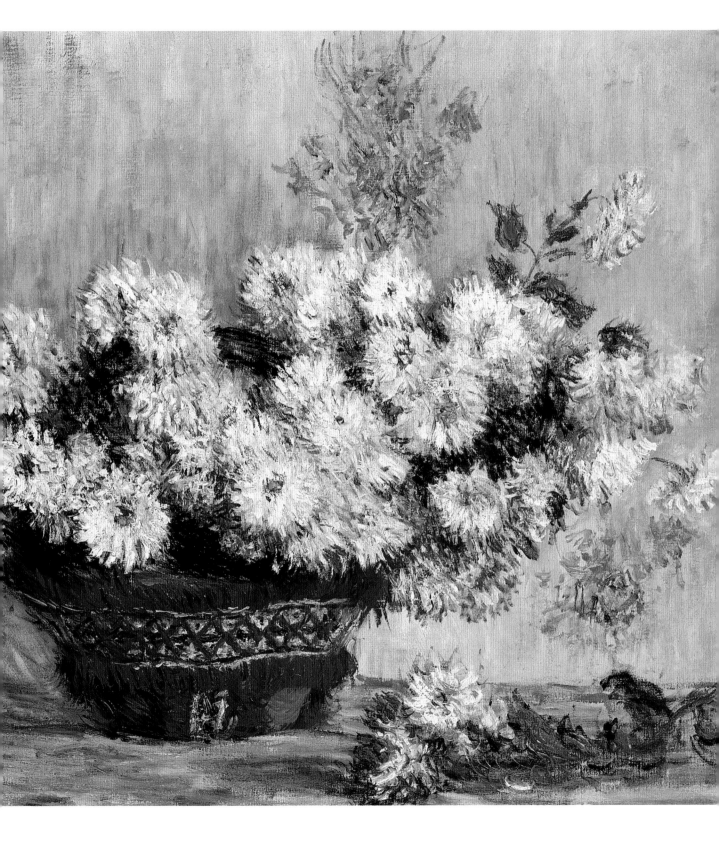

L'ESCALIER (1878)
THE STAIRS
Courtesy of Christie's Images

*T*HIS painting is one that was sold to an American buyer, although later it was bought back by the collector Durand-Ruel. America proved to be a profitable market for the Impressionists, thanks to Durand-Ruel, who opened it up to them through exhibitions.

The appeal of *L'Escalier* lies in its subject matter and composition. The stairs leading up are inviting, while the archway provides a provocative glimpse into the courtyard. This is in contrast to *Vétheuil* (1901), where the town is seen from a distance and the viewer is set apart by an expanse of water. *L'Escalier* is an intimate and inviting view of a building at close hand, with the viewer now at the heart of the town. *L'Escalier* is unusual for its choice of an everyday rural building as its subject. Most of Monet's paintings of buildings depict either modern or Gothic architecture or groups of buildings seen from a distance, as in *Vétheuil*.

The warm pinks and golden colors used in this painting combine with the deep blue of the sky to create the effect of a balmy, lazy summer's day. Even the shadow falling across the bottom left corner does not detract from the warmth.

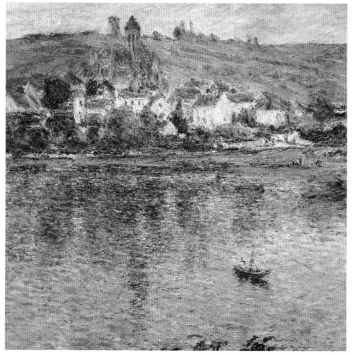

Vétheuil (1901)
Pushkin Museum, Moscow. Courtesy of Topham. (See p. 216)

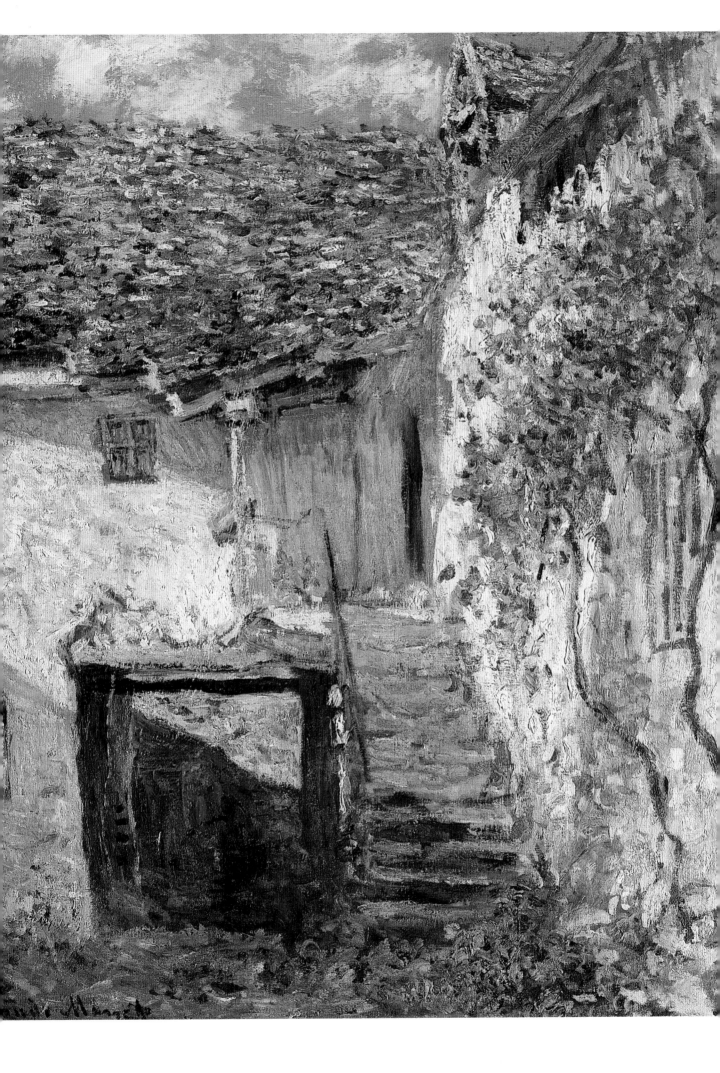

POMMIERS PRÈS DE VÉTHEUIL (1878)
APPLE TREES NEAR VÉTHEUIL
Courtesy of Christie's Images

THIS painting depicts the view down into the valley of Vienne-en-Artheis. It is typical of the rural scenes that Monet produced once he moved to Vétheuil. There is no evidence of industrialization in this painting, which instead focuses on the apple trees in the foreground.

Monet uses small brushstrokes of different colors on the trees to create the effect of sunlight falling across the blossoms. These smaller strokes gradually become longer as he moves down into the valley. These longer strokes have the effect of merging colors together and creating a blurring of lines so that the trees in the foreground appear to be strongly in focus compared with the valley in the background.

The critic, Philippe Birty, saw this painting exhibited at Durand-Ruel's gallery, along with others by Monet. His response was as follows: "It is from afar that these paintings must be judged, and the near-sighted and insensitive will only perceive a confused mixed-up, tough or shaggy surface resembling the underside of a Gobelin tapestry with an excessive use of chromium-yellows and orange-yellows"

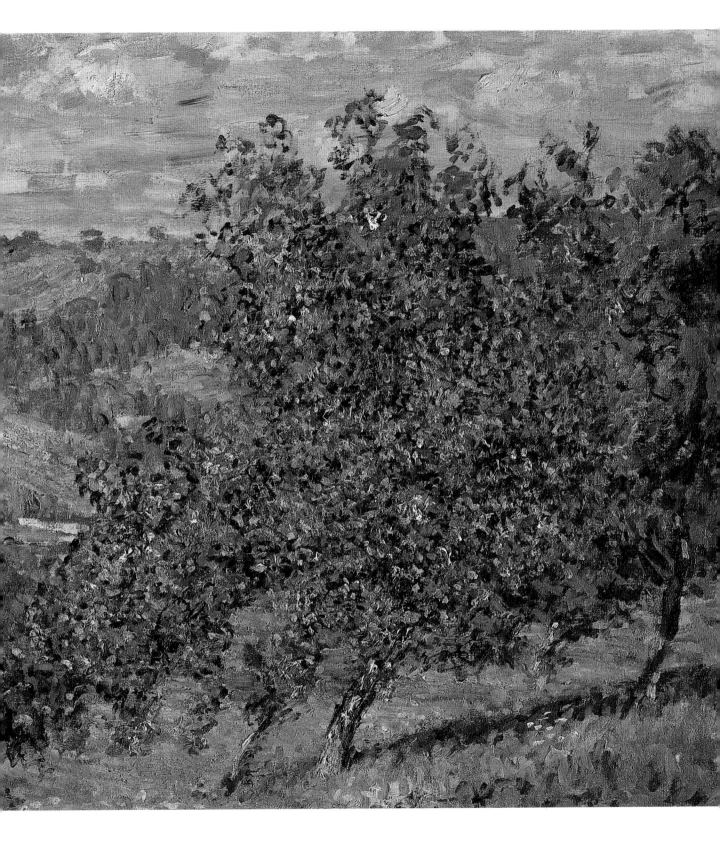

LA RUE MONTORGEUIL FÊTE DU JUIN 30, 1878 (1878)
MONTORGEUIL STREET FAIR, JUNE 30, 1878

Musée d'Orsay. Courtesy of Giraudon

*T*HIS painting is easily confused with *Rue St.-Denise Celebrations, Juin 30, 1878* (1878) as they depict virtually identical scenes. It is a testimony to Monet's enthusiasm for the subject that he devoted two canvases to the cause of reproducing the excitement in the streets on one day.

The occasion was a celebration of the World Fair that Paris had been hosting. As can be seen from the painting, the streets were decked with flags and banners. A sense of national pride is present in this work, as well as an incredible air of spontaneity. Monet's pride in his country is evident in the overpowering national colors of red white, and blue. The quick brushstrokes and pulsing colors are all testimony to Monet's desire to capture quickly the atmosphere of the scene. His rendition of a street below had been painted in a similar manner earlier in *Boulevard des Capucines* (1873). The view Monet paints in both pictures is from an upper story, providing a similar perspective.

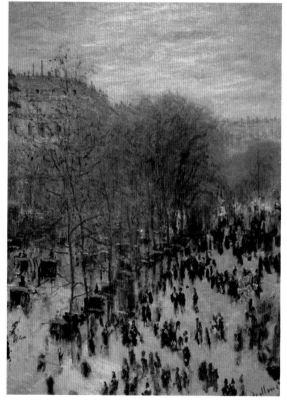

Boulevard des Capucines (1873)
Courtesy of the Visual Arts Library, London.
(See p. 68)

In addition, Monet chooses to depict the crowds in both paintings by using quick, dark brushstrokes that emphasize the individuals being caught in mid-movement. In both these works, the people are anonymous, but in the later work this has developed to the extent that even the men and women cannot be differentiated.

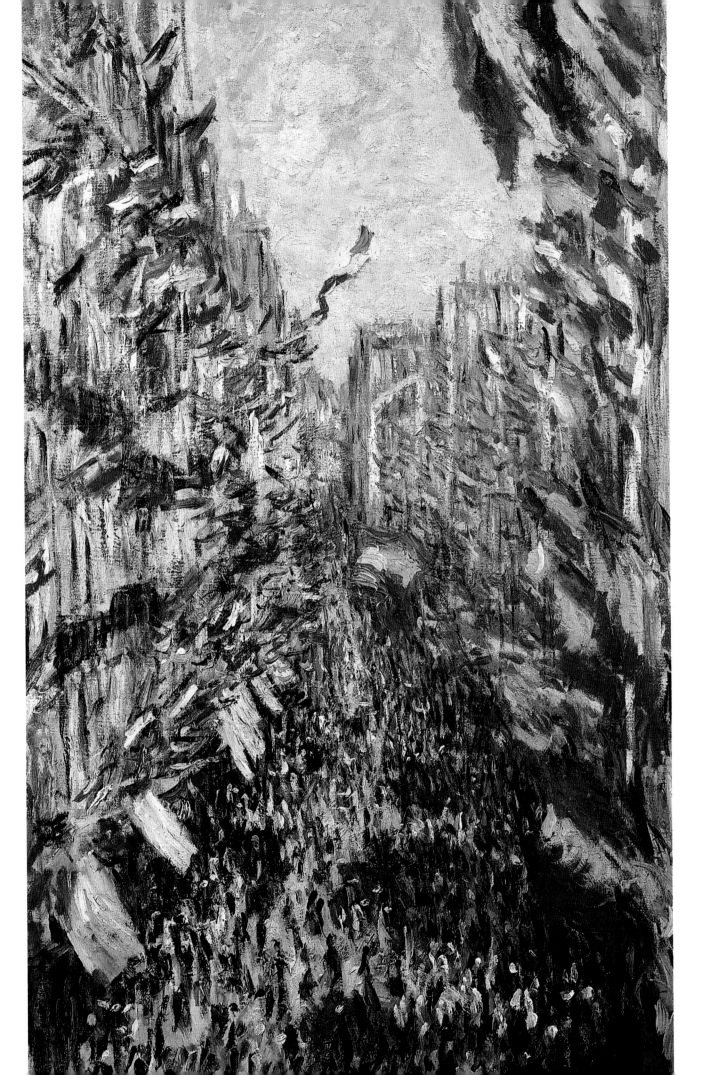

LE GIVRE (1879)
THE FROST

The Louvre, Paris. Courtesy of Giraudon

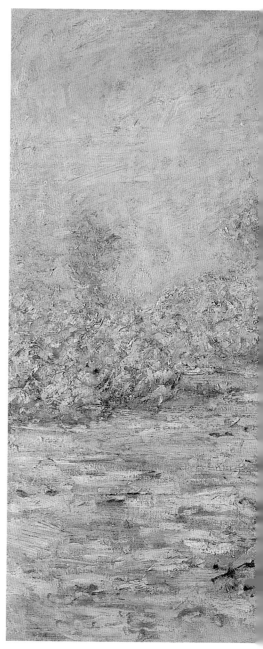

*T*HIS period was a desolate one for Monet. Financially, the household was stricken, and he was heavily in debt. The winters of 1878 and 1879 were severe, forcing prices up. In September 1879 Camille died.

Many critics have attempted to draw parallels between Monet's mood at this time and his paintings. It is true that the gloom of *L'Eglise à Vétheuil, Neige* (1879) could reflect his emotions, but a look at *Le Givre* undermines this. Although the subject matter itself could represent Monet's personal desolation, his treatment of it suggests that this is not the case. *Le Givre* shows ice and frost sparkling in the sunlight, the white frost warmed up with pink and blue. Although a barren scene, the colors used give it a warmth lacking in the buildings of *L'Eglise à Vétheuil, Neige*. The whole scene is harmonized through the use of strong horizontal strokes on the ice and small vertical strokes on the bushes. The vertical of the poplars balances the horizontal of the river bank. This use of horizontal and vertical balance can be found in *L'Eglise à Vétheuil, Neige* as well.

Although it is difficult to try to read the artist's personal life into his work, these paintings do reveal that Monet's changing moods meant that he was being attracted to very different styles.

L'Eglise à Vétheuil, Neige (1879)
The Church at Vétheuil, Snow
Louvre, Paris. Courtesy of Giraudon.
(See p. 110)

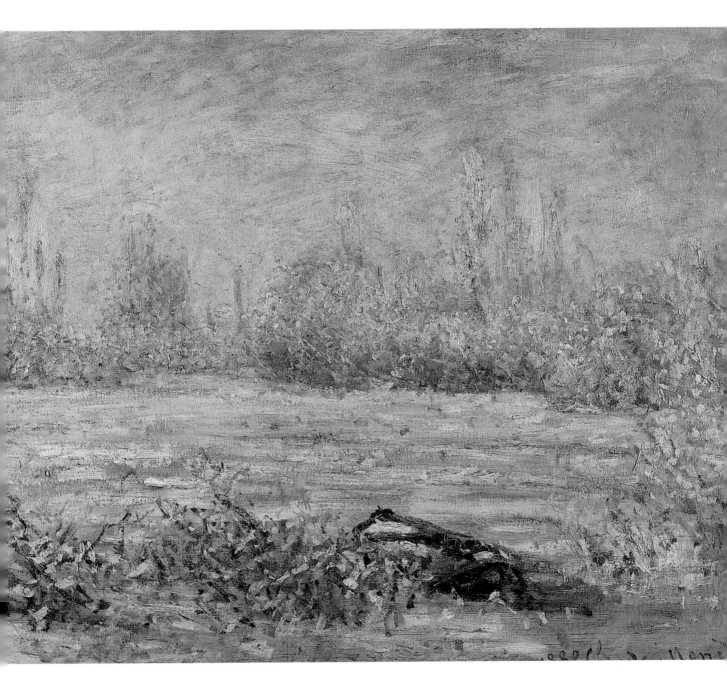

L'Eglise à Vétheuil, Neige (1879)
The Church at Vétheuil, in Snow

The Louvre, Paris. Courtesy of Giraudon

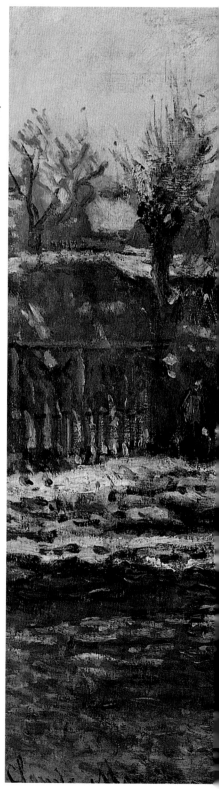

P AINTED from the opposite bank of the river, this somber work is very different from some of Monet's summer paintings in Vétheuil. The palette of colors used is extremely restricted, offering very little relief from the white and dark colors. *Le Jardin de Vétheuil* (1881) provides a useful contrast to demonstrate how tightly controlled this palette was.

Matching this rigid color scheme, Monet adheres as doggedly to the rules of symmetry. The bank forms a solid, horizontal line that is repeated in the hedgerow growing above, counterbalanced by the vertical of the church tower and the poplar trees. The buildings all form solid shapes on the canvas, making a pattern of oblongs, squares, and triangles. In *Le Jardin de Vétheuil*, the house, veranda, and steps form similar shapes on the canvas and attempt to replicate the balance of horizontals and verticals. However, this is disrupted by the garden with the strong, twisting shape of the tree dominating the rigid shape of the house.

Some relief from the rigidity of the painting is given by the short, broken brushstrokes used to create the water surface; these help to soften the impact of the flatter bank above.

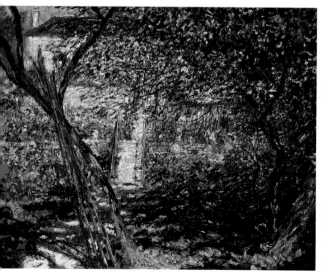

Le Jardin de Vétheuil (1881)
The Garden at Vétheuil
Courtesy of Christie's Images.
(See p. 120)

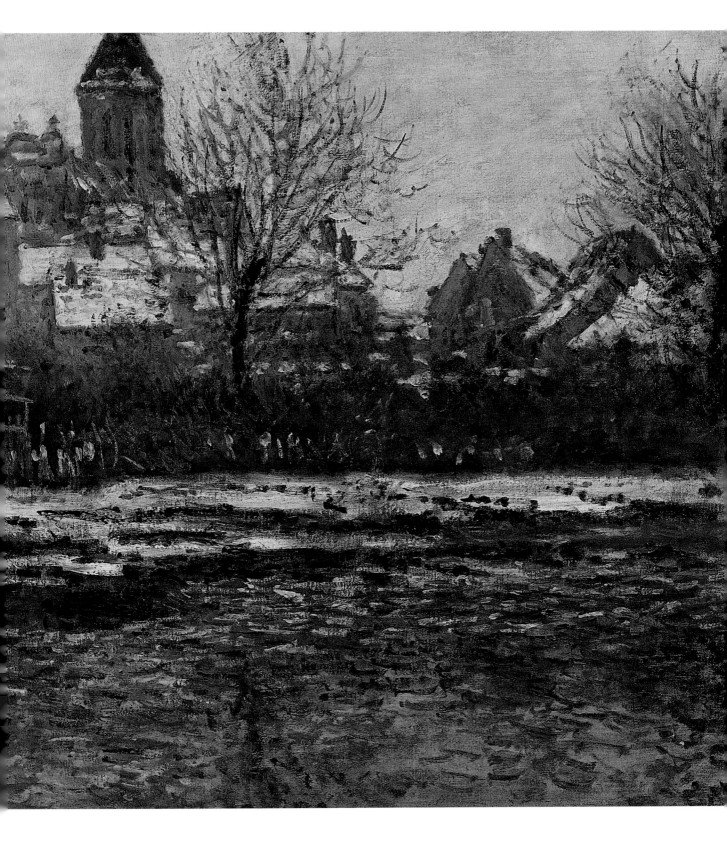

PORTRAIT DE MICHEL MONET BÉBÉ (1878–79)
PORTRAIT OF MICHEL MONET AS A BABY
Courtesy of Giraudon

*T*HIS painting was produced not long after Michel was born. He still has the full cheeks of a very young baby, although he does have a lot of hair. Despite the quick brushwork, Monet succeeds in creating an impression of Michel that is immediately recognizable as the same child in later portraits.

This style of creating an impression of the person rather than producing a detailed portrait was a change from his earlier work; Monet treats his portraits from this period in the same style as his landscapes. There are a number of portraits of his sons from around this period. His family had, until now, often featured as the human presence in many of his landscapes. However, from around 1880 onward Monet included people less and less in his landscapes, which might explain his desire to record them in portraits.

The portrait of Michel is intimate and does not attempt to exaggerate any features or caricature the child. This is a very different style from that used in *Portrait de Poly* (1886), where the man posing is painted in a manner suggestive of his personality. When looking at Michel's portrait, there is no indication as yet of his character.

Portrait de Poly (1886)
Portrait of Poly
Musée Marmottan. Courtesy of Giraudon. (See p. 148)

PORTRAIT DE JEUNESSE DE BLANCHE HOSCHEDÉ (1880)
PORTRAIT OF THE YOUNG BLANCHE HOSCHEDÉ

Musée des Arts, Rouen. Courtesy of Giraudon

*B*LANCHE Hoschedé, daughter of Monet's friend and patron Ernest whom he met in 1876, was 14 when this portrait was painted. It is the essence of a young girl, her rosy cheeks, bright eyes, and red lips making her the epitome of youth.

This portrait is very different from that of Camille made 14 years earlier. The style is more typical of Monet's Impressionism. The brushwork is more obvious across the portrait, whereas *Camille au Petit Chien* (1866) has this type of brushwork only on the dog. The colors fuse across the painting, so that there is a blurred effect especially noticeable on Blanche's dress. Although her features are clear, they are not painted in the same sharp style as Camille's. Blanche is painted with a strongly patterned wallpaper behind her that prevents her figure from dominating in this painting in the same way that Camille does.

The colors used are mostly pastels, but the red of the hat attracts the eye. This color helps to emphasize Blanche's red lips, but it also draws the viewer's gaze away from the face. Blanche is painted as part of an overall design, Camille as a separate entity.

Camille au Petit Chien (1866)
Camille with a Little Dog
Private Collection, Zurich. Courtesy of Giraudon. (See p. 32)

PORTRAIT DE MICHEL EN BONNET À POMPON (1880)
PORTRAIT OF MICHEL IN A POMPOM HAT
Courtesy of Giraudon

MICHEL Monet was Monet's second son by Camille. At the time of this portrait he was two years old. Monet had initially felt uncertain about fatherhood, but this doubt had gone by the time Michel was born. Both this portrait and *Portrait de Jean Monet* (1880) are a testimony to the love that he felt for his children.

In Michel's portrait, the two-year-old sat apparently docile while his father painted him. The quick brushstrokes, used on the red coat and the red of his cheeks in particular, suggest that Monet at least wanted to create the impression of the portrait having been dashed off. This is especially noticeable when compared to the shorter strokes used on Jean's portrait. Although Michel's features are identifiable, the nose, lips, and eyes are not painted in as much detail as the features are in Jean's portrait.

Both paintings share an anonymity of background. A blanket color has been applied so that each boy is the focus of the painting. In some of Monet's portraits of fashionable women, the background and clothing are given as much detail as the face and body of the woman. This makes a statement about how the women are perceived. With both of these portraits the individual child is the center of attention.

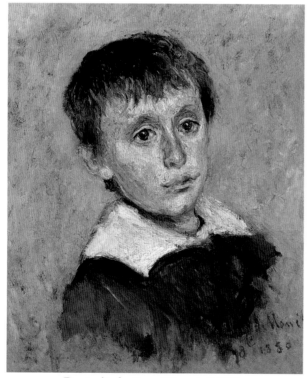

Portrait de Jean Monet (1880)
Portrait of Jean Monet
Courtesy of Giraudon. (See p. 118)

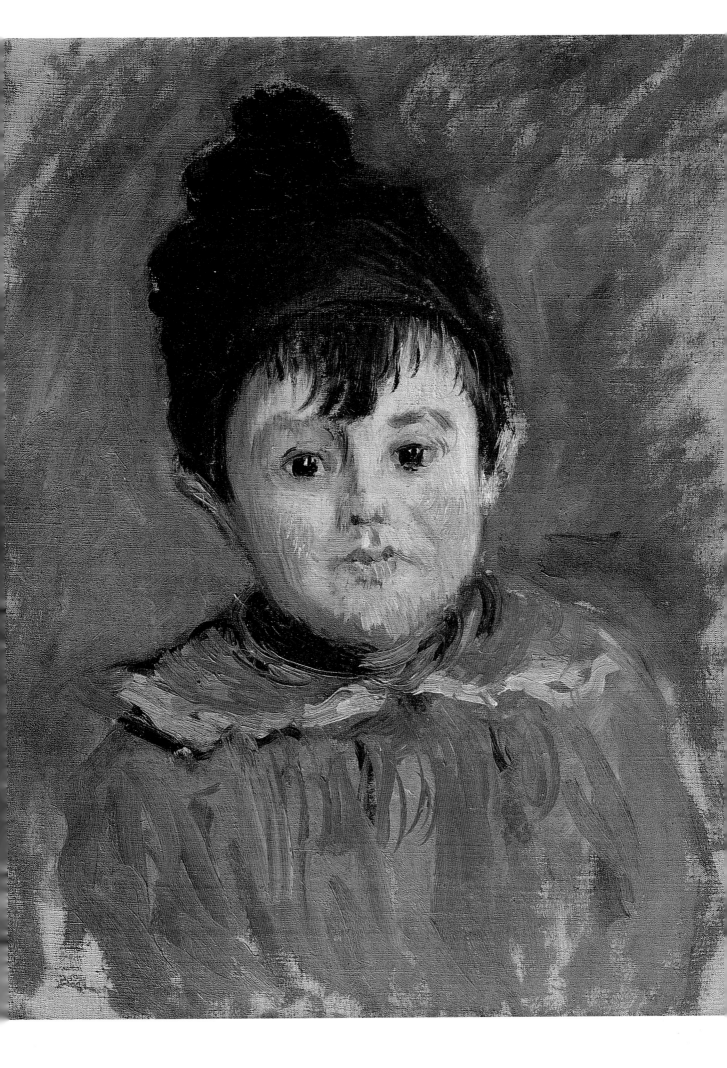

PORTRAIT DE JEAN MONET (1880)
PORTRAIT OF JEAN MONET
Courtesy of Giraudon

JEAN Monet would have been about 13 when this portrait was painted. Monet had used Jean frequently in landscape paintings before this portrait, sometimes with Camille and sometimes on his own. However, in all of these, he can be identified only as a small child rather than as an individual in his own right.

This portrait is entirely concerned with Jean as Jean. Care is taken to record his features, and he is painted as a full–face portrait. When compared with *Portrait de Madame Gaudibert* (1868), where the woman's face is averted to the point that her features are almost hidden, the intimacy of *Portrait de Jean Monet* is understood. Monet is recording Jean in a very personal style. The lack of detail to the background compared with *Portrait de Madame Gaudibert*, where even her clothes are carefully recorded, indicates clearly that Monet is interested in illustrating the individual that is Jean. Madame Gaudibert is recorded as yet another society woman whose identity is found in her clothes and her home rather than in her face.

Monet's style has changed over the intervening years between these paintings. The brushstrokes are thicker, and he is not afraid to use blocks of color solidly placed on the canvas. Unlike his treatment of Madame Gaudibert's dress, Monet does not paint his son's clothing in detail.

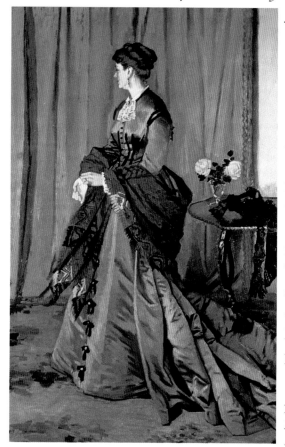

Portrait de Madame Gaudibert (1868)
Portrait of Madame Gaudibert
Musée d'Orsay. Courtesy of Image Select. (See p. 45)

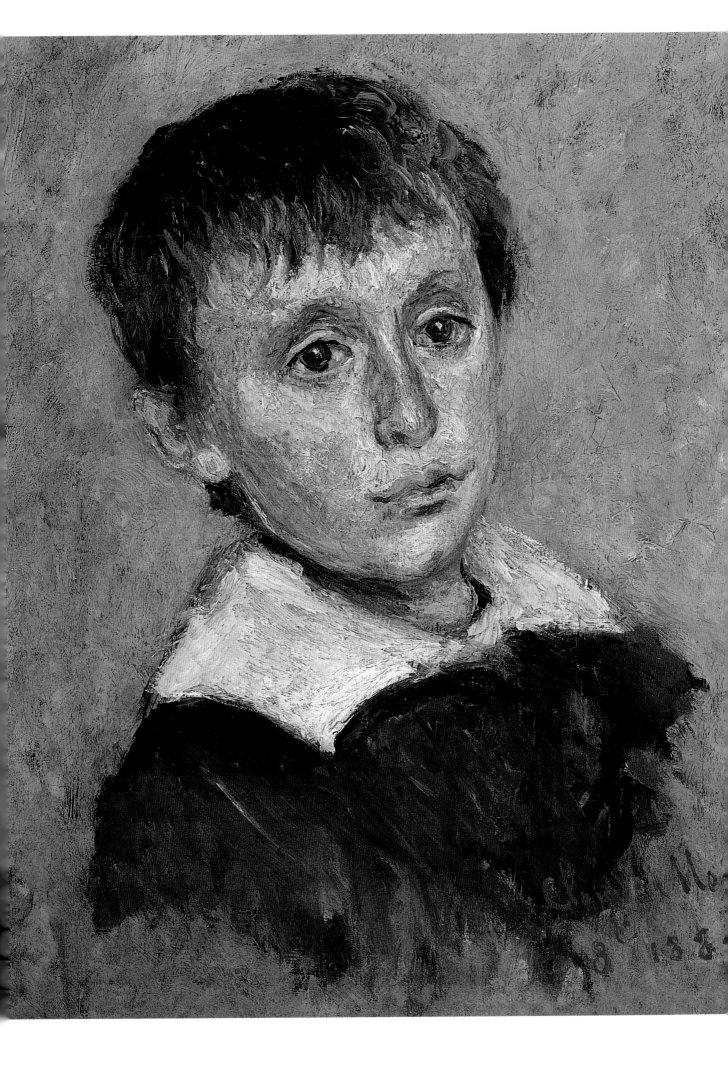

LE JARDIN DE VÉTHEUIL (1881)
THE GARDEN AT VÉTHEUIL

Courtesy of Christie's Images

*H*ERE, Monet shows an unruly and untamed garden. When compared with the earlier work *Jeanne-Marguerite, le Cadre au Jardin* (1866), this disorder is particularly marked. The regularity and structure provided by the steps and the china-blue plantpots on the terrace are fighting a losing battle with the foliage. The tree on the left of the painting snakes across the canvas and virtually obliterates the house. The shadow on the lawn is irregular in shape and adds to the sense of chaos. In *Jeanne-Marguerite, le Cadre au Jardin,* the shadows of the woman and the flowerbeds are neat blocks of black. In this later painting, the garden is trained and controlled, the beds and trees providing a safe environment to walk in. In *Le Jardin de Vétheuil* there is no one walking in the garden; its unruly appearance suggests that nature has gone wild.

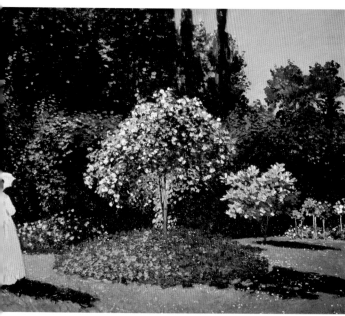

Jeanne-Marguerite, Le Cadre au Jardin (1866)
Jeanne-Marguerite, the Image in the Garden
The Hermitage, St Petersburg. Courtesy of Topham.
(See p. 30)

The colors used in *Jeanne-Marguerite, le Cadre au Jardin* are laid on to the canvas as separate blocks so that the woman forms a block of white, the lawn a block of green and so on. This distinction is lost in *Le Jardin de Vétheuil*, where colors merge into each other, making one element difficult to differentiate from the next; the white of the house, for example, becomes the white on the tree leaves.

FLEURS À VÉTHEUIL (1881)
FLOWERS AT VÉTHEUIL

Courtesy of Christie's Images

THE town depicted in *Fleurs à Vétheuil* is small and vulnerable on the canvas, isolated by a gray sky that matches the gray water in front of it. The same is not true in *Vétheuil* (1901), where the town has a strong presence on the canvas and attracts the eye to its jumble of colorful rooftops.

In contrast, the eye is drawn to the riot of color formed by the flowers in the foreground of *Fleurs à Vétheuil*. In fact, the flowers are not restricted to the foreground but threaten to envelop the picture. They are so bright that the town in the background seems washed out in comparison. Although the opening in the bushes provides a vista of Vétheuil, the tall flowers that spike up from the general melee of color that covers the bottom half of the canvas are threatening to close over the gap. Vétheuil is in danger of being swallowed up by nature, but in *Vétheuil*, the little town is serenity itself.

The colors used in *Fleurs à Vétheuil* form connections between themselves. The red flowers that band across the picture are repeated in color on the spiked flowers. These also have the rosy-white color of the flowers in the foreground. This provides them with a unity out of the confusion of colors.

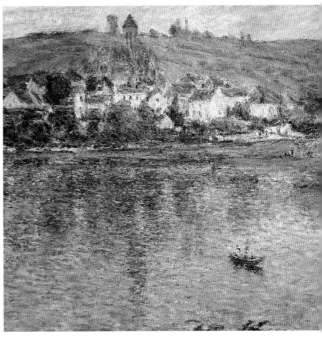

Vétheuil (1901)
Pushkin Museum, Moscow.
Courtesy of Topham. *(See p. 216)*

BARQUES DE PÊCHE DEVANT LA PLAGE ET LES FALAISES DE POURVILLE (1882)
FISHING BOATS IN FRONT OF THE BEACH AND THE CLIFFS OF POURVILLE

Courtesy of Christie's Images

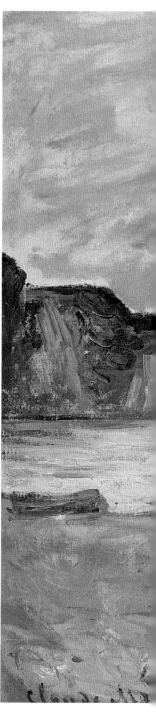

*I*N ORDER to paint this picture, Monet made a great effort to reach the exact location that he thought was necessary for the best viewpoint. It is recorded that he was seen clambering over cliffs and rocks dragging six or seven canvases with him. This would be in keeping with his ideals concerning *plein-air* technique, although the reality was that he finished most of the canvases in his studio.

Barques de Pêche devant la Plage et les Falaises de Pourville and *La Falaise de Ste.-Adresse* (1873) seem to lack some of the obvious spontaneity evident in other paintings, although the scurrying clouds in the former have some sense of being captured on canvas on location. The painting depicts sailing boats, which had already proved a popular subject when Monet lived at Argenteuil. Here the lonely figure on the shore is isolated by being detached from the fun of the boats at sea. This isolation is emphasized by the careful blocking Monet adopts with each element. Strong lines separate the shore from the sea and the sea from the sky. There is no blurring of the boundaries in either painting, as has been seen in other work. Instead, each element is clearly differentiated from its neighbor.

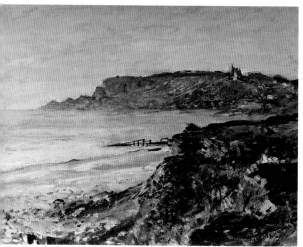

La Falaise de Ste.-Adresse (1873)
The Ste.-Adresse Cliffs
Courtesy of Christie's Images. (See p. 66)

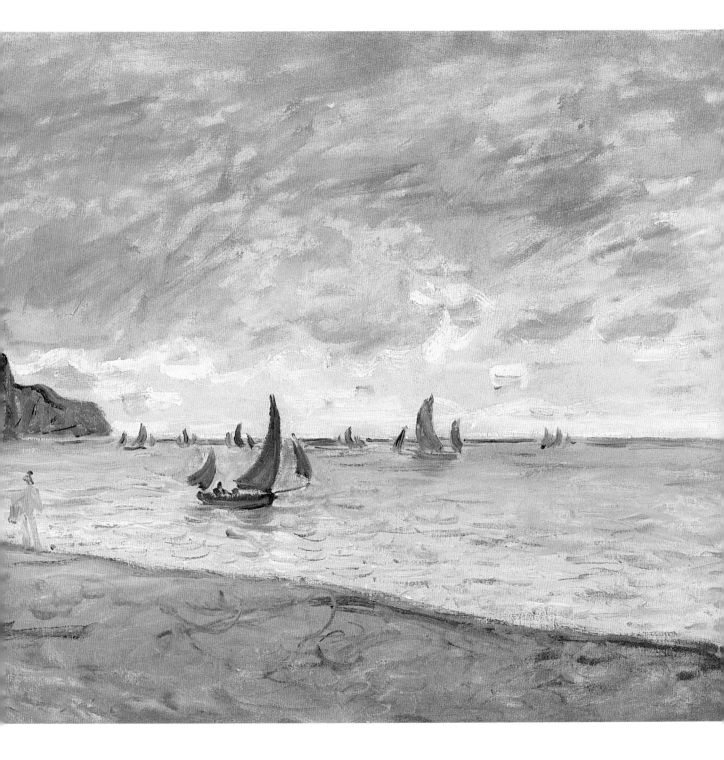

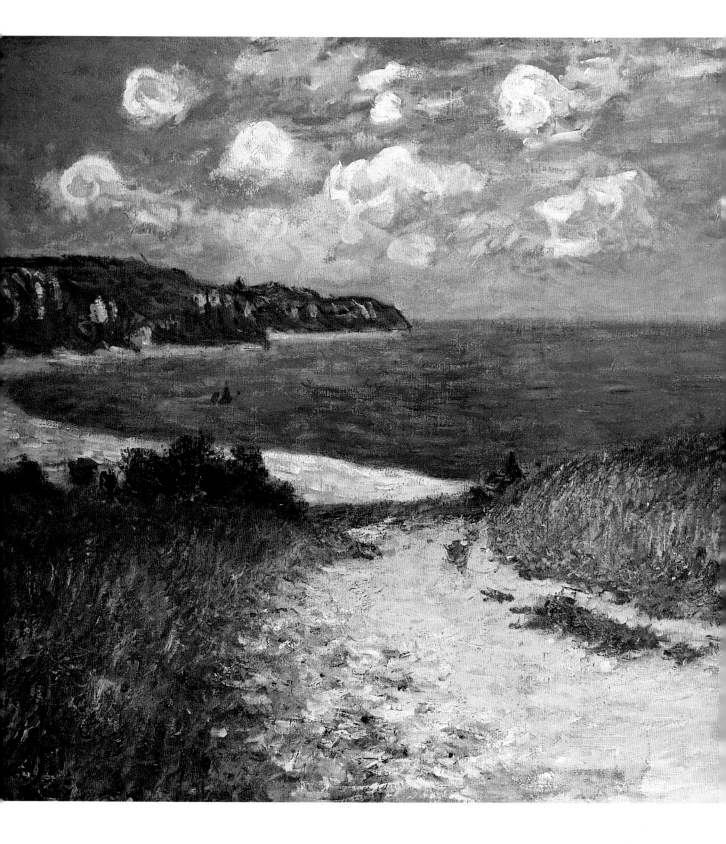

CHEMIN DANS LES BLÉS À POURVILLE (1882)
PATH THROUGH THE CORN AT POURVILLE
Courtesy of Christie's Images

WHAT is most noticeable about this painting are the strong, bright colors. The blue of the sea is reminiscent of some of Monet's paintings from the Mediterranean. What he set out to do was to capture the effects of a brilliant summer's day on the beach landscape.

By using strong colors that contrast with each other rather than blend together, he achieves the effect of each color appearing even stronger. Thus, where the red of the wheat touches the blue of the sea, each benefits from the contrast; the same is true where the sea meets the shore. This time, the effect of the sun is to render the sand a brilliant white. These blocks of colors work together to create an impression on the viewer. There is actually very little detail in the picture itself.

This painting has strong lines that form horizontals and verticals. In the picture the curved path not only draws the eye toward the sea but also provides a vertical curve that meets the sand and continues to the horizon. This balances the horizontal of the sea and cliff.

LA PLAGE À POURVILLE, SOLEIL COUCHANT (1882)
THE BEACH AT POURVILLE, AT SUNSET

Musée Marmottan. Courtesy of Giraudon

*T*HE effect of the sun setting on the beach is entirely decorative. The sweep of the beach across the bottom of the painting is balanced in equal measure by the sea and the sky. Unlike other paintings from this period, there is no sense of drama between the three elements.

La Plage à Pourville, Soleil Couchant is harmonized by the colors used. The orange and yellows of the sun in the sky are reflected on to the water beneath and again in the colors used on the beach. This strengthens the link between the three elements and harmonizes the picture. Similarly, blue paint is used on the shore as well as the sea and sky. The painting has been produced purely for the pleasure of viewing it. Monet has dispensed with the previously held beliefs of the official French art world that paintings need to have a purpose other than beauty. Prior to the appearance of the Impressionist artists, only paintings with moral or religious significance were considered correct subjects for art.

The painting is purely concerned with the harmony of nature. No humans are present in the painting, and no message is intended. "Art for art's sake" was soon to become one of Monet's central beliefs.

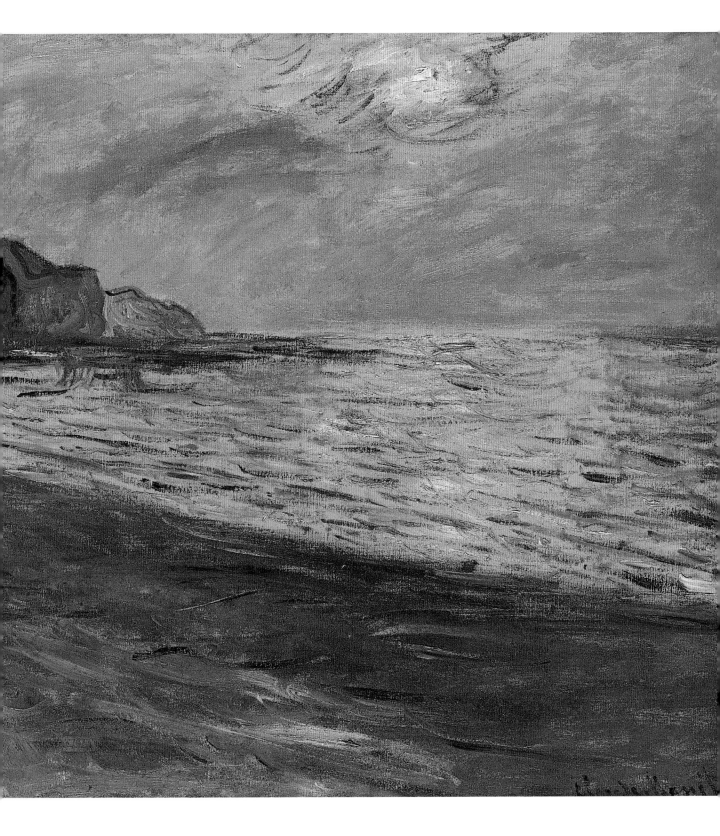

LES GALETTES (1882)
THE CAKES
Courtesy of Giraudon

*A*LTHOUGH Monet did not paint many still lifes, he chose to present one to the Municipal Council of Le Havre. This suggests that he felt strongly that they were of significance within the portfolio of his work. His still life paintings tended to appear in the earlier part of his career, from the late 1860s to the early 1880s.

This later work in the period shows evidence of his changing technique. The treatment of the tablecloth compared with *Nature Morte au Melon* (1876) reveals much more vigorous brushwork and thicker strokes. Similarly the cakes are painted with obvious brushwork and are not attempting to be an exact copy of the subject in the same way as was Monet's treatment of the grapes in *Nature Morte au Melon*. More startling still is his use of perspective. The earlier work shows the subjects on a tablecloth with a wall behind; the plate leaning against the wall helps the viewer understand the perspective. No such aid is provided in *Les Galettes*. The cakes are painted onto a tablecloth which is merely a flat background of color. No sense of depth is given to the picture, so that the cakes are in danger of sliding off what appears to be a sloping plane. This is a huge step forward in terms of Monet's perception of his subjects.

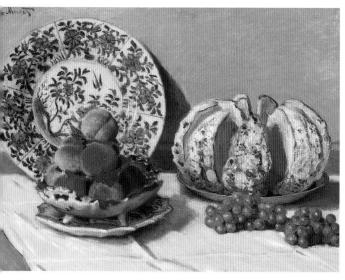

Nature Morte au Melon (1876)
Still Life with Melon
Courtesy of Giradoun. (See p. 60)

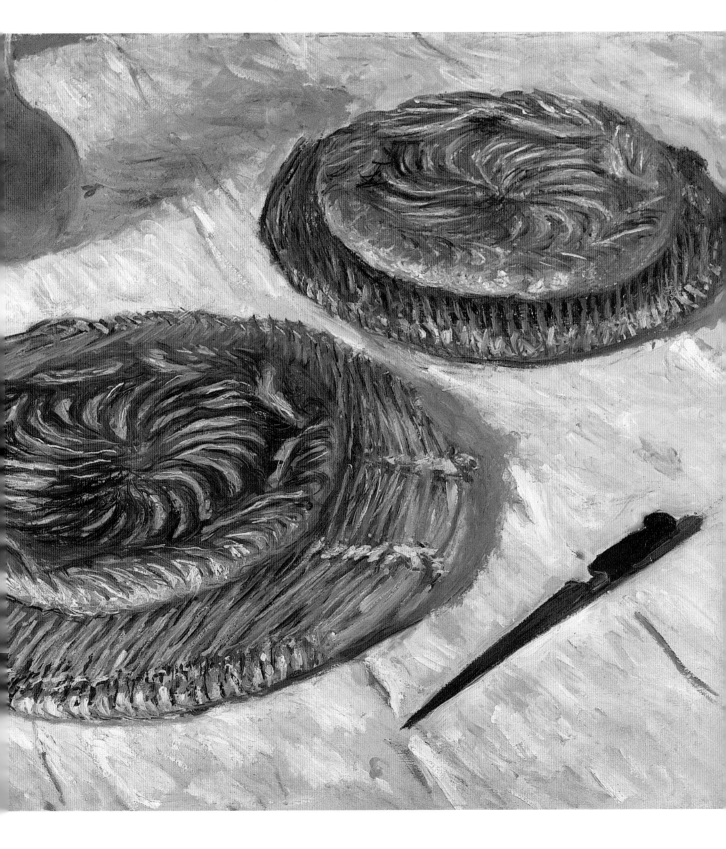

EGLISE DE VARENGEVILLE, EFFET DU MATIN (1882)
VARENGEVILLE CHURCH, MORNING EFFECT
Courtesy of Christie's Images

*T*HIS remarkable painting is unusual for its composition. Many of Monet's paintings from this period were created from the top of the cliffs looking down or along, but here he has broken that precedent and chosen to paint the cliffs at their base, and face on.

To reach this position Monet would have had to make strenuous efforts, dragging his canvas with him. His desire to paint this particular subject is expressed in the enthusiastic manner in which the paint is applied to the canvas. Swift strokes of varying colors are laid side by side. The cliff face in particular is a medley of color. No effort to tone in the paint is made, so each color stands in stark contrast to its neighbor. This gives the painting its sense of drama and an overall brilliancy of color. This lack of washing colors together and, instead, contrasting them with each other has become synonymous with Impressionist work.

Monet creates a sense of the scale of the cliffs by using long vertical brushstrokes on the cliff face, their height is emphasized by the small strip of canvas reserved for the sky, so that the cliffs completely dominate the space. Finally, the perilous nature of the cliffs is expressed by the church that stands at their apex; it is almost threatening to tip over.

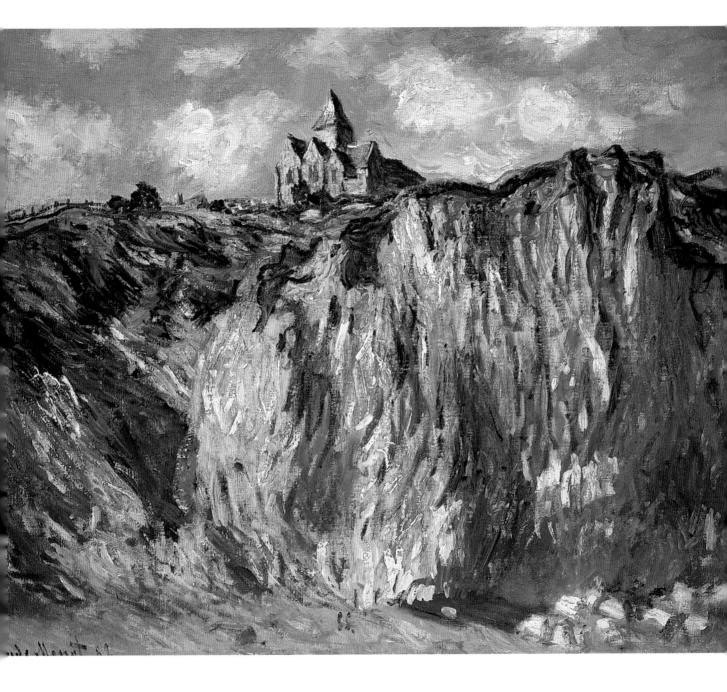

LA CHEMIN CREUX
DANS LA FALAISE DE VARENGEVILLE (1882)
THE PATH THROUGH THE HOLLOW
IN VARENGEVILLE CLIFF

Walsall Art Gallery. Courtesy of Topham

WHAT must have appealed to Monet about this scene has to be the strong geometric shapes that are formed by the valley and the sea. This is in contrast to the cliff paintings such as *Sur la Falaise près de Dieppe* (1897), where the view of the coastline does not lend itself to such shapes.

The triangular shape of the hills is complemented by the inverted triangle of the sea. The top of the cliffs and the horizon form horizontal lines that are counterbalanced by the vertical path. This path draws the eye forward toward the sea. It is now that the viewer realizes that the perspective cannot be accurate. The sea appears to be about to fall on to the heads of the women walking along. Monet must have manipulated the scene in order to emphasize the geometric qualities of the landscape. A similar problem occurs with the Dieppe painting where, in order to understand the perspective of the cliff banking on the right in relation to the cliffs on the horizon, the viewer assumes the viewpoint to be taken from a hollow.

The minute figures in the Varengeville painting appear to be overwhelmed by the land swelling around them and by the sea in front of them. They are tiny and derive their importance only as a focal point to draw the observer's eye forward along the path.

Sur la Falaise près de Dieppe (1897)
On the Cliffs near Dieppe
Courtesy of Image Select. (See p. 210)

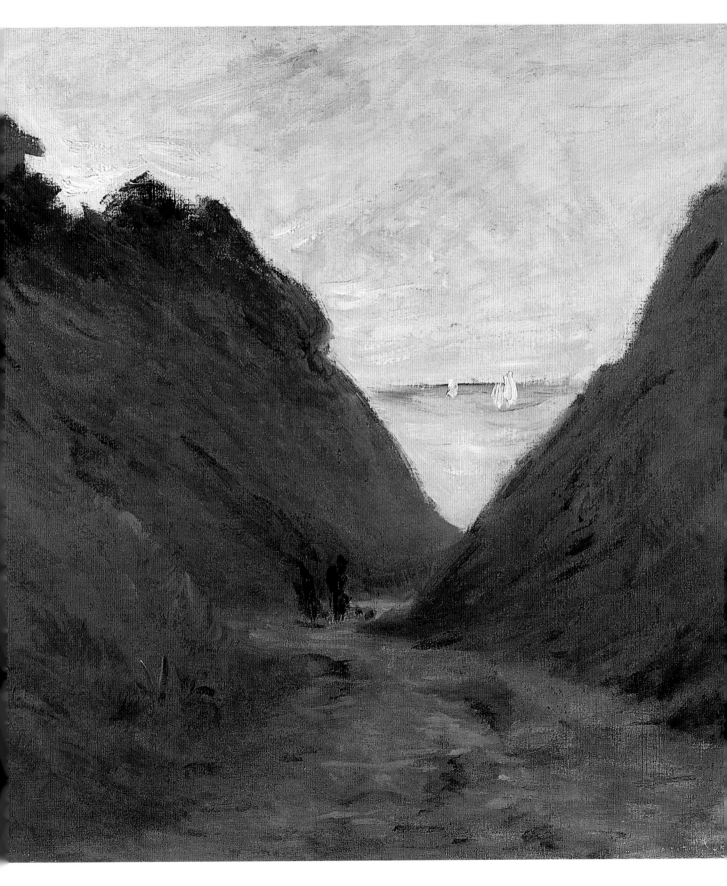

LA SEINE À PORT-VILLEZ (1883)
THE SEINE AT PORT-VILLEZ
Courtesy of Christie's Images

*I*N this picture of 1883, Monet chose to paint the view without including either buildings or people in it, unlike his recreation of the same subject in 1908–09. The result is a tranquil picture that focuses on the contours of the land.

The tranquility is matched by the water, which is calm and reflects the scene around it almost perfectly. The shorter brushwork on the surface of the water differentiates it from the land. The whole blends together to form a harmonized view of nature. The same cannot be said for the later piece with an identical title. In this, Monet has included the town as the central focus. The simplicity of the scene in the 1883 painting has been extended to a simplicity of color and style in the 1908–09 work. Here colors are applied as thick bands on the canvas in contrasting tones to each other so that harmony is not the object of the piece.

The artist chose warm gold and yellow tones to complement the green of the land in the earlier work. The water reflects the tones of the land. The result is a very restful painting.

La Seine à Port-Villez (1908–09)
The Seine at Port-Villez
Courtesy of Christie's Images. (See p. 218)

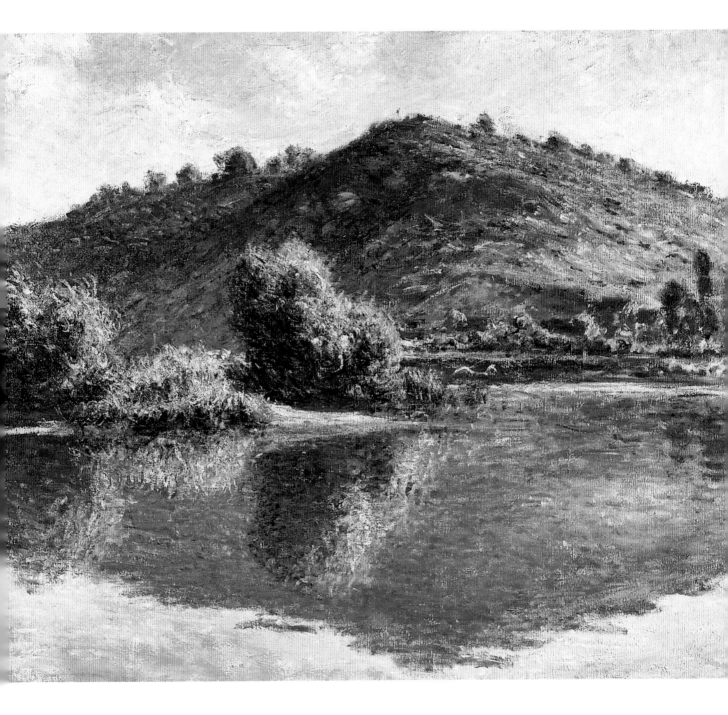

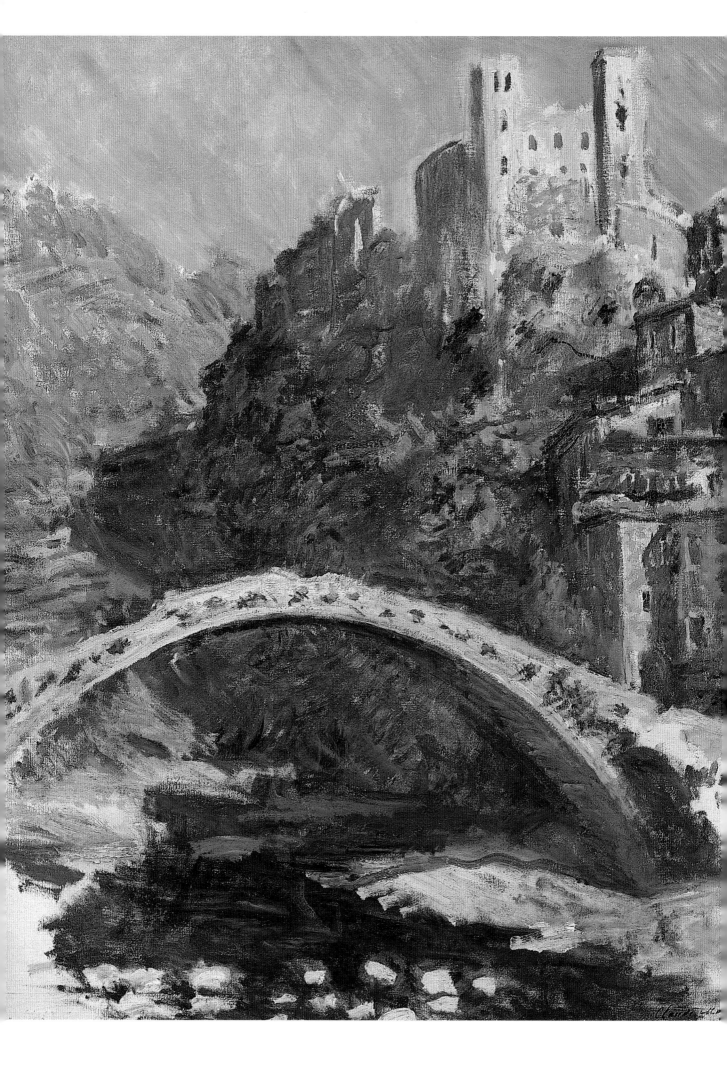

LE CHÂTEAU DE DOLCEACQUA (1884)
THE DOLCEACQUA CHÂTEAU

Musée Marmottan. Courtesy of Giraudon

PAINTED in 1884, this winter scene of the château has a symmetry to it that makes it aesthetically pleasing. The curve of the bridge, which cuts horizontally across the painting, is counter-balanced by the curve of the river bed, which moves from the front to the back of the painting.

The buildings on the right of the valley are a sign of human life, but the opposite side of the river is free to nature. The green of the left bank has encroached on the right and is creeping up the sides of the château. This suggests that, rather than man dominating nature, nature is claiming back the land. This theme occurs increasingly in the artist's later work. Monet's preoccupation with the power of nature is particularly evident in the paintings that he did of the Creuse Valley. *Vallée de la Creuse, Effet du Soir* (1889) is typical of these, perfectly capturing the barrenness of the wild landscape.

In *Le Château de Dolceacqua* Monet suggests that, in a few years' time, nature will have completely reclaimed the land and the valley will be like the Creuse. The comparison is furthered by the sweep of the river bed in both pictures, forming the central dissection of the canvas.

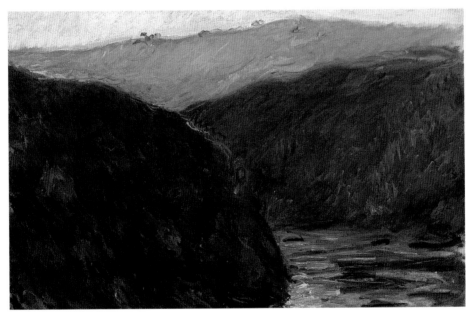

Vallée de la Creuse, Effet du Soir (1889)
Creuse Valley, Evening Effect
Musée Marmottan. Courtesy of Giraudon. (See p. 178)

ETREAT, LA PLAGE ET LA FALAISE D'AVAL (1884)
ETREAT, THE BEACH AND THE AVAL CLIFF

Courtesy of Christie's Images

*T*HERE is evidence from Monet's sketchbook that, in 1884, he was experimenting with the idea of "framing" within a picture. In this painting the cliff juts into the picture on the left, creating a frame. In the earlier work, *Chemin dans les Blés à Pourville* (1882), there is no attempt to frame the piece; instead, the landscape fills the canvas to the edge.

The cliff frame in *La Plage et la Falaise d'Aval* gives the painting some depth. The composition establishes a relationship between the cliffs and the sea in two ways. First, the horizontal lines of the waves are paralleled in the horizontal shading on the far cliffs and on the shore. Although their purpose on the sea is to denote movement and on the shore unevenness, they do help to establish a relationship between the two. In a black and white reproduction of this painting, it is almost impossible to distinguish where the sea ends and the shore begins.

A second relationship is established by the use of shade and light. Using purple to indicate the effect of light softens the solidity of the rock. This is especially evident around the base of the rock on the shore. The sea in turn has patches of dark color, indicating shadow and the rippling of the waves.

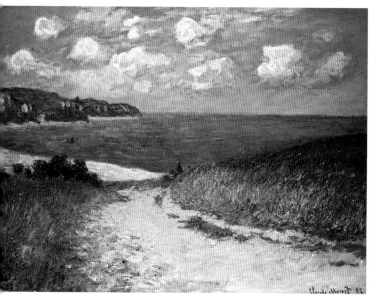

Chemin dans les Blés à Pourville (1882)
Path through the Corn at Pourville
Courtesy of Christie's Images.
(See p. 127)

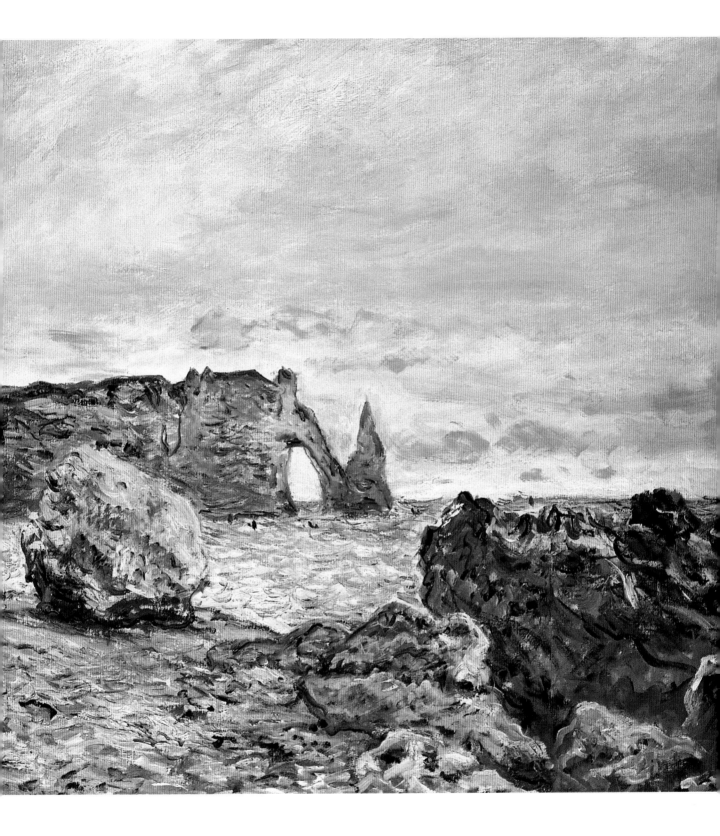

BORDIGHERA (1884)

Chicago Art Institute. Courtesy of Giraudon

*T*HIS painting of a view of Bordighera is dominated by the trees in the foreground. Their trunks rhythmically twist across the picture, dissecting the view of the town and preventing the strong blue of the sea from forming a solid band of color across the canvas.

This is in contrast to *Bras de la Seine près de Giverny* (1897), where the trees are used as a frame to the view. The contrast in styles between these paintings is obvious. For the earlier landscape Monet uses a palette of vibrant colors that mark out each element against each other; the green of the trees contrasts with the blue of the sea. With the Seine painting, Monet concentrates on harmonizing the color. The colors are subtler and flow together so that it becomes difficult to identify where one color ends and another begins. Across the whole, a pale blue seems to hang. In *Bordighera* the landscape is sharp in comparison. No one color pervades the whole painting.

The tangle and shape of the trees form a contrast to the solid squares and oblongs of the town. The brushstrokes on the leaves are rounded with flecks of white paint. The surface of the sea is expressed using several horizontal lines of contrasting blue.

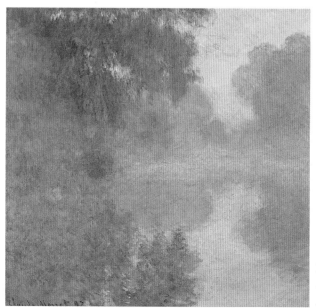

Bras de la Seine près de Giverny (1897)
Branch of the Seine near Giverny
Musée Ile de France. Courtesy of Giraudon. (See p. 204)

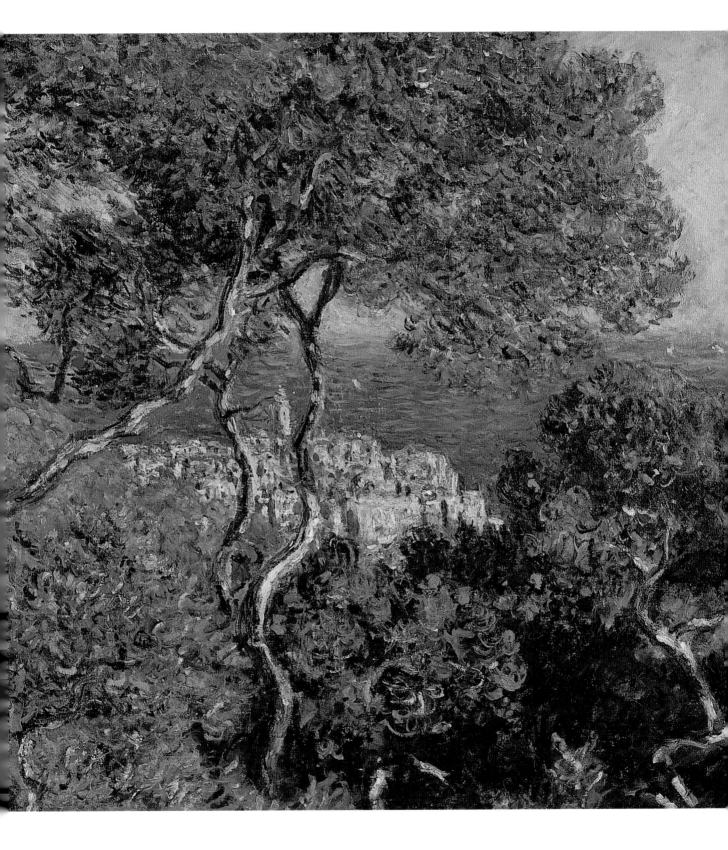

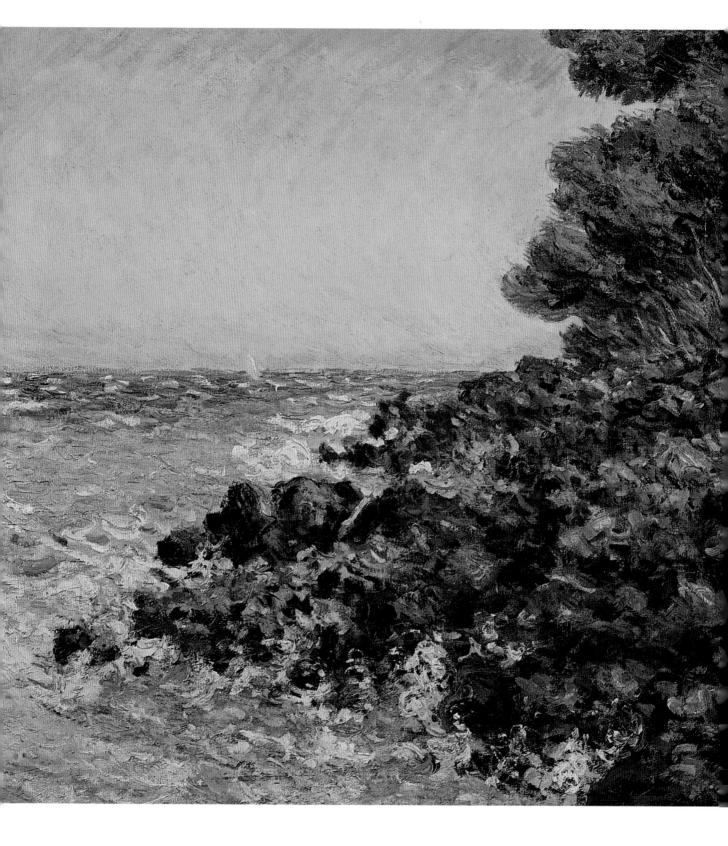

LE CAP MARTIN (1884)

Musée des Beaux Arts, Tournai. Courtesy of Giraudon

MONET first discovered the beauties of this headland when he came here with Renoir. They intended to paint it together, but in 1884 Monet secretly visited the area on his own. The resulting pictures are full of energy and color.

The roughness of the rocks complements the uneven brushstrokes used on the sea. The strokes are laid on quickly and thickly, the sea has odd, broad, white dashes of color on it to represent the waves and the horizontal lines of the sea contrast with the rocks, with brushstrokes painted in several directions. The trees provide the vertical mass that balances the horizon. The horizontal and vertical are particularly emphasized in this painting by the contrasting techniques used on the sky, sea, and trees. The sky is painted as a smooth surface, making use of pale colors; the sea and trees are painted in stronger colors using shorter brushstrokes, and a definite line is formed where they each meet the sky.

On the sea, a single vertical white line is highlighted against the pink skyline, this represents a sail. When compared with Monet's earlier detailed paintings of boats at Argenteuil, it is obvious how his technique and composition have changed. By 1884, Monet was content to represent the boat as a dash of white paint, an impression on the horizon.

PORTRAIT DE L'ARTIST DANS SON ATELIER (1884)
PORTRAIT OF THE ARTIST IN HIS STUDIO
Musée Marmottan. Courtesy of Giraudon

*T*HIS painting is unsigned, and the bottom half of the canvas has been worked on only slightly. It can, therefore, be assumed that this is an unfinished work. Monet did other self-portraits, but what makes this interesting is its setting in his studio.

Unlike the 1880 portrait of Michel (*Portrait de Michel en Bonnet à Pompon*), Monet felt the need to include a background to his own portrait. Significantly, he does not refer to this as a self-portrait but titles it in the third person. This is a portrait of him as artist, not as a private individual; his definition comes from his art. Also, unlike the portrait of his son, his eyes are averted from the viewer, not inviting an intimate response as Michel's do. Thus, although the viewer is being given access to the artist's studio, the experience is not an intimate one, and the viewer of the painting is slightly removed from the subject of the picture.

Despite this, the portrait of Michel appears more formal than this painting. Michel is posed, whereas Monet is pictured caught at an idle moment, his look distant and his hands relaxed onto his legs. It is interesting that Monet chose to paint himself as an artist at a moment when he is not actually working.

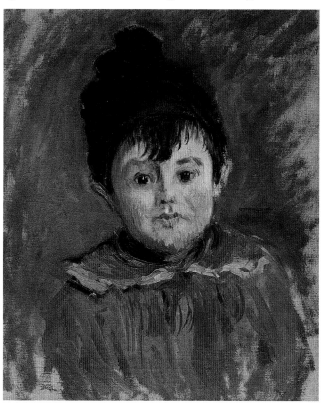

Portrait de Michel en Bonnet à Pompon (1880)
Portrait of Michel in a Pompom Hat
Courtesy of Giraudon. (See p. 116)

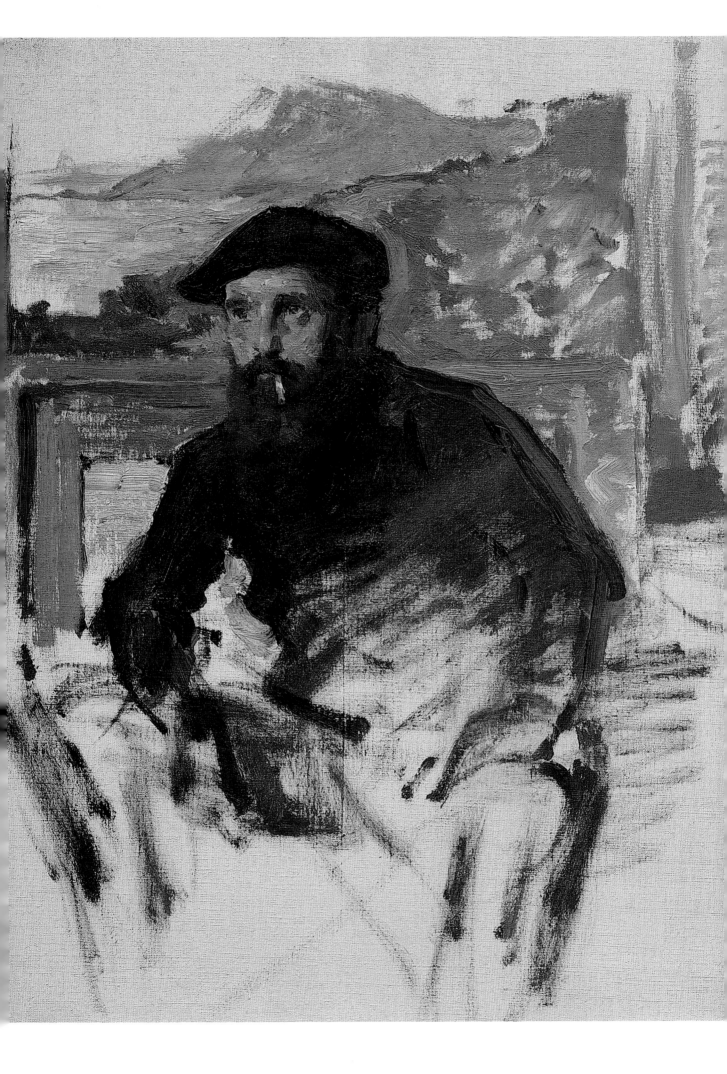

PORTRAIT DE POLY (1886)
PORTRAIT OF POLY

Musée Marmottan. Courtesy of Giraudon

WHILE Monet was working at Belle-Ile, the fisherman Guillaume Poly frequently visited the inn where he was staying. Monet painted this portrait during that period.

What appears to have attracted Monet to Poly as a subject was his features—he began his career as a caricaturist, earning money to go to Paris from selling caricatures of well-known people in his home town. This makes it surprizing that Monet did not produce very many portraits, as he was clearly interested in the human face. Unlike portraits of his children or of himself, as depicted in *Portrait de l'Artist dans son Atelier* (1884), this portrait of Poly is full of character. The eyes are turned toward the viewer, the nose is rounded and the cheeks are ruddy; the hat and beard add character to the face.

In Monet's own portrait he is also wearing a cap and has a beard, but there is no sense of his personality. He is defined as an artist by the canvases in the background. With the painting of Poly, it is easy to read a story into the portrait; his face invites the viewer to read it, and he requires no background to generate interest.

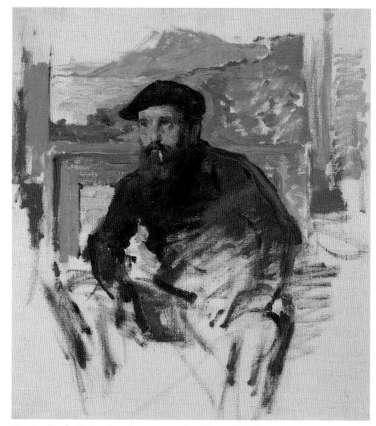

Portrait de l'Artist dans son Atelier (1884)
Portrait of the Artist in his Studio
Musée Marmottan. Courtesy of Giraudon. (See p. 146)

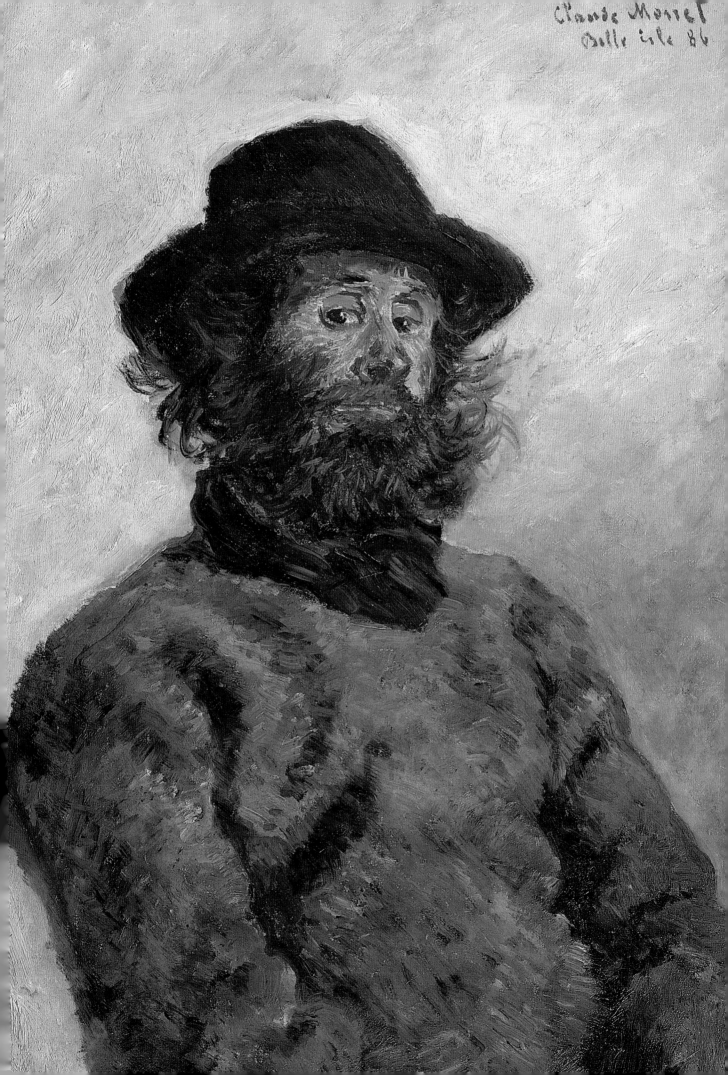

L'EGLISE À BELLECOEUR (1885)
THE CHURCH AT BELLECOEUR

Courtesy of Image Select

*P*AINTED only a few years apart, both *L'Eglise à Bellecoeur* and *L'Escalier* (1878) are intimate, close views of a rural setting. Both are devoid of people and concentrate on the beauty of the buildings. In *L'Eglise à Bellecoeur*, Monet shows a little more of the village, which seems sleepy in the warm sun.

The difference between the two paintings is that *L'Eglise à Bellecoeur* appears to have a greater preoccupation with shapes and patterns than *L'Escalier*. The buildings form a pattern of oblongs, squares, and triangles. They are all, apart from the church, depicted with the slant of their roofs facing the viewer, creating a contrast between the red of the roof and the white of the walls that emphasizes the geometric shapes. The low walls running around the properties echo this. *L'Escalier* does have a similar pattern with its walls and roof, but because the viewer is positioned closer to a single building, this pattern is more difficult to appreciate.

In the later painting, the clouds in the sky provide a contrast to the shapes below. The tree in the foreground helps to disrupt the regular pattern. The amount of space given over to the blue sky helps to prevent the complex of buildings from overwhelming the painting.

L'Escalier (1878)
The Stairs
Courtesy of Christie's Images. (See p. 102)

GLAÏEULS (1882–85)
GLADIOLI
Private Collection, Paris. Courtesy of Image Select

THE agent Durand–Ruel commissioned Monet to paint a set of decorative panels; it took the artist over two years to complete them. They each depicted either fruit or flowers and were designed to reflect the changing seasons.

The shape of the gladioli is perfect for an upright panel. Painted positioned on what appears to be a tabletop, the background is very simple, unlike in *Chrysanthèmes* (1878), where the wallpaper pattern is clearly in evidence behind the flowers. By placing the gladioli against a blue background the colors of the flowers are revealed to startling effect. In contrast, the chrysanthemums lose impact to the effect created by the flowers on the wallpaper. Whereas the chrysanthemums move across the canvas, the gladioli form vertical lines counterbalanced by the edge of the table.

The strange vase that the flowers are presented in forms a second focal point, drawing the eye away from the gladioli and down the canvas to the white flowers on the vase. With the chrysanthemums it is the wallpaper that draws the eye up. The vertical linear rhythm of the gladioli painting is pleasing to the eye.

Chrysanthèmes (1878)
Chrysanthemums
Courtesy of Christie's Images. (See p. 100)

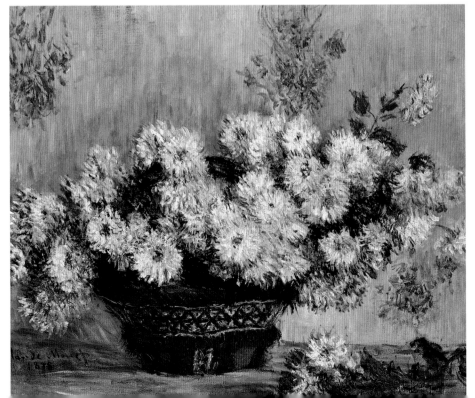

TEMPÊTE, CÔTES DE BELLE-ILE (1886)
STORM ON THE COAST OF BELLE-ILE
Courtesy of Giraudon

MONET found the changing weather conditions on the Brittany coast very exciting. In particular, when the weather was rough, he was impatient to capture the moment on canvass. The swiftness of the brushstrokes in these Belle-Ile paintings adds to the air of dashing the pictures off in a frenzy of excitement.

In both paintings, a sense of drama is created by moving the horizon very high up the canvas, making the sea appear to be flooding into the sky. *Tempéte, Côtes de Belle-Ile* in particular exaggerates this effect by using similar colors for both the sky and the sea. The swift brushwork on the sea versus the more solid strokes of the sky help the viewer to identify the horizon. In *Les Roches de Belle-Ile* (1886) Monet uses a bank of cloud to identify the dividing line.

In *Tempéte, Côtes de Belle-Ile*, the sea itself is painted with a lot of white, to create the turbulence of the waves hitting the rocks. Because the painting has been cropped on the left, the viewer feels that he has been placed on a level with this turbulence. In *Les Roches de Belle-Ile* the artist's viewpoint is higher, which helps to maintain a distance from the water, leaving the observer removed from the intensity of the action.

Les Roches de Belle-Ile (1886)
The Belle-Ile Rocks
Musée d'Orsay. Courtesy of Giraudon.
(See p. 156)

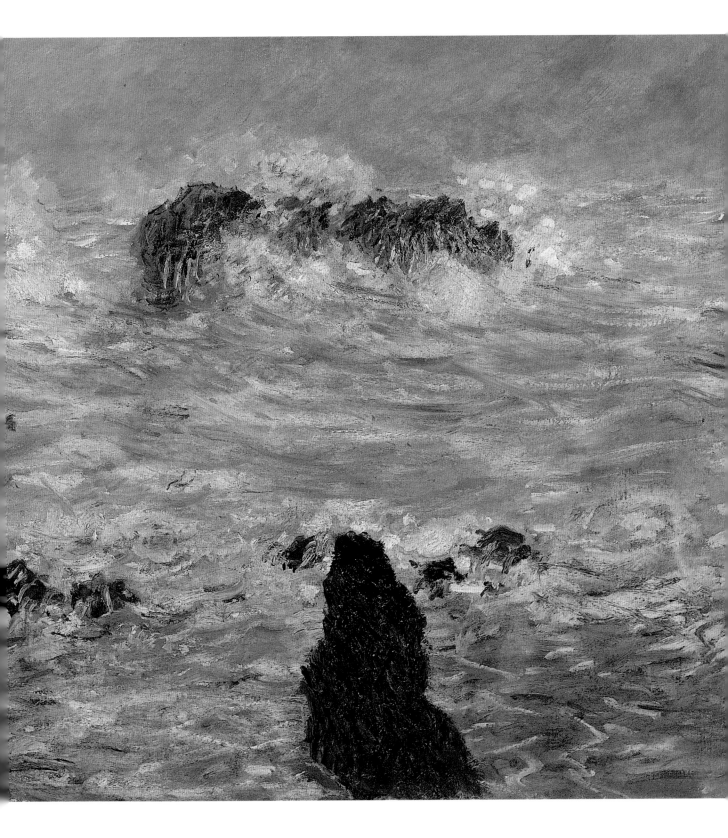

LES ROCHES DE BELLE-ILE (1886)
THE BELLE-ILE ROCKS

Musée d'Orsay. Courtesy of Giraudon

THE wildness of the sea is captured here by Monet's use of color, the dark blues and greens typical of a stormy sea. In contrast, when the sea is viewed on a calm day, as in *La Plage à Pourville, Soleil Couchant* (1882), the sea has softer tones. The color of the sea in *Les Roches de Belle-Ile* does not indicate a specific time of day, but the end of day is explicit in the second painting.

The drama of this painting lies entirely in the stormy waves of the sea. Their power is complemented by the solid dark mass of the rocks. The movement of the waves is presented by using short brushstrokes and by laying different colors next to each other, so that a dark blue stroke may be placed alongside a green one. In *La Plage à Pourville, Soleil Couchant* Monet lengthens the brushstrokes along the surface of the sea to produce a more regular surface and manages to create the impression of tranquility.

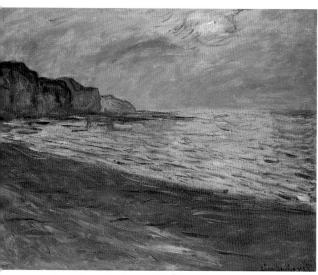

La Plage à Pourville, Soleil Couchant (1882)
The Beach at Pourville, at Sunset
Musée Marmottan. Courtesy of Giraudon. (See p. 128)

The menacing presence of the rocks actually takes up nearly the same amount of canvas space as the sea. By painting them encroaching across to the bottom left of the painting, but losing ground to the sea in the top right-hand corner, Monet depicts the eternal battle between land and sea.

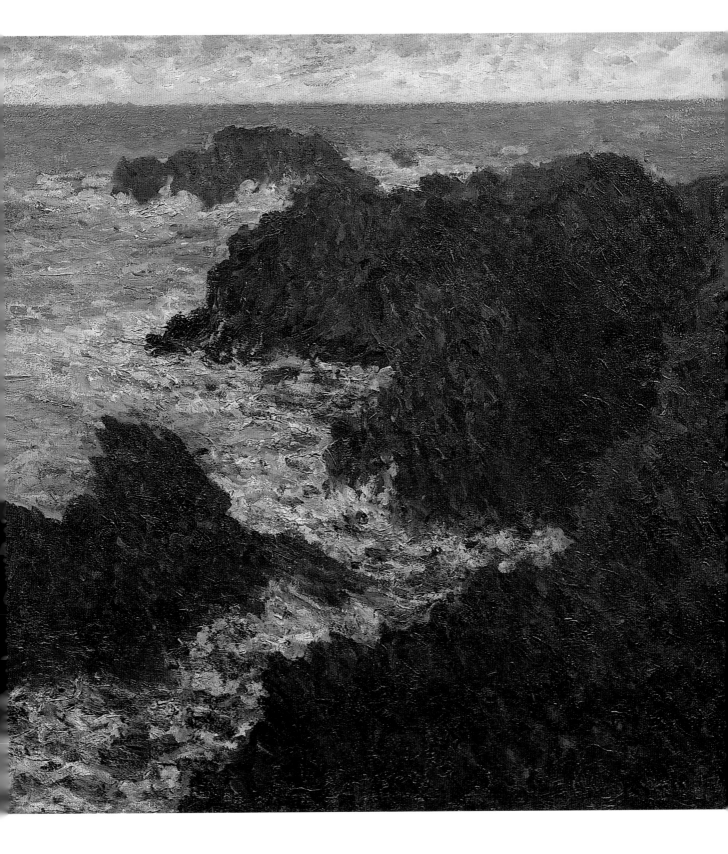

CHAMP DE TULIPES, HOLLANDE (1886)
TULIP FIELD, HOLLAND
Courtesy of Giraudon

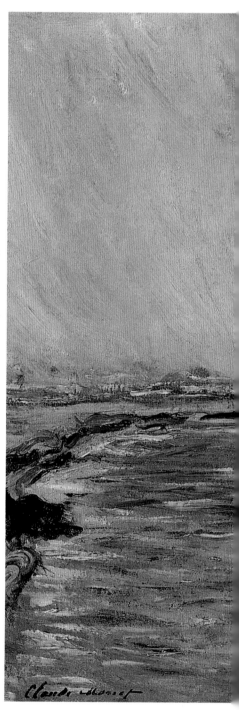

MONET was inspired by the flatness of Holland when he visited the country in 1871. This picture emphasizes that flatness by the equal split between land and sky. The windmill at the center helps break up the never-ending horizon and gives a perspective to the view.

It was not just the flat landscape that inspired Monet; he was animated by the colors he saw as well. This is evident in the quick brushwork that switches from color to color. Such chaos of color is echoed in *Le Bassin aux Nympheas, les Iris d'Eau* (1900–01), where contrasting colors are painted on to the canvas side by side. The result in both works is an explosion of color that floods the viewer's sensations. So inspired by the color was Monet that he did not feel it necessary to give the flowers form. Their color is their essence, so it was sufficient to represent them by a patch of red or purple. This is especially noticeable in *Champ de Tulipes, Hollande*, where the scope of a view does not require a detailed rendition of a flower as if viewed from up close.

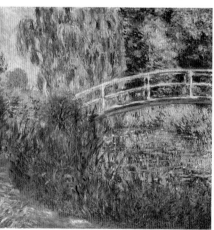

Le Bassin aux Nymphéas, les Iris d'Eau (1900–01)
Water Lily Pond, Water Irises
Courtesy of Christie's Images. (See p. 214)

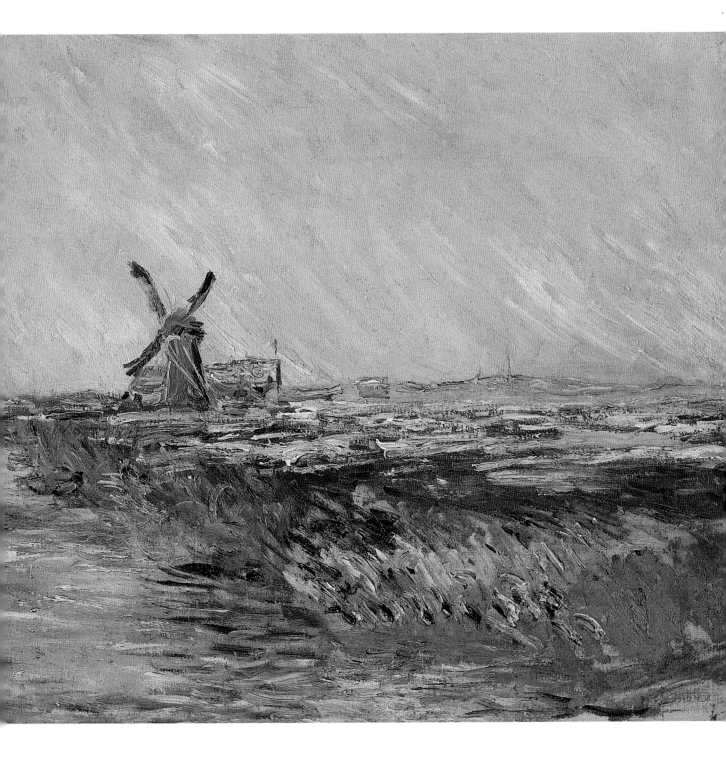

ESSAI DE FIGURE EN PLEIN AIR
(VERS LA GAUCHE) (1886)
STUDY OF A FIGURE OUTDOORS (FACING LEFT)
Courtesy of Giraudon

MONET painted a pair of figure pictures, one depicting a woman turned to the left and one to the right, in 1886. The model for both was Suzanne Hoschedé, the daughter of his friends Ernest and Alice. Following Camille's death, Suzanne had become Monet's favorite model. This painting is reminiscent of one of Camille produced in 1873.

Suzanne's features are blurred, making her an anonymous figure.

Monet deliberately did not want the viewer to be looking for a personality or story in this painting. Because she has no expression, the woman becomes a part of the overall picture and should be viewed as part of the landscape. The wind is seen to affect her in a similar manner as it does the grass. Her skirt is being blown against her legs, and the ribbon from her hat is blowing forward. The majority of the short brushstrokes representing the grass are moving in the same direction. The grass on the brow of the hill is more defined and can be seen clearly to bend in the wind.

The colors used on the grass are very different from those in Monet's earlier work. This time they include pinks and whites, as well as green and yellow. This helps to harmonize the figure with her environment. The flecks of white from the grass make a connection with the white of her dress and with the clouds.

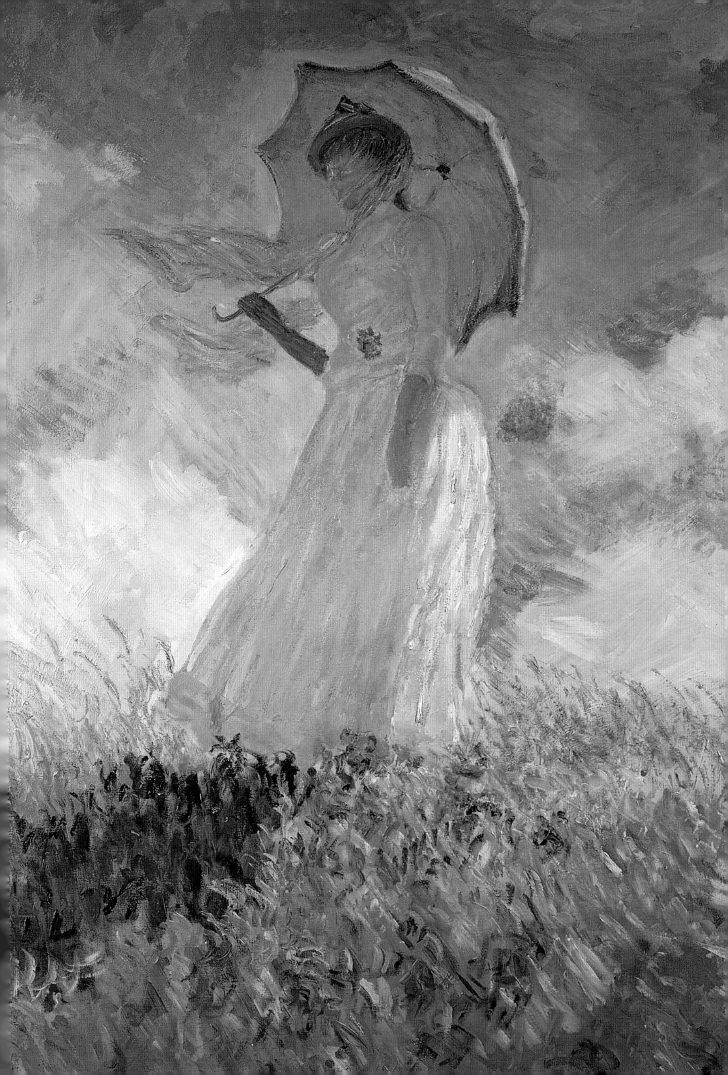

LA BARQUE (1887)
IN THE ROWING BOAT
Courtesy of Topham

F OR some critics, this painting is concerned with the nature of girls passing into womanhood. Their looks and bodies are undergoing constant change. This perpetual development is illustrated in the three girls by the lack of features shown. Even when compared with Blanche Hoschedé's face in *Blanche Hoschedé Peignant* (1892), which is only rendered in the vaguest terms, these girls' faces are sparse of detail.

Their association with nature is strong. Not only is Monet recording them at their most transient and developmental period in their lives, but, unlike Blanche Hoschedé, their clothing identifies them with the natural background they are in. The pink on their dresses is a reflection of the pink in the grassy bank behind the boat. For some critics this is symbolic of nature often being referred to as a female; to them Monet was using the women as a representation of nature.

Whether this was his aim is impossible to assert. What is certain is that this picture is one of harmony and balance. The boat is equally balanced by its reflection in the water, and all the colors work with the subject to create a tranquil painting.

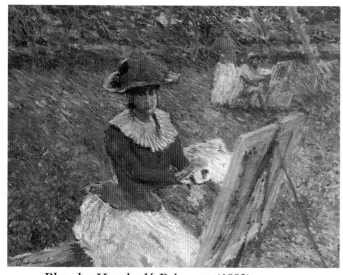

Blanche Hoschedé Peignant (1892)
Blanche Hoschedé Painting
Courtesy of Christie's Images. (See p. 182)

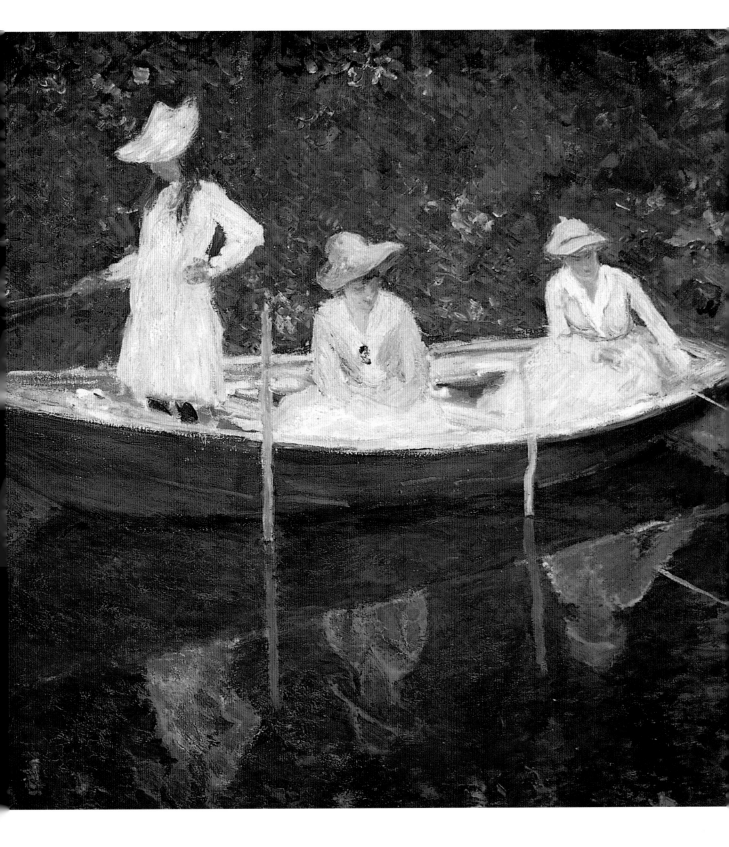

CHAMP D'IRIS JAUNES A GIVERNY (1887)
FIELD OF YELLOW IRISES AT GIVERNY

Musée Marmottan. Courtesy of Giraudon

*D*ESPITE the fact that this painting is entitled *Champ d'Iris Jaunes à Giverny*, two colors dominate—yellow and purple. The purple in the foreground is repeated in the hedges that span the middle of the painting. This is a very different treatment of the iris compared with the later *Iris Jaunes* (1924–25). In that painting, the yellow of the flower is the main focus; here it has been dampened in effect by being mixed with purple.

A second obvious difference is that the flowers themselves are the primary focus of *Iris Jaunes*. Deprived of a background, it is the essence of the plants that Monet is demonstrating. In the 1887 work,

Monet is putting the flowers in their context. They are painted in their natural habitat with a hedge and sky as background. They have none of the Oriental style that can be found in *Iris Jaunes* when placed back in a natural background.

This painting has the horizontal banding found in many other paintings by Monet. The field of flowers forms the first band, the hedge the second and the sky the third. Painted in landscape format, this linear design is very obvious.

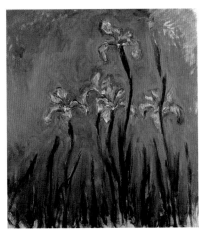

Iris Jaunes (1924–25)
Yellow Irises
Courtesy of Christie's Images. (See p. 250)

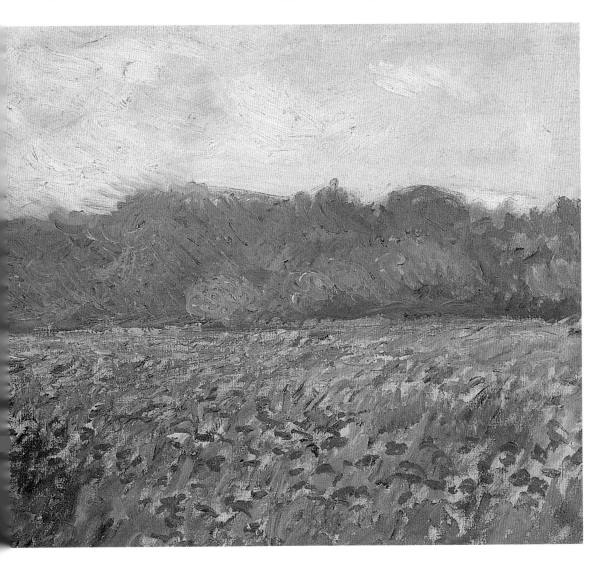

PRAIRIE DE LIMETZ (1887)
LIMETZ MEADOW
Courtesy of Christie's Images

THE figure in the foreground is believed to be Alice Hoschedé, later to become Alice Monet. The two boys following her are her sons. This is one of the few paintings where Alice acted as model.

A natural scene, it captures the moment when the family is walking from Giverny. This summer outing is a theme that frequently recurs in Monet's work. The warmth of the day is made explicit by the parasol Alice carries; the use of yellow on the field adds to the warmth of the painting. The brushwork reflects the angle of the different planes it is used to depict: thus, horizontal brushstrokes are used on the field because it is a flat plane and diagonal ones are used on the hill in the background to emphasize the angle of the slope. Monet is trying to capture the nature of each element not only in terms of color but also its substance. The grass seems long and wild in the foreground precisely because it is painted with quick strokes that dart in all directions. This is of more importance to Monet than a detailed, accurate picture of the grass.

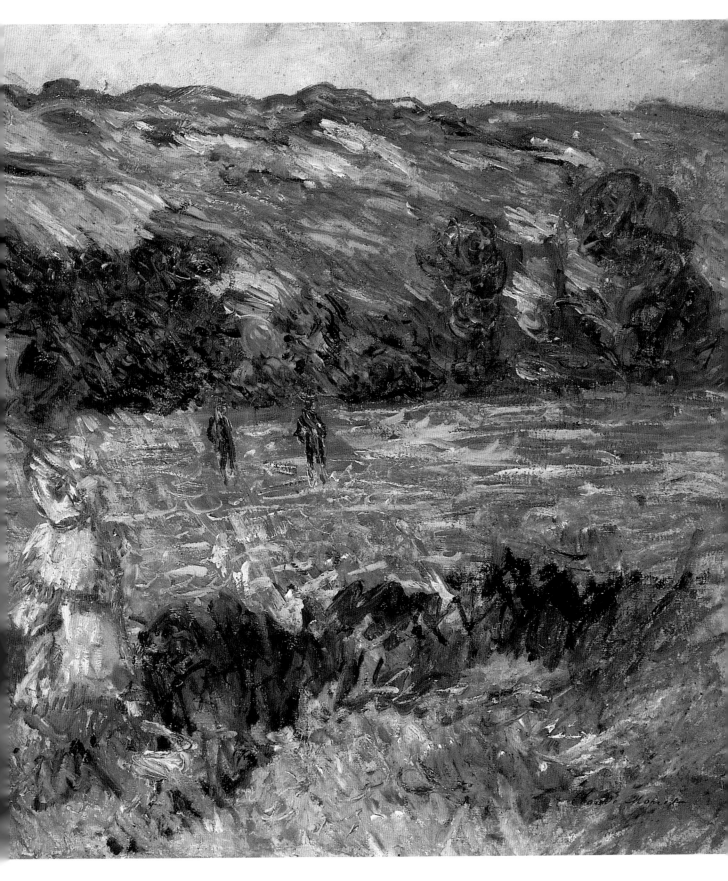

VUE D'ANTIBES (1888)
VIEW OF ANTIBES
Courtesy of Image Select

*T*HE trees in the painting frame this distant view of the coastal town of Antibes. The blue of the sea and sky are so similar that they provide a backdrop against which to display the tree. It is the shape of the branches of the tree and its leaves that interests Monet.

In contrast, the bushes in the foreground of *Antibes, Vue de Cap, Vent de Mistral* (1888) are used for perspective purposes and to add to the linear quality of the painting. The tree in the *Vue d'Antibes* is the focus, its strong solid trunk and branches contrasting with the soft, almost translucent quality of the leaves. By placing the tree so prominently in the foreground, Monet emphasizes the subtlety of the colors and light that surround the city. The solid structure of the tree makes Antibes dreamlike in contrast. It floats on the water in a wash of gold and pink that creates a haze around it. In the second painting, thicker strokes and vibrant colors are used so that Antibes is not surrounded by the same mystical air.

A great deal of space on the canvas is given to the sky, which allows the tree to be emphasized and results in Antibes appearing small and delicate. This is one of four paintings of this composition, which forms a mini-series.

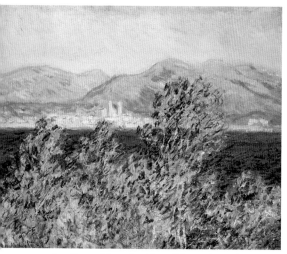

Antibes, Vue de Cap, Vent de Mistral (1888)
Antibes, View of the Cape in the Mistral Wind
Courtesy of Christie's Images. (See p. 170)

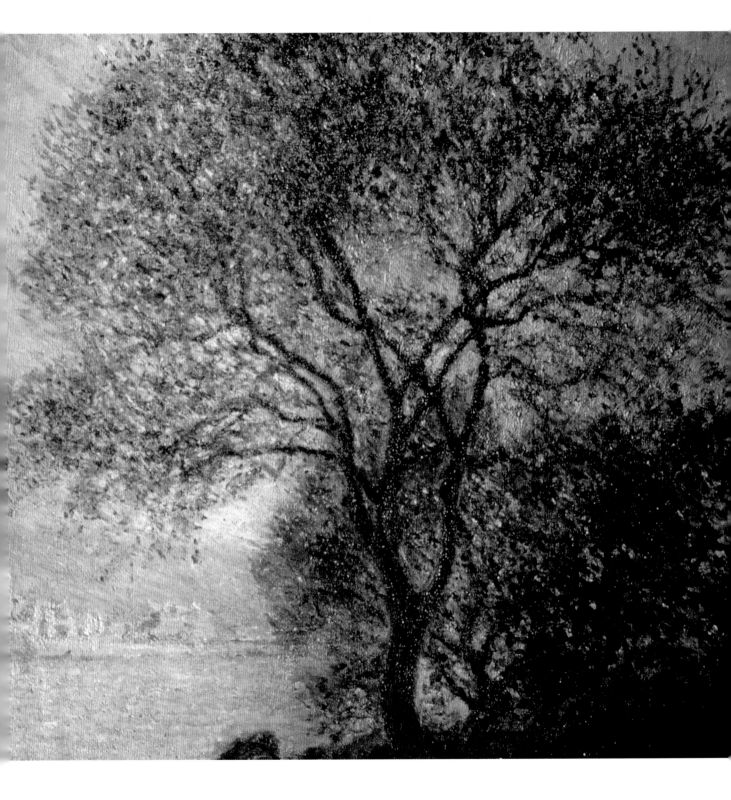

ANTIBES, VUE DE CAP,
VENT DE MISTRAL (1888)
ANTIBES, VIEW OF THE CAPE IN THE
MISTRAL WIND
Courtesy of Christie's Images

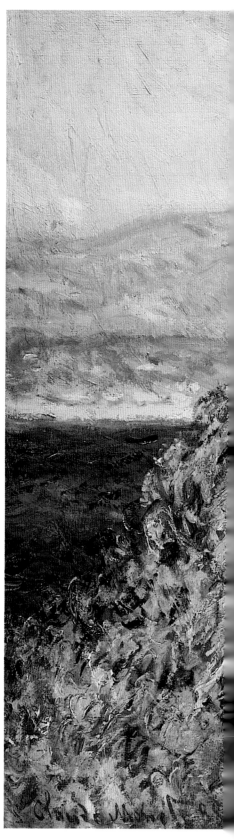

WHEN Monet arrived in Antibes, he wrote to Alice Hoschedé complaining about the difficulties that he was having capturing the unusual color of the local light. He wrote: "You swim in blue air, it's frightful."

This one is an example of the jewel-like colors he used in many of his Mediterranean paintings. The blue of the sea is almost unreal and is perhaps a symbol of what he was seeing rather than an accurate rendition. When compared with the pale sea in *Antibes, Vue de la Salis* (1888) it is even more startling. It is not allowed to dominate the painting too much by being kept in check by the bushes in the foreground. These form a horizontal line across the bottom of the work made up of yellows, greens, and pinks. The bushes are allowed to push into the band of color that is the sea and to break up its horizontal dominance. The sky, mountains, and city all form striking horizontals across the canvas. This trait is present in *Antibes, Vue de la Salis*, but the subtler colors prevent it from seeming so obvious.

Monet's palette of colors during this trip became enriched with new tones. In his earlier work he would never have used such a strong blue to represent the sea. This painting is testimony to Monet's confidence in his work.

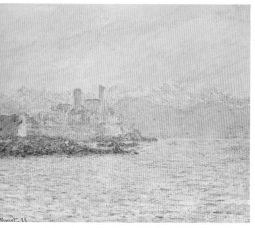

Antibes, Vue de la Salis (1888)
Antibes, View of the Fort
Courtesy of Christie's Images. (See p. 172)

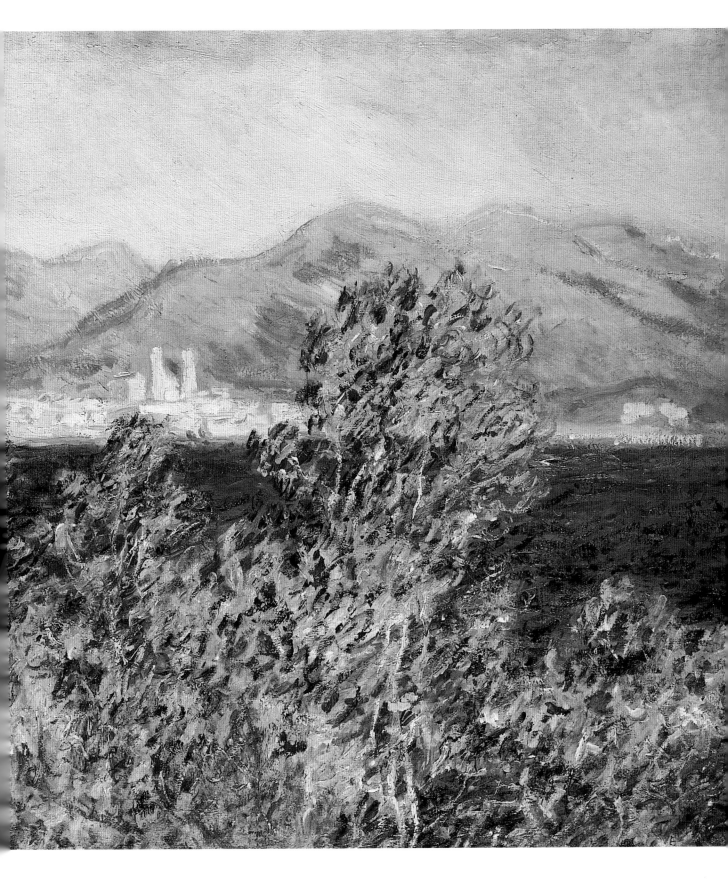

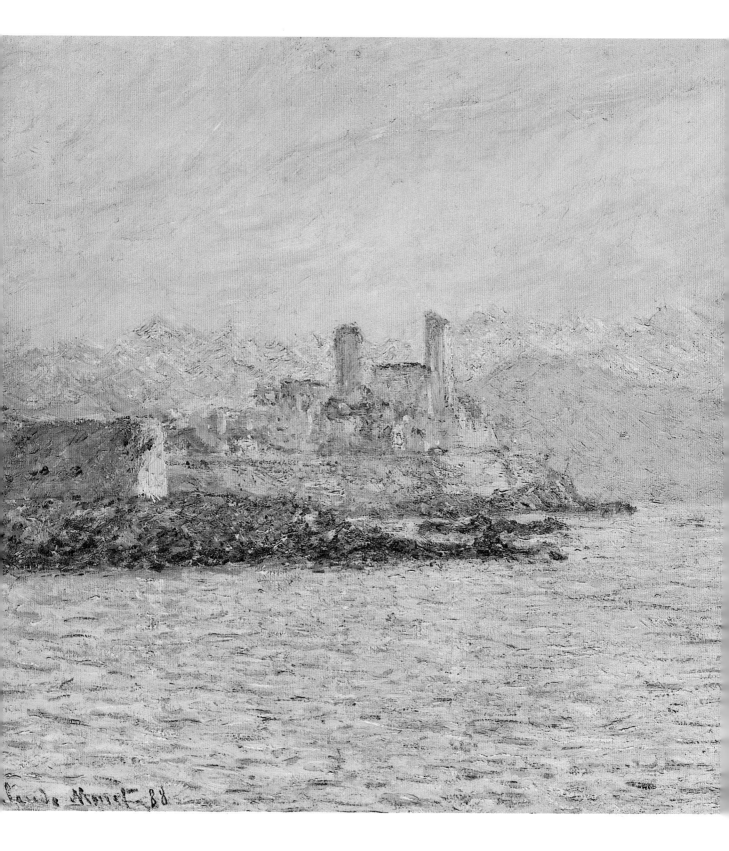

ANTIBES, VUE DE LA SALIS (1888)
ANTIBES, VIEW OF THE FORT
Courtesy of Christie's Images

MONET'S motifs are said to shift between the rough and the soft. *Antibes, Vue de la Salis* is definitely a soft subject. The colors glow with hints of gold, pink, and turquoise.

The harmonization of colors present in this painting appears again 20 years later in *Le Grand Canal et Santa Maria della Salute* (1908). The composition is also very similar. Both paintings feature a large expanse of water in the foreground, a building that appears to be floating on the water's surface and an expanse of sky above. This similarity arises from Monet's preoccupation with buildings next to water. His treatment of reflection in both works demonstrates how he was fascinated by the effect of light on a solid structure when it is placed by water. The reflection is reduced to the reflection of color rather than shape, so that the fort's reflection is created with lines of gold and that of Santa Maria della Salute becomes shimmers of pink.

The colors used in both are soft and pastel in tone. However, the Venetian work is dominated by blue and pink to the point that water, sky, and building are all represented in these colors. Antibes, *Vue de la Salis* has more variety using rose, gold, white, blues, and greens. Each part of the picture is painted as distinct from its neighbor rather than fused together.

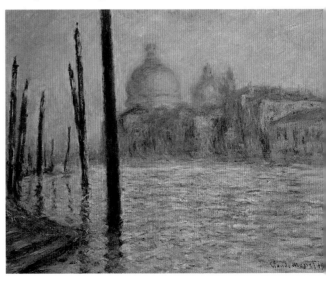

Le Grand Canal et Santa Maria della Salute (1908)
The Grand Canal and Santa Maria della Salute
Courtesy of the Tate Gallery.
(See p. 228)

PAYSAGE AVEC FIGURES, GIVERNY (1888)
LANDSCAPE WITH FIGURES, GIVERNY
Courtesy of Image Select

*I*N the second half of the 1880s, Monet returned to figure painting. He painted 16 pictures of his family between 1885 and 1889; striving to capture figures in a natural background in true *plein-air* style. Monet started trying to achieve this initially in 1865, with *Le Déjeuner sur l'Herbe*. His aim was to approach figure painting in the same spontaneous manner in which he worked on landscapes.

Monet tries to do this in *Le Déjeuner sur l'Herbe* by presenting the figures as if unrelated to each other, using strong blocks of color on the women, with little interest in shading. They are caught in the middle of an action rather than in a posed setting. In *Paysage avec Figures, Giverny* there is the same detachment between the figures. The first and second group are separated by a large space, the three figures in the foreground apparently unconcerned with each other. The viewer is positioned uncomfortably close to the first three people. This unusual angle adds to the air of spontaneity.

The colors used to signify the figures are repeated in the tones of the grass, trees, and hills in the background. Here Monet is using color to incorporate the figures as an integral part of the landscape.

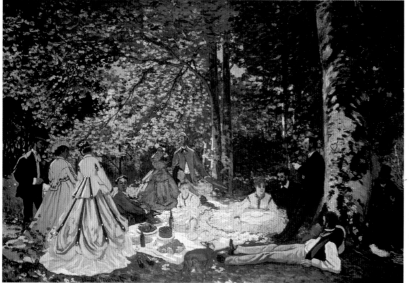

Le Déjeuner sur l'Herbe (1865)
The Picnic under the Trees
Pushkin Museum, Moscow. Courtesy of Giradoun.
(See p. 24)

CREUSE, SOLEIL COUCHANT (1889)
THE CREUSE AT SUNSET
Courtesy of Christie's Images

WHEN Monet visited the Massif Central region of France, its bleakness and savagery instantly impressed him. He decided to paint the region around the River Creuse and try to capture that barren and dramatic landscape. When he started it was winter. To his horror, while he was still working on the details of a tree, spring arrived, causing the tree to bud. Unable to cope with his subject changing into a green and leafy tree, Monet paid the owner to strip the buds off. This demonstrates that Monet was perhaps not so receptive or reactive to nature as he would have liked his public to believe.

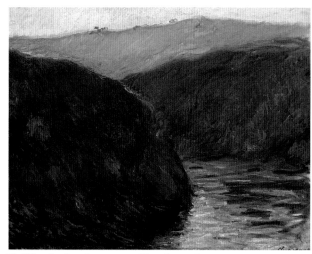

Vallée de la Creuse, Effet du Soir (1889)
Valley of the Creuse, Evening Effect
Musée Marmottan. Courtesy of Giradoun. (See p. 178)

The river and the rocks around it appear in many of the pictures of the region. This one depicts the river in the glory of a late afternoon. The effect of the light is to make the hills form a solid, dark mass against which the sky and water stand out. In contrast, the same view is cooler but allows the features of the hillside to emerge. The bleakness of the area is enhanced by the lack of vegetation, and the only source of warmth comes from the sky. This glow has gone from the hills once the sun has gone down.

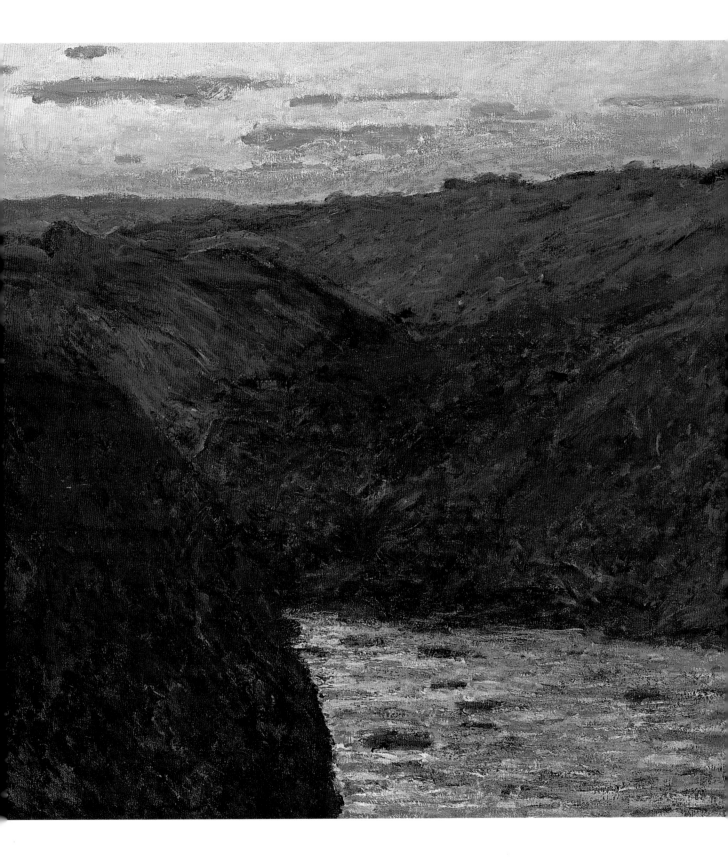

VALLÉE DE LA CREUSE, EFFET DU SOIR (1889)
VALLEY OF THE CREUSE, EVENING EFFECT
Musée Marmottan. Courtesy of Giraudon

THE barren landscape of the Creuse Valley intrigued Monet, and he sought to capture its savagery. This is in contrast to other work from the period, such as *Sur la Falaise près de Dieppe* (1897). In that painting, Monet renders a rough landscape soft. Here the Creuse is empty and cold.

The strange blue light of the evening adds to the coldness of the painting. The blue touches the hills and the water. In contrast the hills seem red. They swell up on the canvas to form imposing round forms that seem to be never-ending. The sense of infinity that surrounds them is achieved by having them stretch right across the canvas and by giving them the appearance of forcing the sky back so that only a slim strip is left. In *Sur la Falaise près de Dieppe*, the expanse of sky adds to the sense of tranquility.

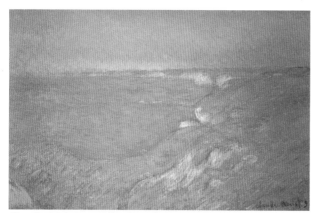

Sur la Falaise près de Dieppe (1897)
On the Cliffs near Dieppe
Courtesy of Image Select. (See p. 210)

What is interesting about the Creuse paintings is the range of effects Monet creates from the same subject. His study of different light at different times of day produced a set of pictures that come alive through the variety of colors used. Here blue has a strong presence; in others, orange, red, or purple are the dominant colors. In this way Monet maintains the interest of the viewer.

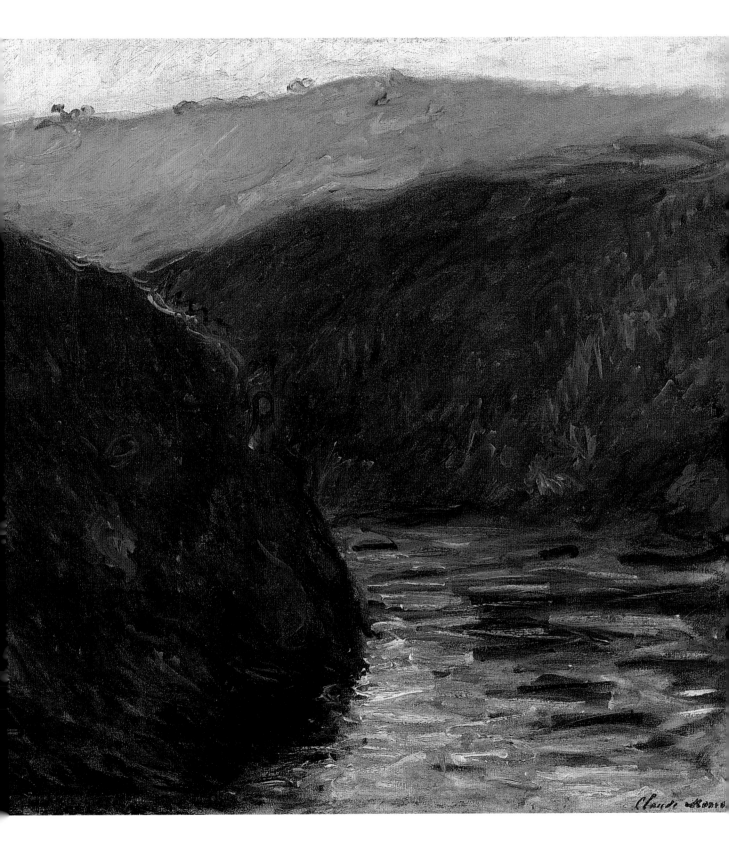

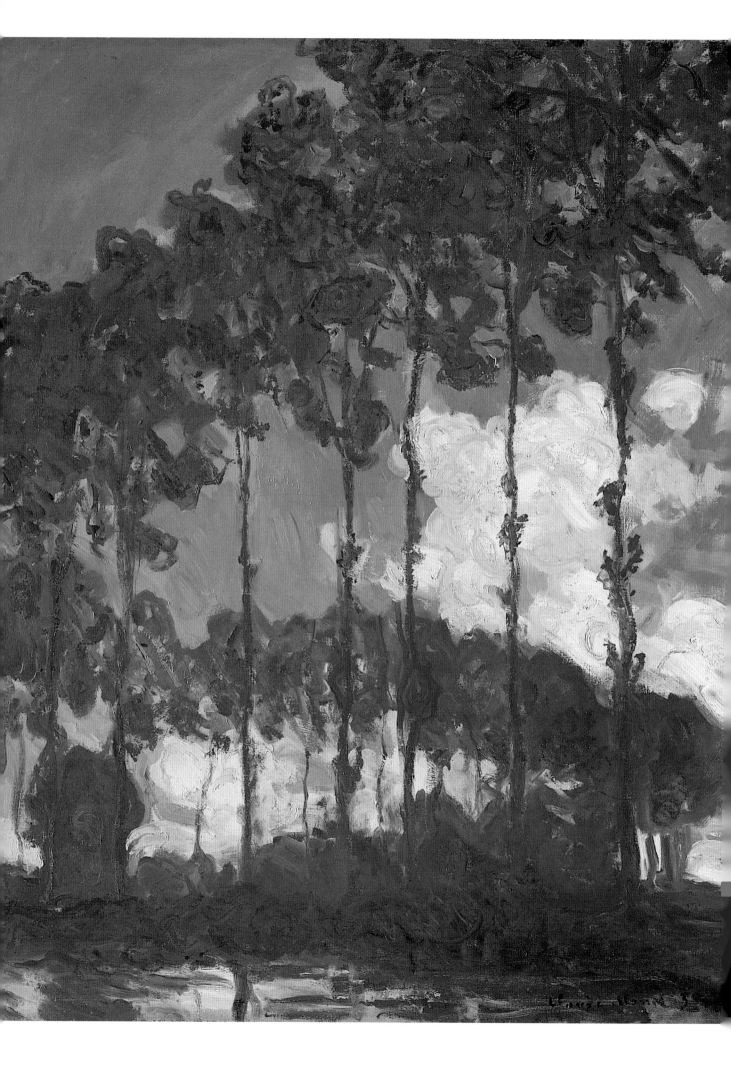

PEUPLIERS AU BORD DE L'EPTE (1891)
POPLARS ON THE BANK OF THE EPTE

Courtesy of the Tate Gallery

*A*S with the grainstack series of paintings, Monet often used poplars in his work. Like the subject of his first series, poplars were of great commercial importance to the rural community. The very trees that Monet was painting were due to be harvested for timber before he had completed the series. Monet struck a deal with the timber merchant, and together they bought them on condition that the merchant left them standing until Monet had completed his series of paintings.

Most of the 24 paintings in the series were made on board Monet's boat studio. They are painted at a point where the river bends back on itself to form an "S." Hence the double line of trees. By painting from on board his boat, Monet's vantage point is low, allowing the trees' height to be emphasized. They soar across the painting. The strong vertical trunks are contrasted by the soft curves of the leaves at the top, the billowing clouds echoing the shape of the treetops.

By painting a foreground of water, Monet creates the sensation for viewers that they are floating in the middle of the river. This has been described as a "duck's-eye" perspective. He is attempting to immerse his viewers into the landscape, as opposed to holding them back from it.

BLANCHE HOSCHEDÉ PEIGNANT (1892)
BLANCHE HOSCHEDÉ PAINTING
Courtesy of Christie's Images

IN the painting *Paysage avec Figures, Giverny* (1888) Monet uses short strokes across the canvas. The same technique is used in this picture. However, unlike the earlier painting, *Blanche Hoschedé Peignant* does not form connections between the background and the figures using similar colors. Here Blanche is in contrast with her surroundings rather than blending in.

Although there is a similar air of spontaneously catching the moment, this painting is less concerned with people as an integrated aspect of the landscape. The red of the jackets and hats on the women are strikingly in contrast to their background. However, Monet's brushwork is the same for the figures and their surroundings. Both people and trees are blurred. The face of Blanche Hoschedé is not dealt with in any kind of detail, and her hand is represented only by a dash of paint. The leaves on the trees are treated in the same way.

As in *Paysage avec Figures, Giverny*, in *Blanche Hoschedé Peignant* Monet uses two groups of people to give the painting a sense of depth and perspective. In this painting, the red clothes worn by both women forms a connection that invites the eye forward into the painting.

Paysage avec Figures, Giverny (1888)
Landscape with Figures, Giverny
Courtesy of Image Select. (See p. 174)

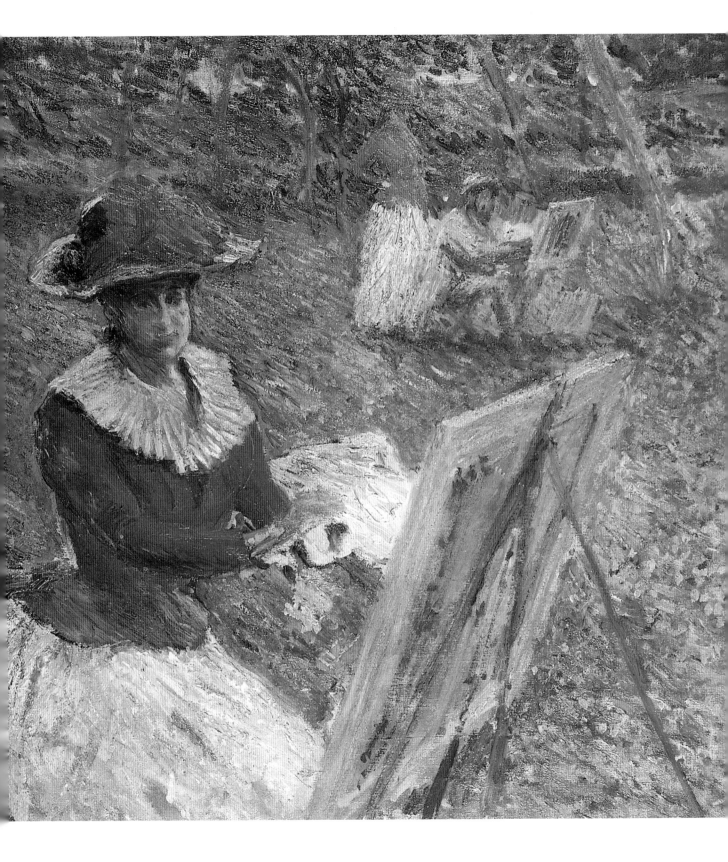

VUE DE ROUEN DEPUIS LA CÔTE DE STE.-CATHERINE (c. 1892)
VIEW OF ROUEN NEAR THE COAST OF ST. CATHERINE

Courtesy of Christie's Images

THIS work was probably left unfinished. It is not signed and it is possible to identify the outlines of buildings that Monet was obviously intending to include. However, this does not detract from the work, which is fascinating because of its choice of subject.

Monet painted very few industrial scenes in his career, preferring quieter rural landscapes or the modern buildings of cities as subject matter. In both the paintings shown on this page, the subject is modern and industrial. The paintings share a similar color palette, so that the scene has been painted with primarily dark or subdued colors. This gives the whole a somber air. *Vue de Rouen depuis la Côte de Ste. Catherine* lacks the regularity and machine quality that the men evenly spaced on the ramps provide in *Les Déchargeurs de Charbon* (1875). Each man mimics the next in posture, adding to the balance of the painting.

In the main picture, Rouen is shown from a slight distance and its smoking chimneys feature prominently. This again is unusual. Chimneys have appeared in other works by Monet, but usually they are found in the background, romanticized by shrouds of fog and smoke. Here they dominate the skyline forcing the viewer to acknowledge their presence and providing the pivot around which the industrial town is set.

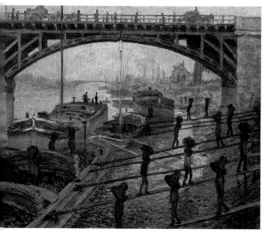

Les Déchargeurs de Charbon (1875)
Unloading Coal
Courtesy of Giraudon. (See p. 86)

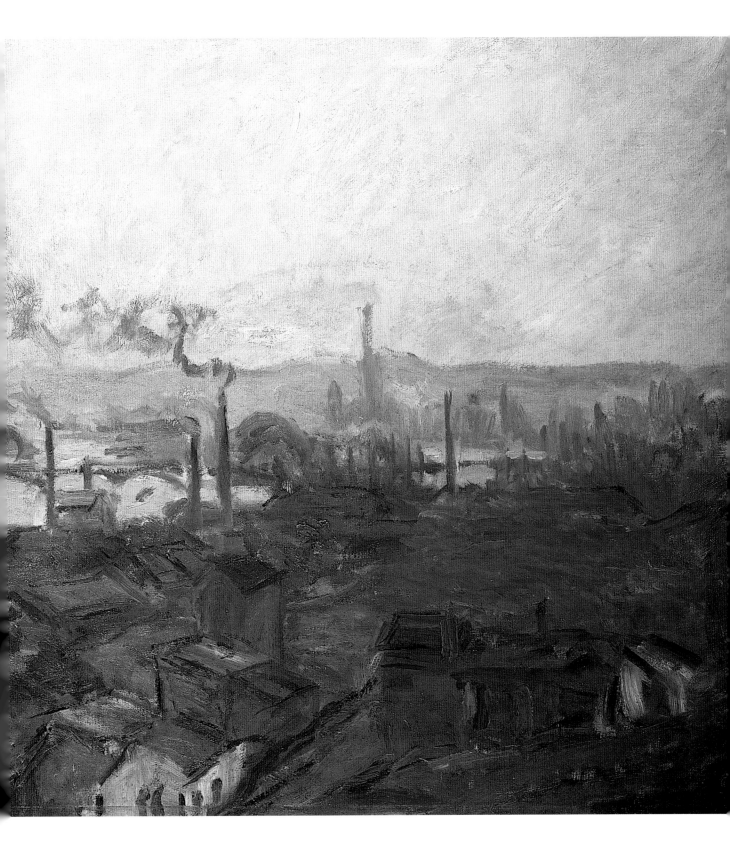

LA SEINE À BENNICOURT, HIVER (1893)
THE SEINE AT BENNICOURT, WINTER

Courtesy of Christie's Images

*I*N January 1893, the ice floes that had been carried downriver stuck at Bennicourt. Monet painted several pictures of this scene over the next few weeks, of which this was the first. At this stage the river is almost frozen over.

This view of the Seine is very different from the one that Monet was to produce four years later. In this painting Monet is still using the formula of horizontal planes of color contrasted with vertical subjects. As can be seen, the trees on the island provide the vertical balance to the horizontal bands of the sky, the hills, and the snow. In *Matinée sur la Seine, Effet de Brume* (1897) the use of horizontals and verticals is still there but in a subtler manner. The water forms one band of color but because the trees frame either side of the river, the water draws the eye forward toward the horizon rather than across along its width.

Matinée sur la Seine, Effet de Brume (1897)
Morning on the Seine, Mist Effect
Courtesy of Christie's Images. (See p. 206)

The use of color contrasts in both works. The later painting centers around different tones of blue and purple. This has the effect of harmonizing the picture. *La Seine a Bennicourt, Hiver* uses a range of colors placed next to each other to form a contrast.

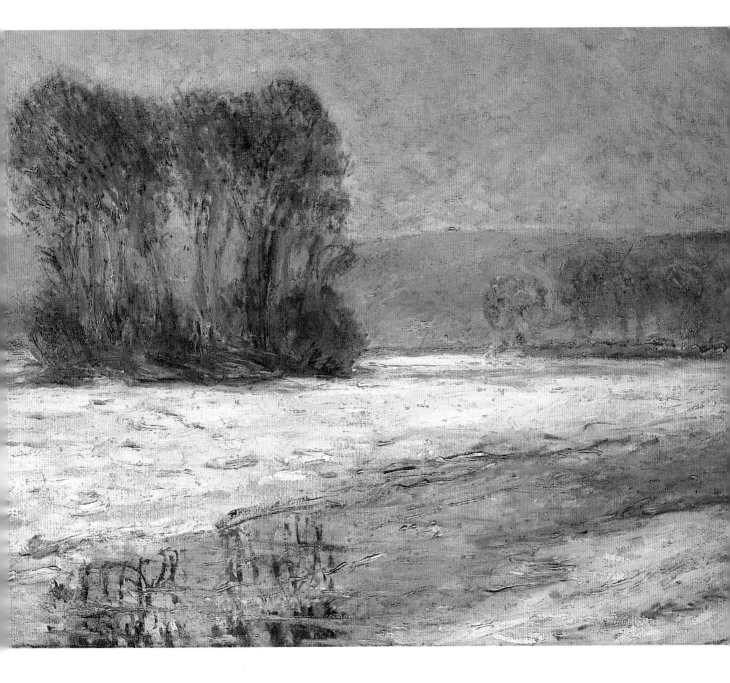

LES MEULES, EFFET DU SOIR (1884)
HAYSTACKS, EVENING EFFECT
Pushkin Museum, Moscow. Courtesy of Giraudon

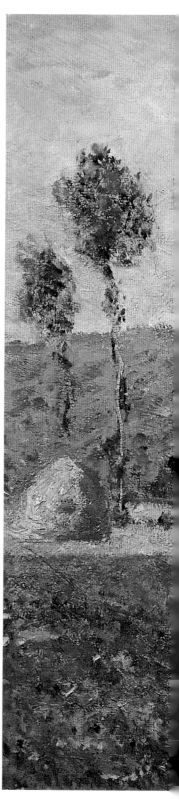

*I*N 1890 Monet began a series of paintings that had a central motif of the grainstacks. He chose to depict them at varying times of day and season, creating intimate portraits of a traditional French symbol.

This painting is a forerunner to that series, and is similar to it in many aspects. He has chosen to depict a single haystack in the foreground with a second one further away; likewise the Grainstacks series mainly concentrates on a single stack or two stacks. However, this painting has placed the haystack in a detailed background context. The viewer is not just responding to the changing colors of light on a single motif. Instead, Monet has painted a background of poplars, hills and sky that also demand the viewer's attention. The poplars would have been of equal symbolic importance to French viewers as the haystacks and are painted in as much detail.

The technique used on the grass in the foreground is also similar to that used in the Grainstacks series. Small strokes of paint are laid next to each other, in varying shades of color, in order to create an overall effect. However, although this work can be seen as a forerunner to the important Grainstacks series, it was not painted as part of a group of paintings designed to be viewed together.

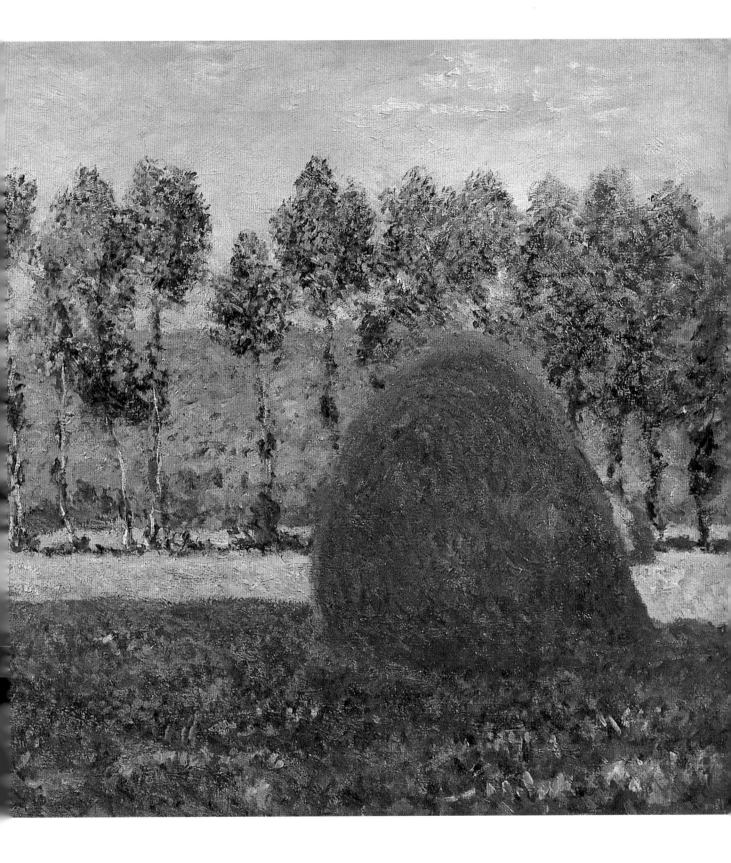

LES MEULES (1887)
THE HAYSHEAVES

Courtesy of Image Select

THIS is a contrasting view of haysheaves to many of the others that Monet painted. The angle is similar in both paintings so that the viewer is taken quite close to the haysheaves and is given an intimate view. However, these paintings do have an empty feeling to them. They are devoid of people or any evidence of them. The strange regularity of the sheaves in this work has a disquieting effect.

The primary focus of the work is the haysheaves, unlike in *Les Meules, Effet du Soir* (1884) where it can be argued that the poplars are equally as important. Here, the sheaves' triangular shape is in keeping with the geometry of the overall picture. Broad bands of color representing grass, hedge, and sky are emphasized by the lines of the sheaves. In the earlier work, the rounded shape of the stacks and the rounded heads of the poplars are a counterbalance to the lines of the trees, hills, and grass. The effect of the sun dappling across the field also helps to prevent the strength of the linearity from dominating. One of the most striking aspects of this painting is its simplicity of composition, which Monet also employed in the Grainstacks series of the 1890s.

Les Meules, Effet du Soir (1884)
Haysheaves, Evening Effect
Pushkin Museum, Moscow. Courtesy of Giraudon. (See p. 188)

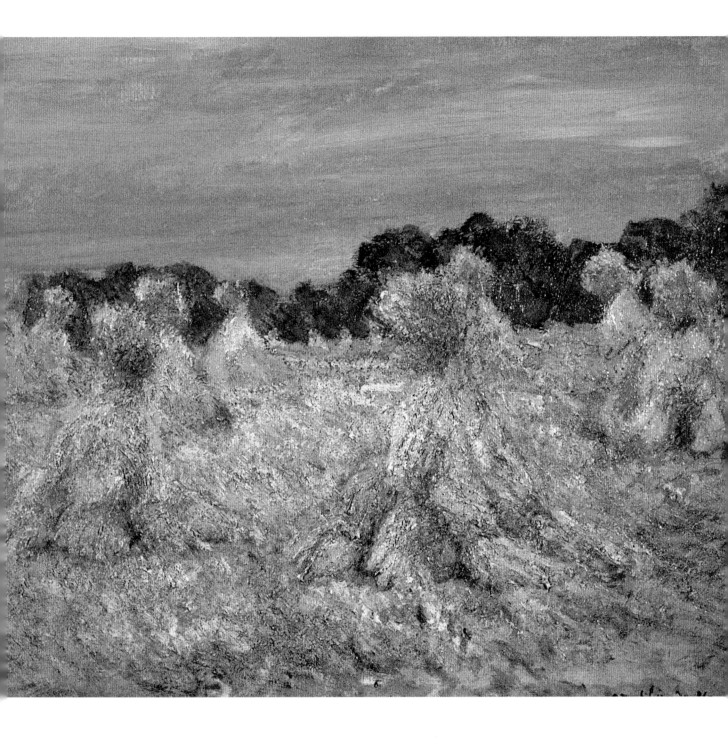

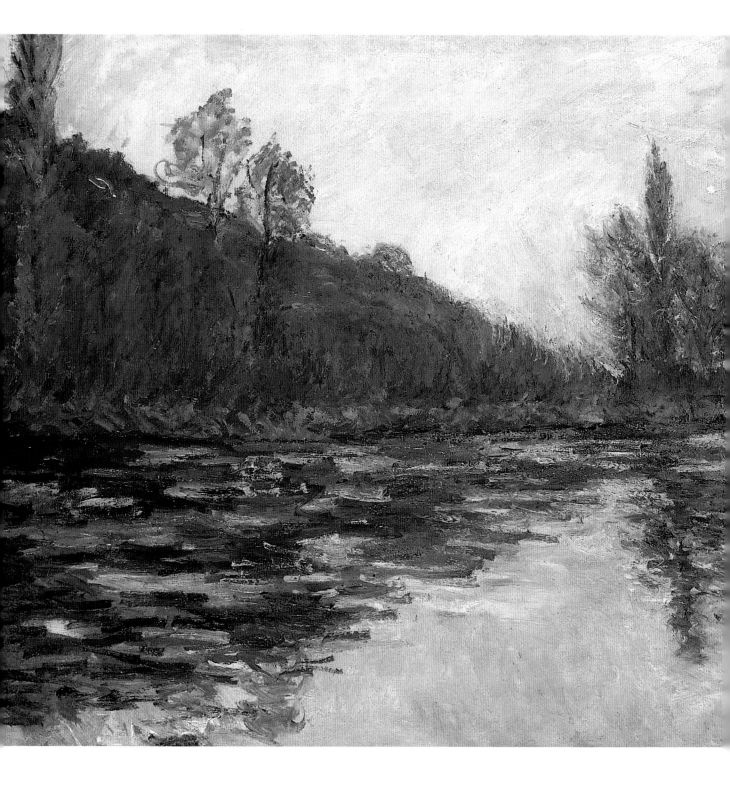

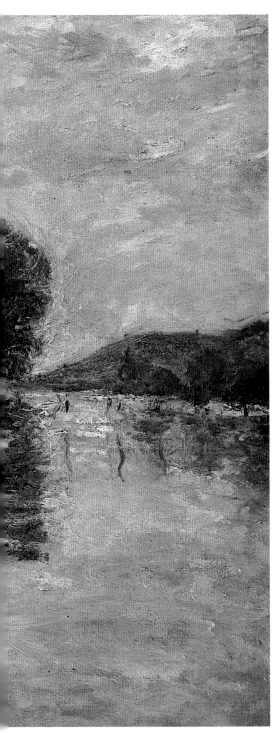

LA SEINE PRÈS DE GIVERNY (1894)
THE SEINE NEAR GIVERNY
Courtesy of Christie's Images

THE main feature of this work is the water. The viewer is on a level with the river, which flows forward, drawing the eye along its course. It fills the bottom of the canvas; in fact the water dissects the canvas virtually in a straight line. Above that line, its color is echoed in the color of the sky. A comparison of the bottom left and top left corner reveals almost identical brushwork and tone.

The land that divides the water and sky prevents them from becoming one. It is only where the land is reflected onto the water that any indication of movement on the water's surface occurs. The brushstrokes become long, horizontal lines of varying colors to indicate the ripples, in contrast to the water away from the dark reflection, where the color is almost one block of paint.

This treatment of the Seine is different from that in *La Seine à Port-Ville* (1908–09). Here there is no sense of perspective. The arrangement of water, land, and sky present in the main painting is simplified into three broad bands of color. This is broken only by the circular strokes of green for the trees, the yellow for the shore, and black strokes indicating the surface of the water.

La Seine à Port-Ville (1908–09)
The Seine at Port-Ville
Courtesy of Christie's Images. (See p. 218)

LA CATHÉDRALE DE ROUEN, EFFET DE SOLEIL (1893)
ROUEN CATHEDRAL, SUNLIGHT EFFECT

Clark Art Institute, Williamstown. Courtesy of Image Select

ROUEN Cathedral became the subject of another series of paintings by Monet, and the first to concentrate so exclusively on an architectural subject. The rationale behind his choice of Rouen Cathedral was in line with his subjects for previous series of paintings, in that it is distinctly French.

Monet's letters of the time describe the struggle he had with his subject: this series took three years to reach completion. As can be seen by comparing *Le Château de Dolceacqua* (1884), Monet has abandoned the conventions of setting and taken the viewer uncomfortably close to Rouen cathedral. Unlike the château, Monet does not paint in the entire building; only a part of the cathedral is shown. Neither painting dwells on architectural detail but aims to capture the effect of a moment. In *Cathédrale de Rouen* in particular the primary interest is the effect of light on the surface of the building. The cathedral is shown here in full sunlight, which creates a golden glow on the building.

As Monet took a year's break between painting the pictures in this series, he often painted over sections again, so the canvases have a crustation of paint on them. Some critics have found this suggestive of the actual stonework of the building.

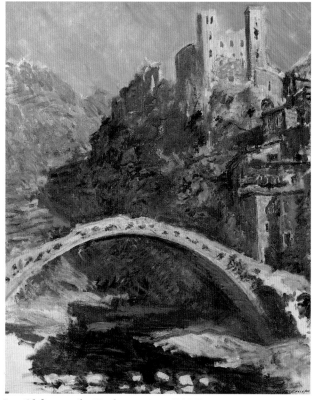

Le Château de Dolceacqua (1884)
The Dolceacqua Chateau
Musée Marmottan. Courtesy of Giraudon. *(See p. 138)*

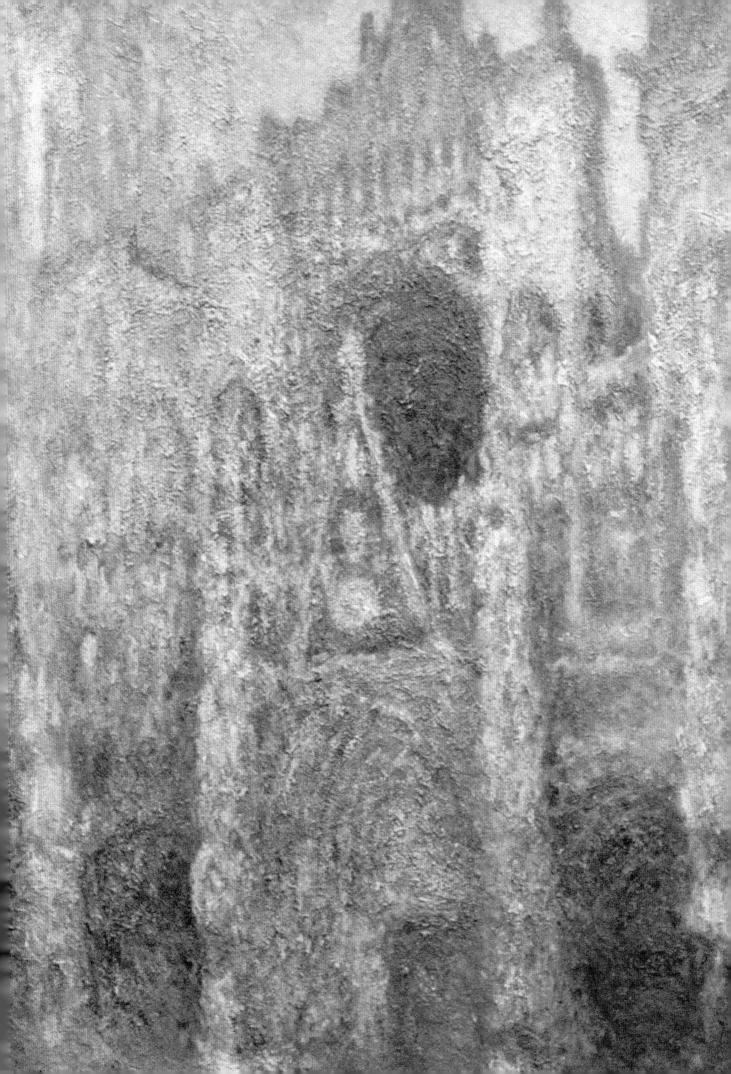

NORVÈGE, LES MAISONS ROUGES
À BJORNEGAARD (1895)
NORWAY, THE RED HOUSES
AT BJORNEGAARD
Courtesy of Giraudon

*P*ART of the commercially unsuccessful series of Norwegian paintings, both of these canvases depict snow landscapes. In contrast to *Paysage Norvège, les Maisons Bleues* (1895), this painting has a more complex arrangement. Rather than taking a viewpoint of the buildings as a part of the landscape, Monet has moved in close so that the buildings dominate the picture.

Although not as simplistic in arrangement as *Paysage Norvège, les Maisons Bleue, Norvège, les Maisons Rouges a Bjornegaard* does have a symmetry to it. The blocks of colors used on the buildings and the lack of architectural detail allow the geometric shapes to emerge from the canvas. The result is that the buildings become secondary to the pattern of squares and oblongs that they make. The redness of the walls is striking in contrast with the deep blue of the sky. Painted at a different time of day, there is little evidence of the rosiness that the sun causes in *Paysage Norvège, les Maisons Bleues*. The contrasting colors help to emphasize the geometry of the painting.

The overall effect is one of remoteness, with no human figures disturbing the white landscape. However, there is a pervading sense of calm that is shared with some of Monet's seascapes.

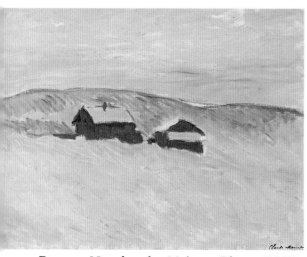

Paysage Norvège, les Maisons Bleues (1895)
Norwegian Landscape, the Blue Houses
Courtesy of Giraudon. (See p. 198)

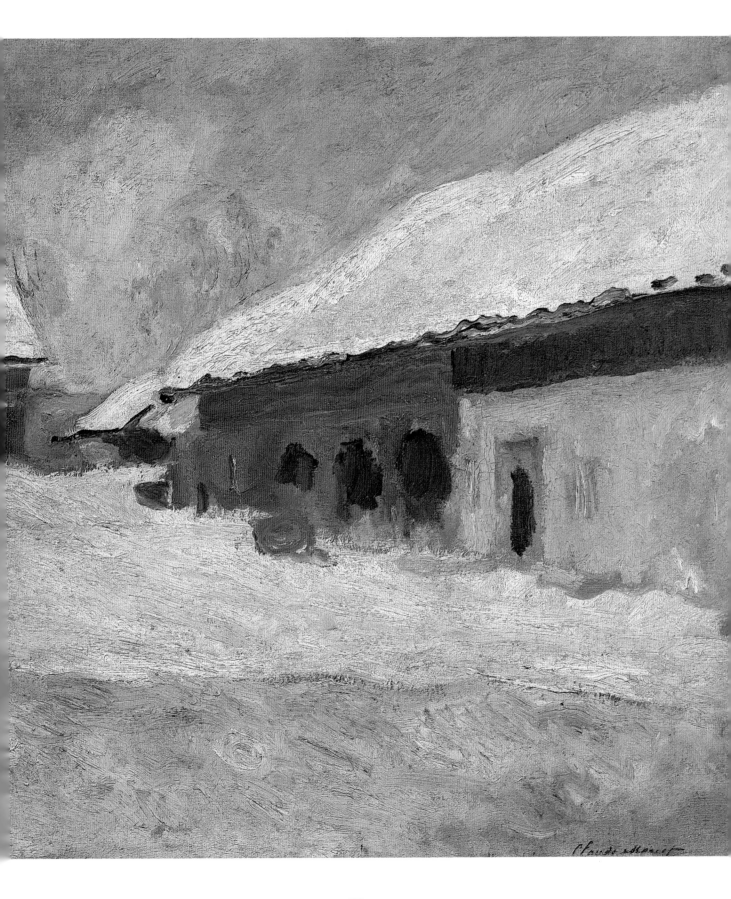

PAYSAGE NORVÈGE, LES MAISONS BLEUES (1895)
NORWEGIAN LANDSCAPE, THE BLUE HOUSES
Courtesy of Giraudon

THE simplicity of the content of this painting means that the true subject matter is the effect of the light and the snow. Monet had been looking forward to painting the snow of Norway because he found the effects of light on snow exciting. However, when he arrived in Norway he found the realities of painting snow in the northern light very difficult. The flatness of the painting is perhaps testimony to those difficulties. The snow blankets all features, making it difficult for distinct shapes to emerge.

So determined was he to capture the strange light of Norway that Monet actually painted many of these pictures in defiance of the cold, with icicles forming in his beard as he worked. In this painting, he has concentrated on showing the effect of light upon the colors of the snowscene. Hence the snow is not pure white but blue and pink, and the sky is yellow and pink. In terms of composition, the painting is reminiscent of the haystack painting of 1884.

The composition—a band of ground with houses set in the center against a line of hills and a band of sky above—is identical in both pictures. The haystacks are painted from a viewpoint closer to the subject, which gives the stacks greater prominence than the houses in the Norwegian work, but the similarity in composition cannot be denied.

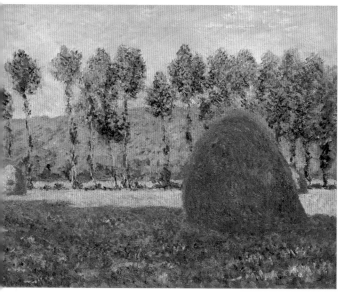

Les Meules, Effet du Soir (1884)
Haystacks, Evening Effect
Pushkin Museum, Moscow. Courtesy of Giraudon. (See p. 188)

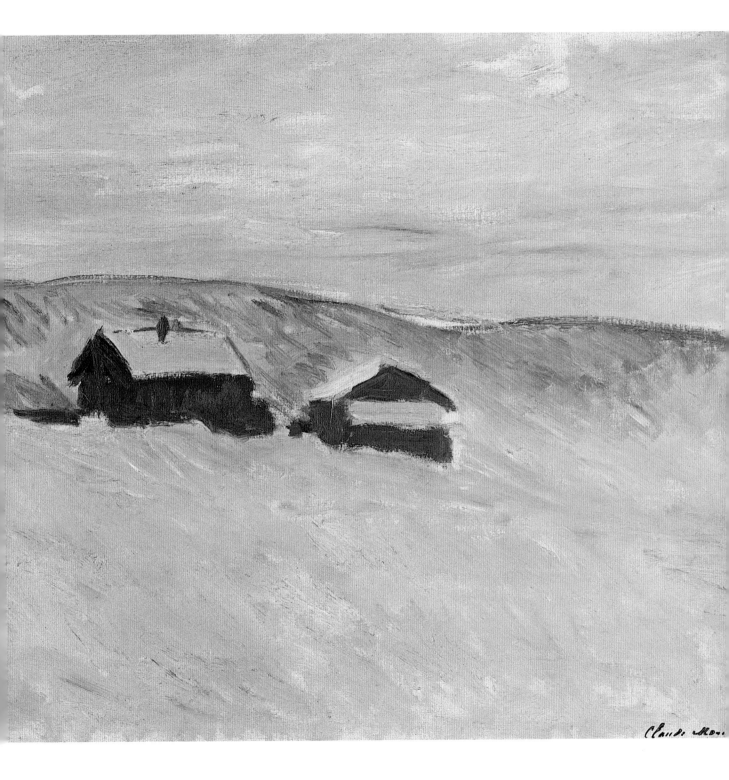

LE MONT KOLSAAS EN NORVÈGE (1895)
MOUNT KOLSAAS IN NORWAY
Courtesy of Giraudon

IN 1895, Monet decided to take a trip to Norway. His purpose was two-fold: he wished to visit his stepson, Jacques Hoschedé, who lived there; and he was looking for inspiring new subject matter.

On arriving, Monet struggled to paint the snowy scenes in the strange Scandinavian light. His problems were solved on discovering Mount Kolsaas. Eventually he painted 13 canvases of this subject, marking the different light effects at various times of day. Unlike previous series paintings, these were all painted from the same viewpoint. Despite this, the paintings are not identical in composition. This can be attributed to Monet's desire to capture the impression of the moment rather than the detail. These two paintings demonstrate how the light at different times of day makes the mountain appear with a rosy hue in the main picture and with more blue in the second image. The main painting uses more vertical brushstrokes, which create a blurred effect, whereas the smaller format image is more sharply defined.

Painted on canvases almost identical in size these Mount Kolsaas pictures are considered most powerful when displayed as a series next to each other. They then resemble a range of mountains. Although attractive, the paintings lack the complex palette of colors from previous paintings, and their non-French subject matter made them unpopular when exhibited.

Le Mont Kolsaas en Norvège (1895)
Mount Kolsaas in Norway
Musée Marmottan. Courtesy of Giraudon. (See p. 202)

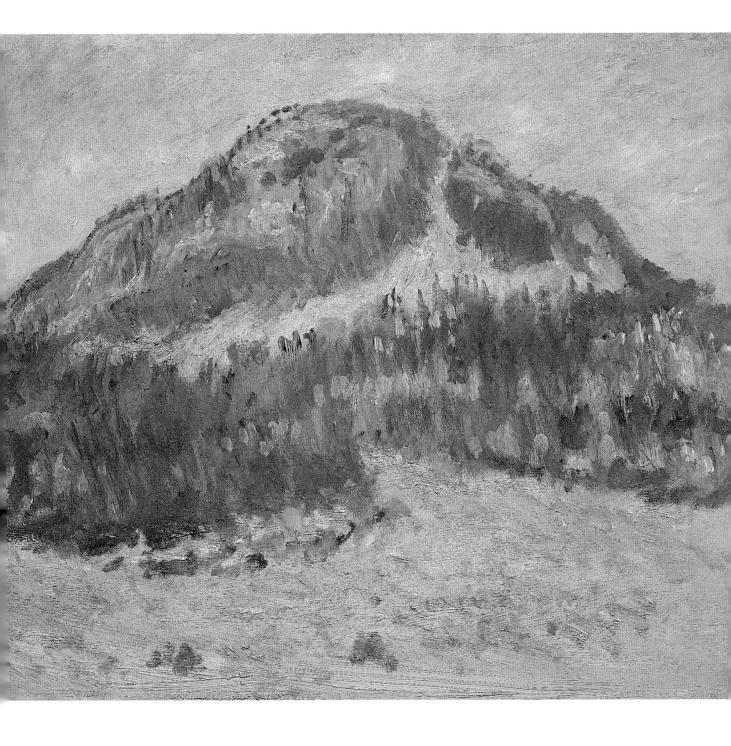

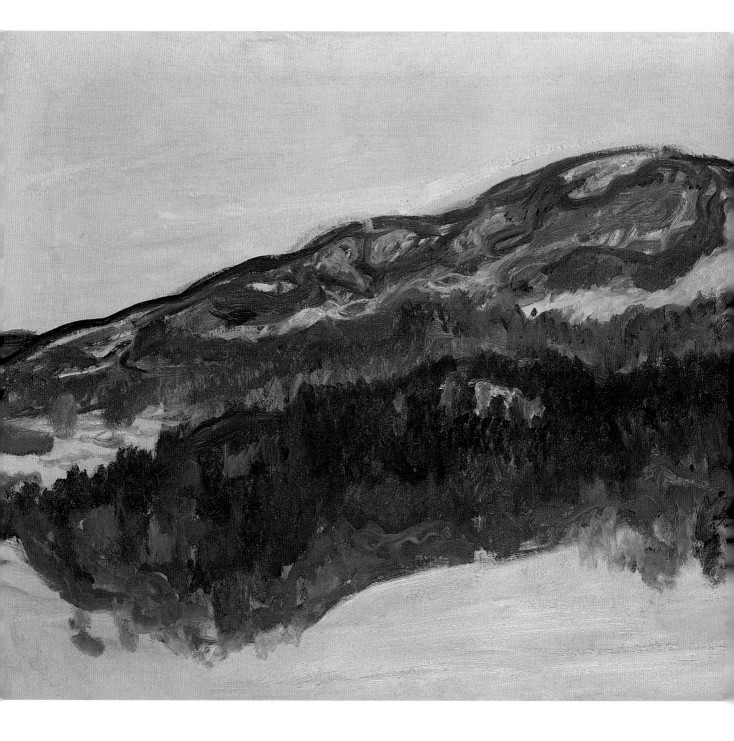

LE MONT KOLSAAS EN NORVÈGE (1895)
MOUNT KOLSAAS IN NORWAY

Musée Marmottan. Courtesy of Giraudon

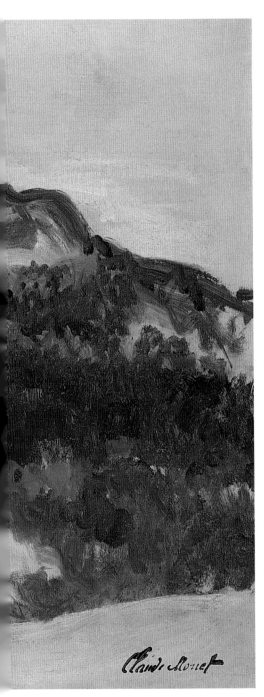

PAINTED within a year of each other, *Le Mont Kolsaas en Norvège* and *La Cathédrale de Rouen, Effet de Soleil* (1893) are each part of their own series. What is of interest here is the different approaches to the use of a single motif.

The painting of Mount Kolsaas is a more conventional composition in the sense that the viewer is placed at a distance from the subject and can see the entire mountain. To a certain extent the mountain is given a context, with sky above and snow at its base. With *Cathédrale de Rouen*, a less traditional stance is taken. The viewer is thrust close to the subject. The whole of the building cannot be seen, and little context is provided, to the point that only a small amount of sky is shown. The mountain is painted in a simpler style, comprising bands of colors that contrast and merge together at different points.

The colors used in the Norwegian picture are either placed in contrast to each other, as with the green line near the base next to the purple line above it, or whirled together, such as at the tip where violet, blue, and white merge. The whole is harmonized through either brushstrokes or color.

La Cathédrale de Rouen, Effet de Soleil (1893)
Rouen Cathedral, Sunlight
Clark Art Institute. Courtesy of Image Select. (See p. 194)

BRAS DE SEINE PRÈS DE GIVERNY (1897)
BRANCH OF THE SEINE NEAR GIVERNY

Musée Ile-de-France. Courtesy of Giraudon

*T*HE Seine, a symbol of France, features in so many of Monet's work that it became his most used motif. Between 1896 and 1897, Monet decided to use the river in a remarkable series of paintings. In all he produced 21 pictures.

What makes this series like no other is that it records the dawn on the river, moment by moment, within one period of time. Although critics had assumed this was what Monet was attempting in other series paintings, none of the previous series had been concerned with the changing light within such a tight time-frame. As can be seen in both *Bras de Seine près de Giverny* and *Matinée sur la Seine, Effet de Brume* (1897), the dawn on the river causes varying tones to appear and disappear. The former has a soft blue, almost lilac color that hangs across the whole of the painting but centralizes where the river meets the sky. In comparison, *Matinée sur la Seine, Effet de Brume* was painted a little later in the morning, when the sun begins to rise. The blue tones are beginning to disappear and the green of the trees, especially in the foreground, to emerge. On the horizon, the sky is starting to glow. Although these two paintings record changes in light that are easy to identify, the differences between other paintings in the series are less clear.

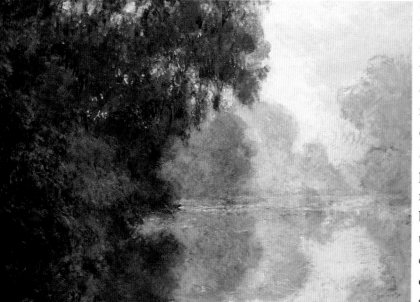

Matinée sur la Seine, Effet de Brume (1897)
Morning on the Seine, Mist Effect
Courtesy of Christie's Images. (See p. 206)

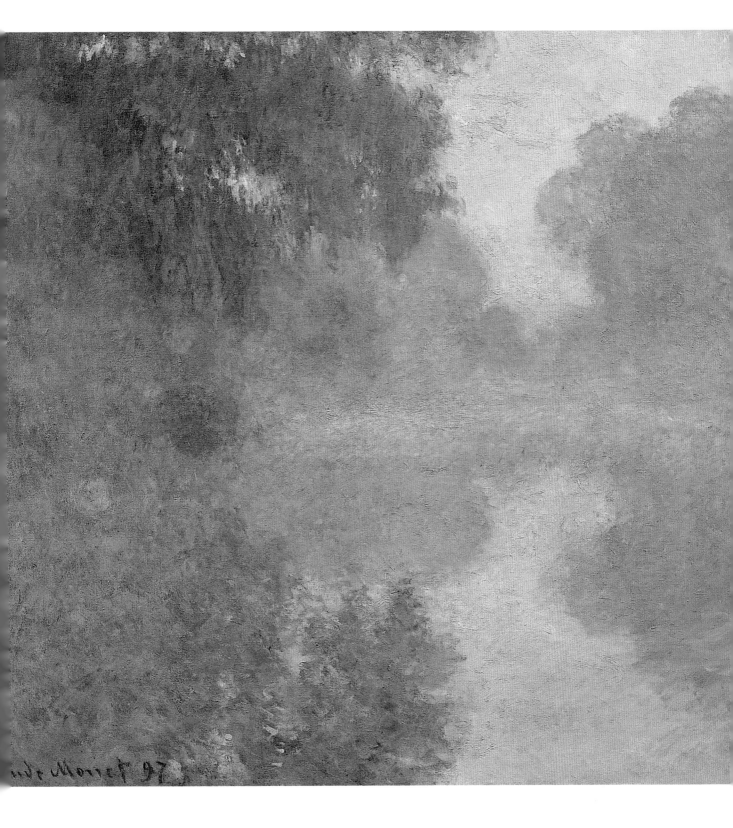

MATINÉE SUR LA SEINE, EFFET DE BRUME (1897)
MORNING ON THE SEINE, MIST EFFECT
Courtesy of Christie's Images

*M*ORE than any other of Monet's series, the Seine paintings require hanging in a specific order for viewers to be able to appreciate the subtle changes in color. Some appear to be virtually identical.

The colors used in the paintings are harmonious, and the effect created has tapestry qualities. In both these paintings the eye is drawn through the work to where the sky meets the water. This is the source of light in both paintings. In each, the sun is starting to rise, causing a rose effect in the sky and a tint to the nearest trees. The two paintings must have been painted soon after each other.

The brushstrokes used are integrated to add to the harmony of the work. The atmospheric tone of each centers around one color—blue—and how it fades slowly with the approaching sun. Here it has almost disappeared. In order to capture the progress of this light, Monet would get up each morning before dawn to work. The end results were exhibited in 1898 and received by most critics as being pictures of true quality.

Matinée sur la Seine, Effet de Brume (1897)
Morning on the Seine, Mist Effect
Private Collection. Courtesy of Image Select
(See p. 208)

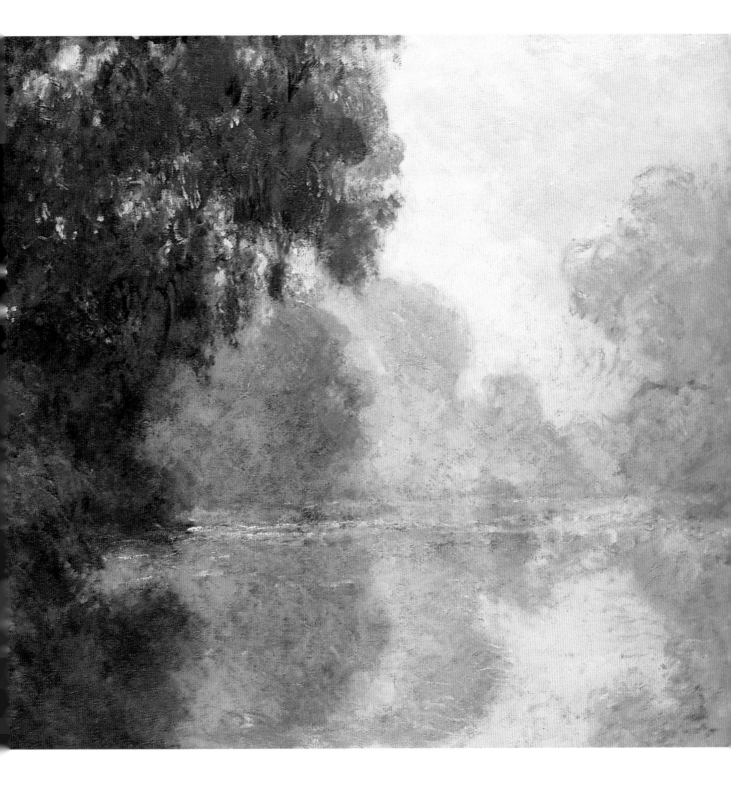

MATINÉE SUR LA SEINE, EFFET DE BRUME (1897)
MORNING ON THE SEINE, MIST EFFECT
Private Collection. Courtesy of Image Select

*T*HE effect created in the Seine series is purely decorative. The colors are manipulated from reality in order to create different combinations. This can make some of the paintings seem very pale when reproduced on the page.

For Monet, the Seine provided the challenge of capturing the changing qualities of light on water. As these two paintings show, his treatment of reflection changed over the years. In *La Seine près de Giverny* (1894), the reflection of the trees is not rendered in detail, instead it is a dark patch that is comparable to the subject only in outline. Monet uses strokes of white paint in th dark reflection to represent the effect of light on water, sparkling off the surface.

In the Seine paintings the nature of reflection has changed. The water has become a mirror image of the subject both in color and density. There is a solidity around the reflection that is missing in other work. In addition, the trees framing the water give the work an enclosed feeling that is lacking in the open landscape of *La Seine près de Giverny*.

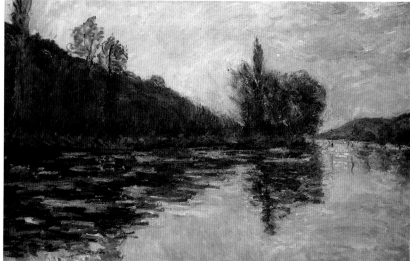

La Seine près de Giverny (1894)
The Seine near Giverny
Courtesy of Christie's Images. (See p. 192)

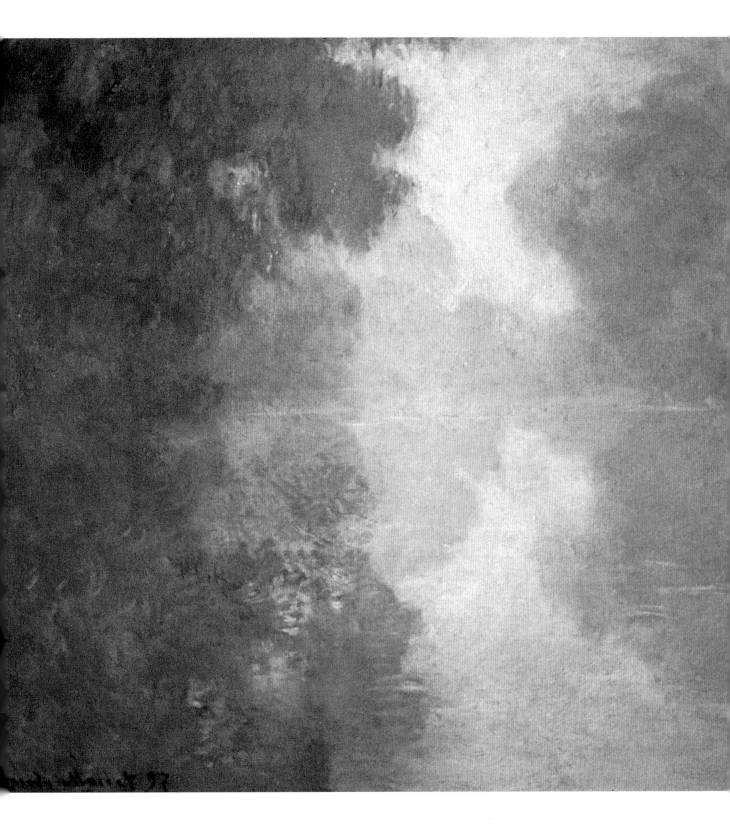

SUR LA FALAISE PRÈS DE DIEPPE (1897)
ON THE CLIFFS NEAR DIEPPE
Courtesy of Image Select

*T*HE beauty of Monet's cliff-top paintings lies in their simplicity. The basic elements are sky, sea, and land. No particular time of day can be attributed to them and so they are imbued with a timeless quality.

In this painting, it is not the strength of the sea that is on show; instead, it is a calm image that demonstrates a softer view of nature than that present in the paintings of the Creuse. In those, Monet wanted to capture the savagery of nature; in this painting he wants to depict an equally harsh landscape—but in a gentler manner. The soft curves of the cliff as it swells into the picture and gently falls into the sea are softened even further by the pastel colors that are used.

The viewpoint taken from the top of the cliff is repeated in many other paintings. In some it is used to more dramatic effect than it is here. In this way the cliff pictures are similar to some of Monet's earlier work such as *Boulevard des Capucines* (1873). His obvious interest in perspectives from higher viewpoints is still in evidence with these cliff paintings. However, the earlier work is concerned with capturing the business of a moment. Here the impression of serenity is what is most important.

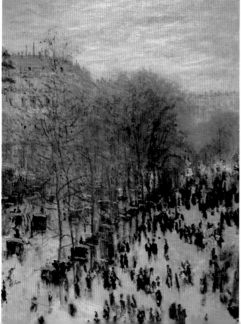

Boulevard des Capucines (1873)
Capucines Boulevard
Courtesy of the Visual Arts Library, London. (See p. 68)

210

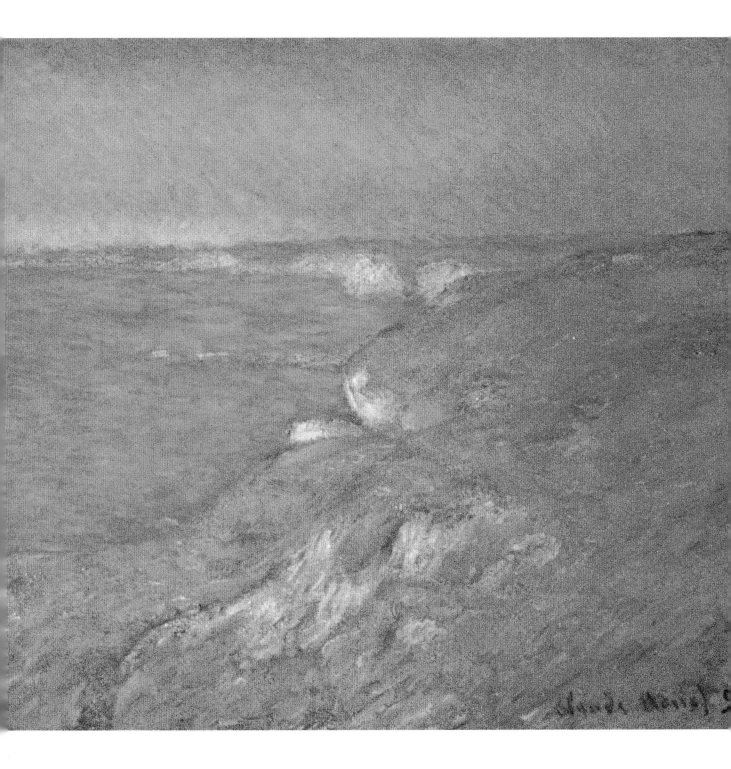

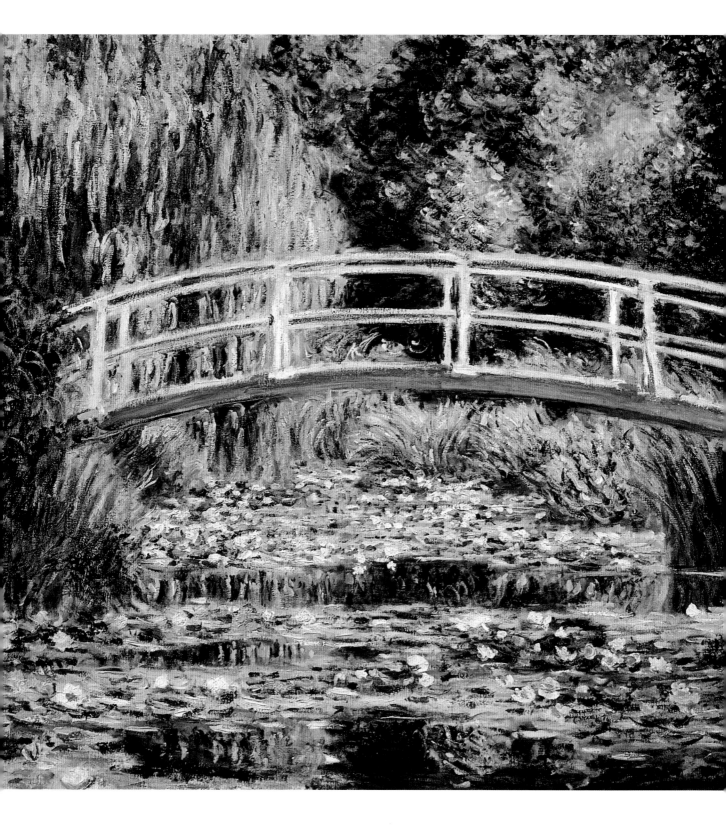

LE BASSIN AUX NYMPHÉAS, HARMONIE VERTE (1899)
WATER-LILY POND, HARMONY IN GREEN

Pushkin Museum, Moscow. Courtesy of Giraudon

*M*ONET began building his water-lily garden at Giverny in the 1890s as an oriental complement to the more traditional western flower garden that he had already designed. A keen gardener, Monet employed a team of workers to maintain the gardens even when he claimed he had very little money.

His gardens at Giverny became virtually his only subject for painting for the remaining 26 years of his life. Monet had long believed that a close relationship with nature on an almost primitive level helped to develop an individual's understanding of himself and the world around him. The Japanese were thought to be a nation that particularly understood this regenerative relationship. His choice of an oriental garden as a theme effectively underlines his beliefs.

Although the subject is distinctly un-French, the color palettes Monet chose for it are, nevertheless, quite traditional. The water draws the eye of the viewer into the distance through a world harmonized in green and blue. The serenity of the scene is derived from the subject matter and the complementary colors. In addition, balance is provided by the water that ends almost exactly at the center of the picture and reflects the foliage in the top half. The bridge spanning the pond forms a symmetrical rounded shape that adds to this balance.

LE BASSIN AUX NYMPHÉAS, LES IRIS D'EAU (1900–01)
WATER-LILY POND, WATER IRISES
Courtesy of Christie's Images

THIS painting is rich in color and tone. Some of this riot of color is present in the earlier picture *Fleurs à Vétheuil* (1881), hinting at the extraordinary use of color employed in Monet's later work. The bottom half of the painting shows a vast mixture of flowers of different colors.

By the time Monet painted *Le Bassin aux Nymphéas, les Iris d'Eau*, the flowers and foliage are dominating nearly the entire canvas. The later painting uses a wider variety of colors that clash to increase the drama. Each flower is painted with less detail but becomes a splash of color. The colors of the irises by the pond are repeated on the footpath and on the water where the lilies are. Even the sky has a tint of pink to it so that the entire area is suffused with color.

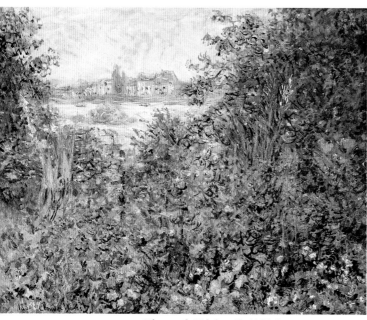

Fleurs à Vétheuil (1881)
Flowers at Vétheuil
Courtesy of Christie's Images. (See p. 122)

The earlier painting shows a view of Vétheuil, which is about to be swallowed up by the flowers and bushes. In the *Le Bassin aux Nymphéas*, the garden appears to have won the battle. Although the bridge and the footpath suggest the presence of humans, the lack of people or buildings gives the garden an air of wilderness. Only a tiny square of sky is left, and even that looks destined to be covered over by the willow. Nature in both paintings is seen as a strong force.

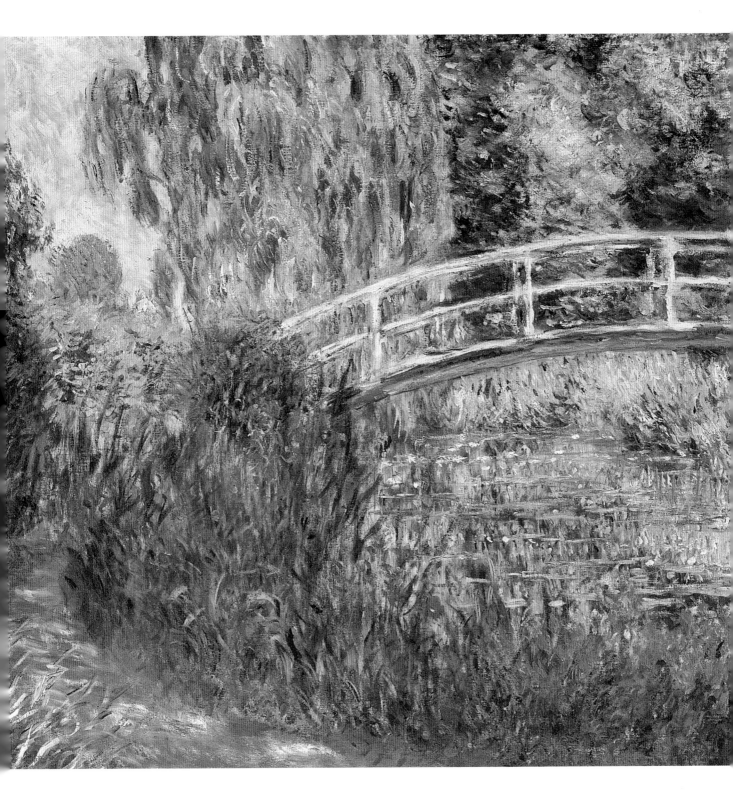

VÉTHEUIL (1901)

Pushkin Museum, Moscow. Courtesy of Topham

W HEN Monet moved to Vétheuil, he moved his family to a more rural town than they had previously encountered. Unlike their previous home of Argenteuil, there was no industry at Vétheuil and the people who lived there were mainly agricultural workers.

This rural setting meant Monet changed his approach to the subject matter. In *Au Pont d'Argenteuil* (1874), the artist celebrated the harmony of nature and industry. In Vétheuil there is no sign of industry. The town exists against a backdrop of hills. The presence of people has been reduced, in physical size: the boat is tiny and the figures unidentifiable. In many of Monet's paintings from this period people are absent altogether. The town provides the focus, the viewer's eye being led up to it by the flow of the water. The town's reflection in the water helps its presence to dominate the work; similarly, the spire of the church thrusts up into the sky. The town is equal to all elements. In *Au Pont d'Argenteuil*, the bridge forms a dominant line across the canvas and, in the foreground, a woman and child are depicted taking a leisurely walk. The scene in *Vétheuil* is restful, with the water calm and the boat helping to break up its expanse. The colors here are muted and warm, with none of the cold, gray tones found in *Au Pont d'Argenteuil*.

Au Pont d'Argenteuil (1874)
The Bridge at Argenteuil
Courtesy of Image Select. (See p. 83)

LA SEINE À PORT-VILLE (1908–09)
THE SEINE AT PORT-VILLE

Courtesy of Christie's Images

THIS painting represents Impressionism taken to the borders of Abstract art. The whole view has been simplified around three bands of color; the sea is turquoise, the land purple, and the sky a very pale blue. Against these, details, such as the boat on the shore, are added without any attempt at complexity.

The surface of the water is indicated by irregular brushstrokes and the occasional black line. Similarly, the trees are represented by swirls of green, brown, and yellow. Some similarities in technique can be seen in *Antibes, Vue du Cap, Vent de Mistral* (1888), in which the sea is a broad band of color, with the town, mountains, and sky beyond. The sea in both has been painted with a strong color, but in the earlier picture Monet has detailed the town and mountains more clearly than in Port-Ville. In addition, he gives the viewer some sense of depth to the painting by including the tree in the foreground.

Antibes, Vue du Cap, Vent de Mistral (1888)
Antibes, View of the Cape in the Mistral Wind
Courtesy of Christie's Images. (See p. 170)

In *La Seine à Port-Ville* there is no clear indication of time of day or season, but the weather is clear and the sky is blue. With the Antibes work, however, Monet took great care to record the sunlight on the hills and the wind in the trees. His representation of nature is strongly conventional in comparison with the Port-Ville painting.

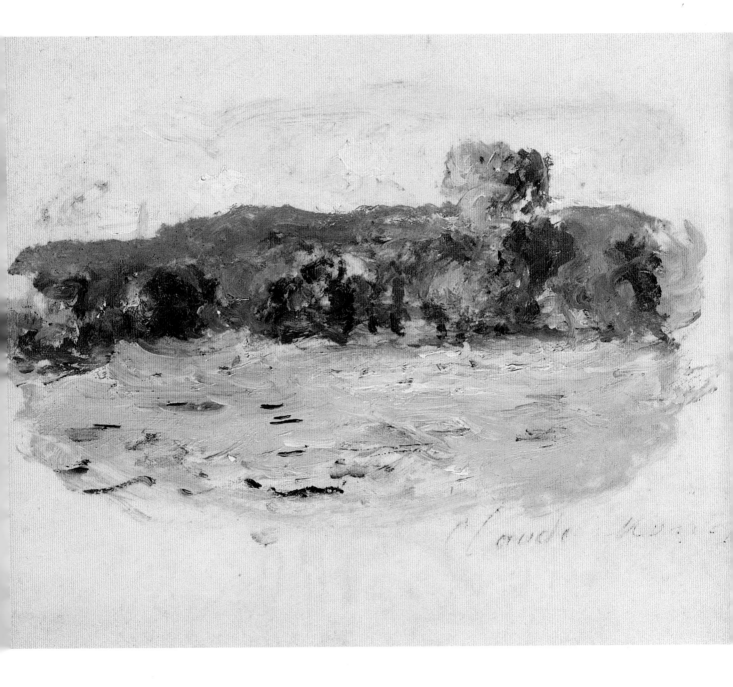

WATERLOO BRIDGE (1902)
Courtesy of Christie's Images

THE mirage quality of the bridge in this painting is taken to the point where it virtually disappears from view. The ethereal quality of the painting can be explained partly by the London fog; Monet was attracted to the constantly changing light that it created. The painting is an example of Monet trying to capture what he referred to as the "envelope" of light that seeps from the subject and surrounds it, giving movement to a static object. He struggled to understand the ever-changing effects that the London climate created.

Here, there is a shroud of romance around the familiar landmark. The boatman in the foreground adding to the sense of mystery, and the bridge shimmers in the background as if it is in close danger of disappearing altogether. Reality tempers the romance in the form of the smoking chimneys just visible in the background. The bridge itself is reduced to a silhouette. The eye is automatically drawn to the boat, which is highlighted by a patch of lighter yellow and white flecks on the canvas.

The real subject of the painting is not the bridge but the fog and the way in which it constantly changes the landscape around it, so that at one moment one area is given prominence, at the next another.

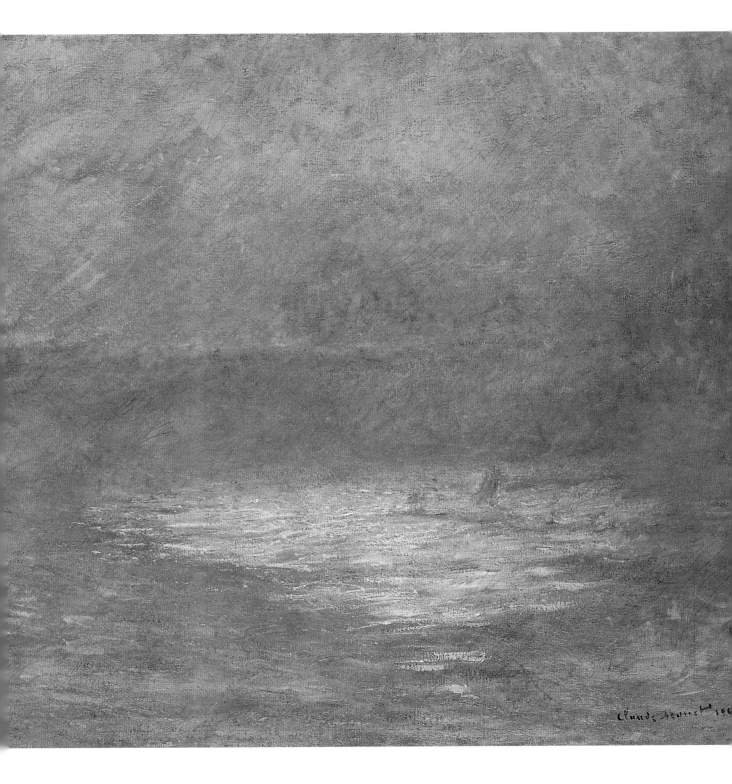

CHARING CROSS BRIDGE, LA TAMISE (1903)
CHARING CROSS BRIDGE, THE THAMES
Courtesy of Christie's Images

*P*AINTED during Monet's second trip to London, this picture is in the same style as the others produced around this time. The London fog is used to distort colors and cloud buildings so that only outlines appear. It reflects the color of the sun across the whole of the painting so that the canvas is transfused with a pink glow.

The unreal quality that the fog gives the painting is similar to that created in some of the water lily paintings. As with *Nymphéas* (1903), the water lilies often appear as if they are hovering over the canvas. There is no reflection in the water, and their presence is not put into any context. *Charing Cross Bridge, La Tamise* clearly has a context in that the Houses of Parliament are recognizable landmarks, but their ghostly appearance does not give them a solid presence in the painting. The trains crossing the bridge are equally as insubstantial, represented purely by plumes of smoke.

The difference between the two works is that

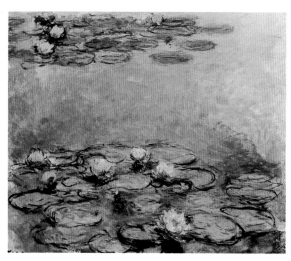

Nymphéas is an intimate painting that forces the viewer close to the subject. *Charing Cross Bridge, La Tamise* lacks that intimacy because it is painted from an obscured distance.

Nymphéas (1914–17)
Water Lilies
Courtesy of Christie's Images. (See p. 234)

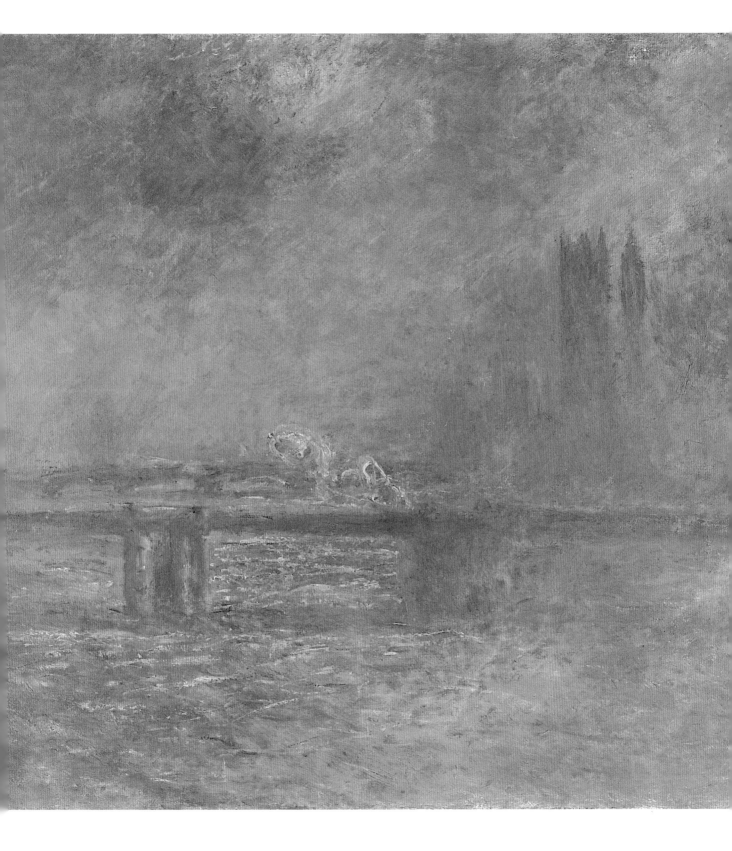

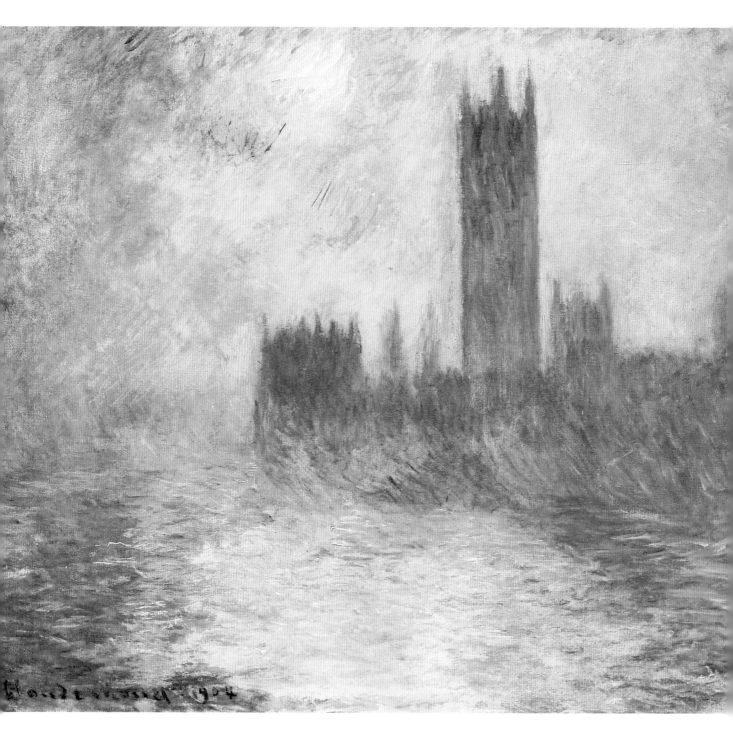

LE PARLEMENT, COUCHANT DE SOLEIL (1904)
THE HOUSES OF PARLIAMENT AT SUNSET
Courtesy of Christie's Images

THIS image was among the most controversial subjects from Monet's London trip, because J.M.W. Turner (1775–1851) had, prior to Monet, successfully painted this among his London scenes. By choosing London as a subject and including in the series landmarks already painted by such an acknowledged master as Turner, Monet was deliberately laying down a challenge. He wanted to prove that his method of painting was the superior.

Monet undoubtedly admired Turner's work and was influenced by him, but he felt that art had moved since his time. His London paintings have also been compared to James Whistler's (1834–1903) *Nocturnes* (subsequently accepted as groundbreaking art although at the time of their creation, they received a mixed reception). Monet had been friendly with Whistler and was, therefore, familiar with his work.

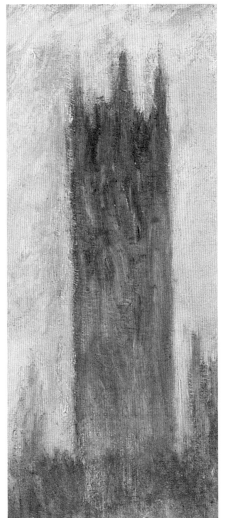

Here Monet is concentrating on the cumulative atmosphere created when architecture is placed near water and suffused with an eerie light. The Gothic spires of the Houses of Parliament have almost succeeded in piercing through the fog, but they are still reduced to a vague image that does not create a strong reflection in the water. The sun and its reflection cast a warm glow upon the scene and provide two focal points; one at the top of the painting and another at the bottom. The whole work adheres to Monet's aesthetic principles of being pleasing to the eye.

GONDOLE À VENICE (1908–09)
GONDOLAS IN VENICE

Musée des Beaux Arts, Nantes. Courtesy of Giraudon

*T*HIS is an unfinished piece of work and it is possible to trace the shadowing of outlines for the gondola beyond the finished end. In this unfinished state it lacks the harmony of the completed *Le Grand Canal et Santa Maria della Salute* (1908).

The gondola and water are painted, like the finished work, using mainly greens and blues, but the tones are much darker, giving the painting a moody air. The patch of purple that represents another boat helps to lift the atmosphere slightly. The reflection of the gondola in the water is painted simply as a dark patch. As with *Santa Maria della Salute*, Monet is not interested in painting a water surface that reflects like a mirror. The water itself has been treated differently in the two paintings: the finished work uses short, horizontal strokes in a variety of colors, which help to capture the movement of the water and the varying colors. In *Gondole à Venice*, the water is painted horizontally again, but with long swirls of paint that represent the reflections. The rest of the water, where painted, is created from one color laid on the canvas in a variety of directions.

Although it is hard to judge from an unfinished work, it would seem that Monet was trying out a different style in this painting from his earlier Venetian subjects.

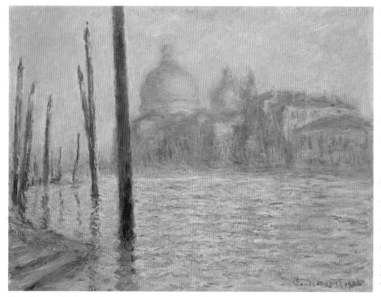

Le Grand Canal et Santa Maria della Salute (1908)
The Grand Canal and Santa Maria della Salute
Courtesy of the Tate Gallery. (See p. 228)

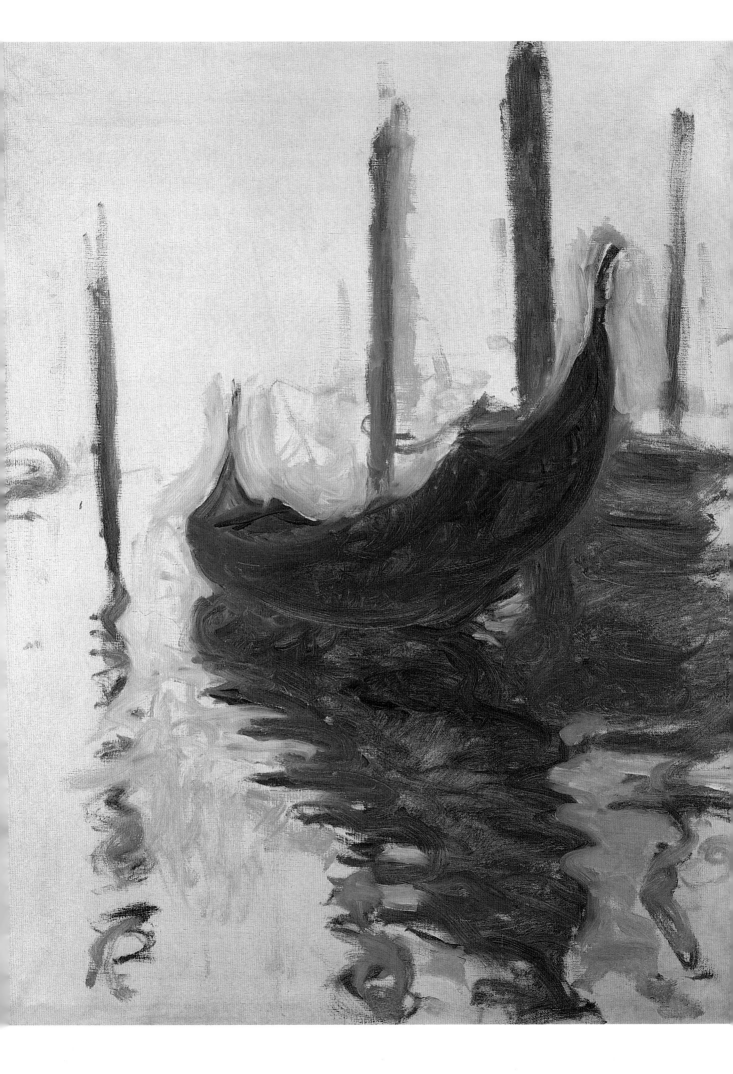

Le Grand Canal et Santa Maria della Salute (1908)
The Grand Canal and Santa Maria della Salute

Courtesy of the Tate Gallery

MONET visited Venice for the first time in 1908. Staying with a friend of the artist John Singer Sargent (1856–1925), Monet was inspired by the magical effects of the light. It is surprizing that he had not visited Venice before, as with its unusual combination of water, architecture, and sky it had all the elements Monet often sought in his work.

Venice has proved fertile ground for artists stretching back across the centuries, but Monet was not interested in recording the city in a conventional style. He was more concerned with the effects of light on the buildings. In this picture the architectural details of the Santa Maria della Salute are reduced to outlines. The strong lines of the edges of the building create a vertical and horizontal grid in the right-hand corner. The vertical lines of the painting are emphasized by the gondola poles rearing out of the water and reaching for the sky.

Painted from the center of the canal, Monet has thrust the viewer on to the water with very little land to act as a boundary. Santa Maria della Salute seems to be floating on the water, an effect furthered by the water reflecting greens and blues on to the side of the building and the white of the stonework reflecting back down on to the water.

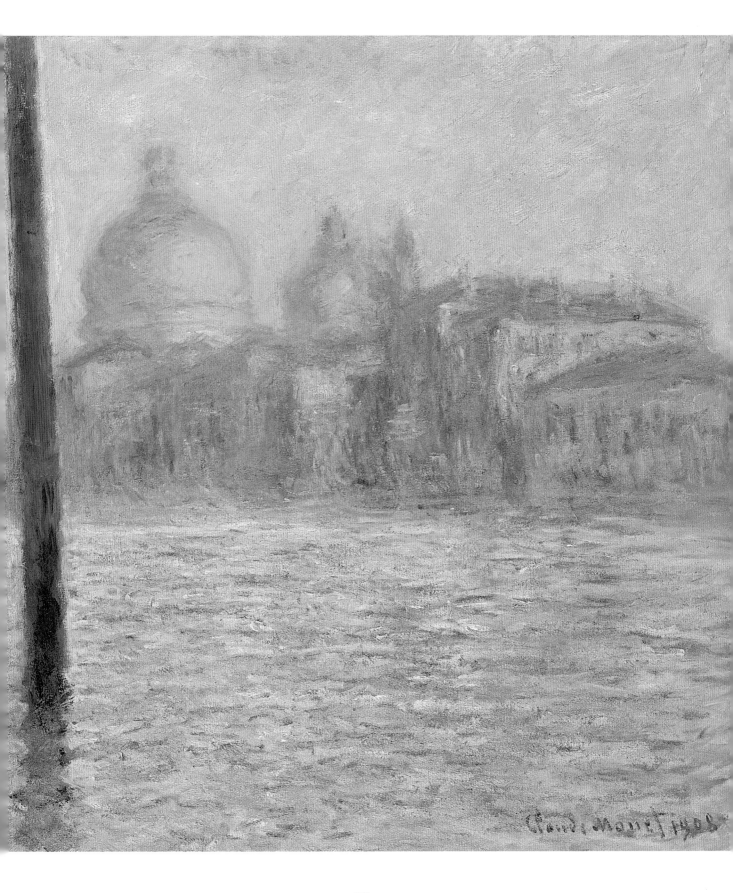

LE PALAIS DE MULA (1908)
VENICE, PALAZZO DA MULA

National Gallery, Washington, D.C.. Courtesy of Image Select

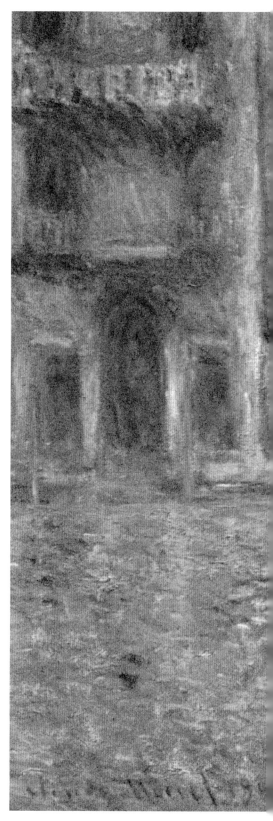

AFTER the close intimacy of Monet's garden paintings from Giverny, these dramatic pictures from Venice mark a return to painting on a monumental scale. This extraordinary work confirms that Monet's main interest was the effect of light. Traditionally the *Palazzo da Mula* would have been depicted in all its glory as the primary focus of a painting, with its architectural details accurately recorded. Here, Monet has dispensed with this notion; the building has been cropped short so that the top floors are not shown and, by removing the sky and showing only part of the palazzo, he has disassociated it from its surroundings. The horizontal and vertical lines of the architecture provide him with a grid which he deconstructs. By focusing on the relationship between the colors of the water and the colors of the building, Monet has made the palazzo a part of nature rather than being apart from nature.

Some critics have found elements of abstract design in this painting. The emphasis on the grid work of the building and the fading away to nothing of the actual details of the stonework has led them to connect this with work by more established Abstract artists.

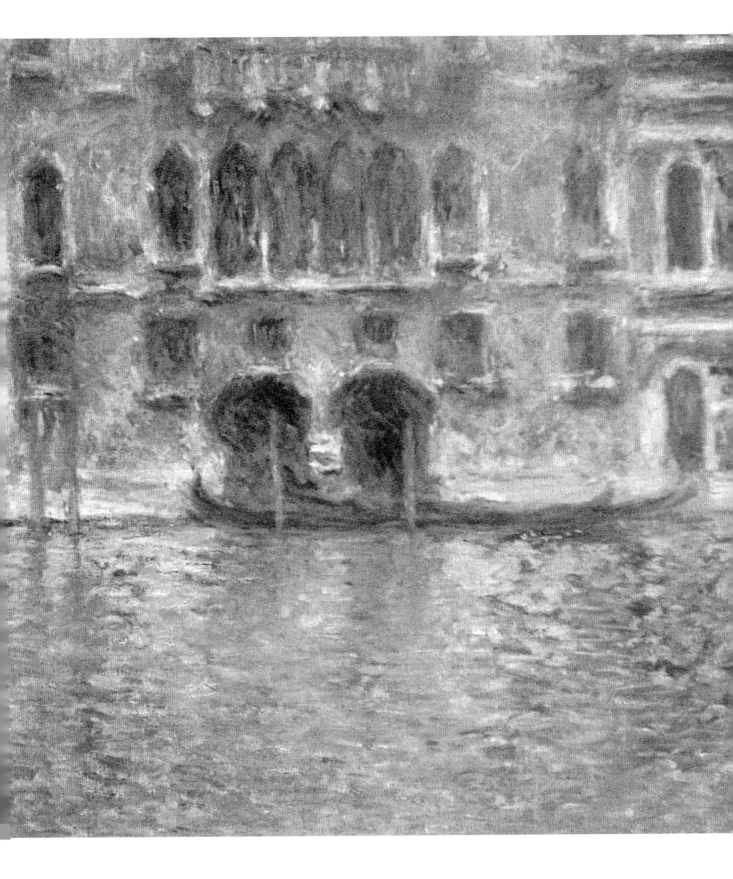

NYMPHÉAS (1907)
WATER LILIES
Courtesy of Christie's Images

*T*HERE is a sense of suspension about many of the water lily paintings, particularly those that depict water without land or sky above it, as both these paintings do. The viewer is suspended in this strange place where surroundings have been dispensed with and all that remains is the world of water.

The 1907 painting is a prime example of this world of water. The reflection of clouds can just be made out, and what appears to be the reflection of willow trees appears on the left and right. However, by filling the canvas entirely with water, the planes of the water and of the canvas have become one. The water lilies are carefully laid on the canvas in horizontal lines in both this picture and the later *Nymphéas* (1914–17).

Both the 1907 and the 1914–17 paintings are intimate to Monet because they not only represent his own private garden but also his peculiar vision of that garden. By having a subject that is so intimate,

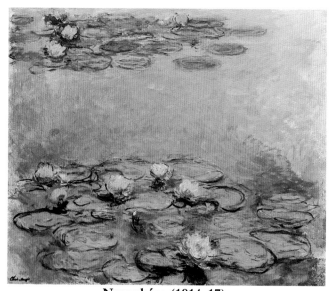

Monet pulls the viewer into sharing his own experience. The brushstrokes in the later works become progressively broader, which was primarily a result of his failing eyesight.

Nymphéas (1914–17)
Water Lilies
Courtesy of Christie's Images. (See p. 234)

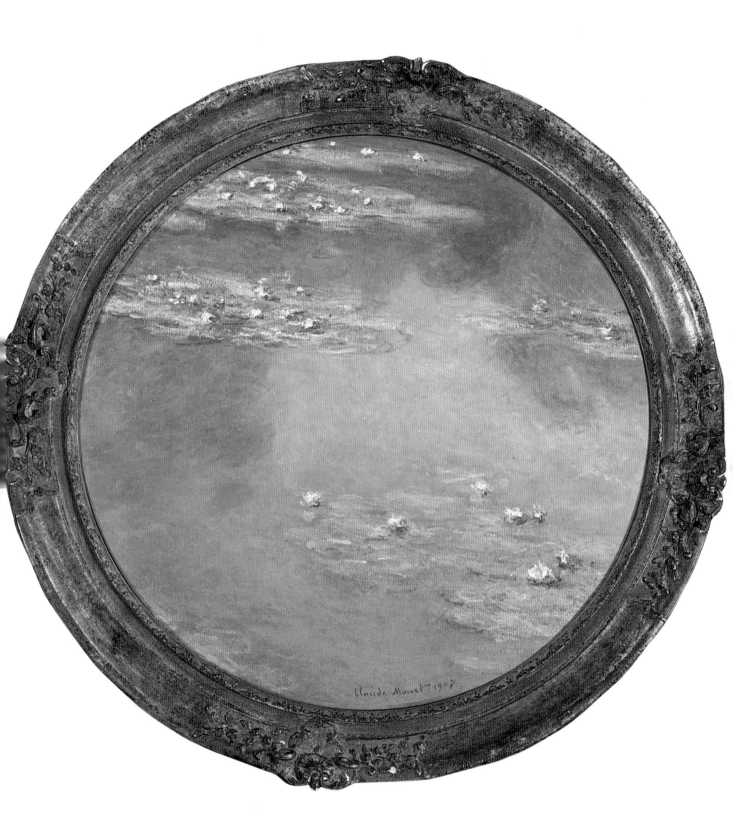

NYMPHÉAS (1914–17)
WATER LILIES
Courtesy of Christie's Images

PRIME Minister Clemenceau had always been a loyal supporter of Monet's work. In 1914 he urged the artist to work on a larger project, which became a formal state commission in 1916. This was for a set of large canvases depicting water lilies that would be displayed together permanently. Between now and his death this was to be the main preoccupation of Monet's work.

The paintings were destined to be hung in two basement rooms of the Orangerie in Paris. The paintings were hung together all the way around the two oval rooms so that the viewer was completely surrounded by Monet's water lilies. This style of painting extends the experience the artist has had with the subject out to the viewer. It was the ultimate resolution of all of Monet's series work.

A comparison between this intimate painting and the earlier *En Promenade près d'Argenteuil* (1875) demonstrates how far Monet's style had changed. The earlier landscape is open, balanced, and keeps the viewer at a distance. The use of horizontals is common to both paintings but *Nymphéas* forces the viewer close to the subject so all that is visible is the flower in a background of water. Nothing else exists.

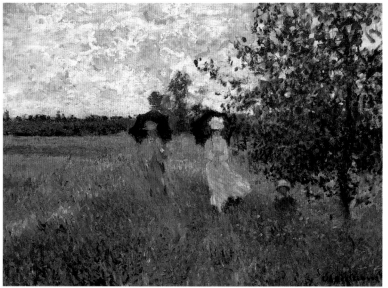

En Promenade près d'Argenteuil (1875)
Walking near Argenteuil
Courtesy of Giraudon. (See p. 92)

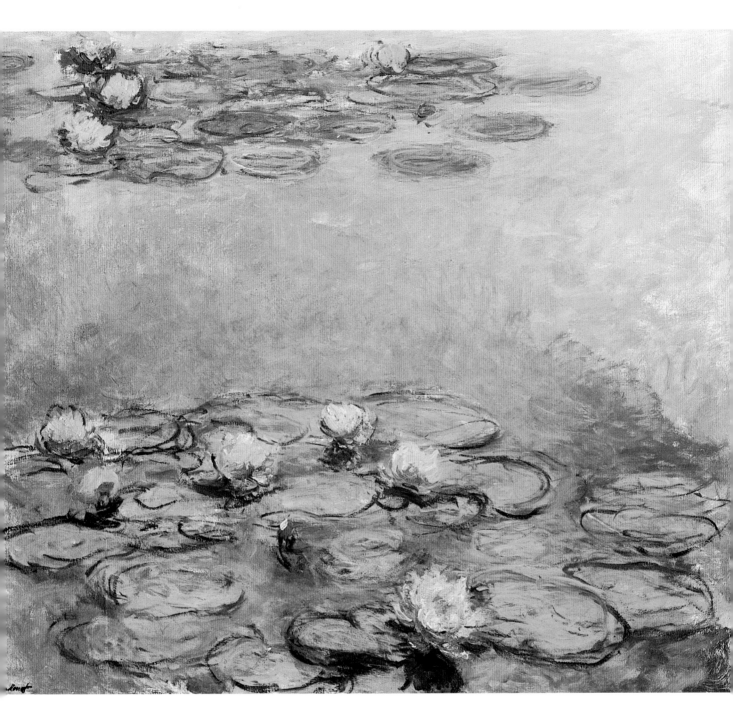

NYMPHÉAS (1914–17)
WATER LILIES
Courtesy of Christie's Images

*D*URING the course of this painting, Monet's cataracts were getting progressively worse. He could see so badly that he had to read the names on the tubes of paint to find out which colors he was using. Nevertheless, his sense of color and harmony was not affected, and this painting is a stunning testimony to that.

The effects of the cataracts can be seen primarily in the brushstrokes. A comparison between this and the painting of c. 1919 shows that this one has been painted with thicker strokes. There is a mixture of broad, horizontal and vertical brushwork that is especially noticeable in the top of the painting, which suggests a sense of urgency on the part of the artist. There is also a pervading sense of darkness that is missing from the second picture. This is a result of dark colors used in heavy strokes, causing the delicacy of the lilies to be lost. Monet was so concerned that his cataracts would ruin the water lily paintings that he abandoned work on them until he had had an operation on his eye. These two paintings together provide an excellent study of how he could treat the same subject in a completely different way. One is tranquil and calm, the other full of drama and frenzy.

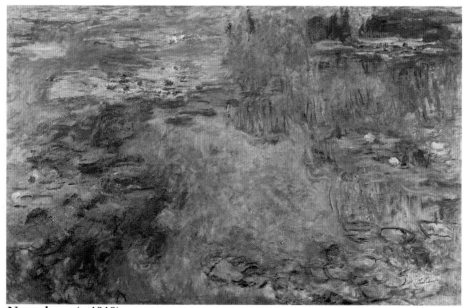

Nympheas (c.1919)
Water Lilies
Courtesy of Christie's Images. (See p. 239)

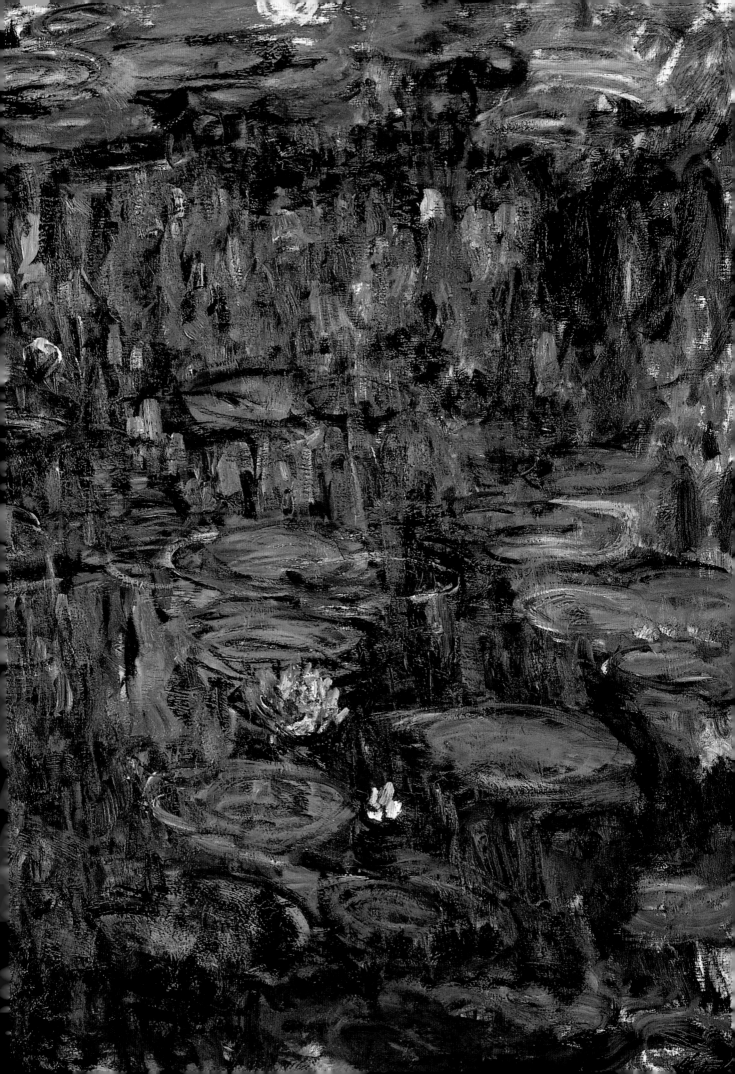

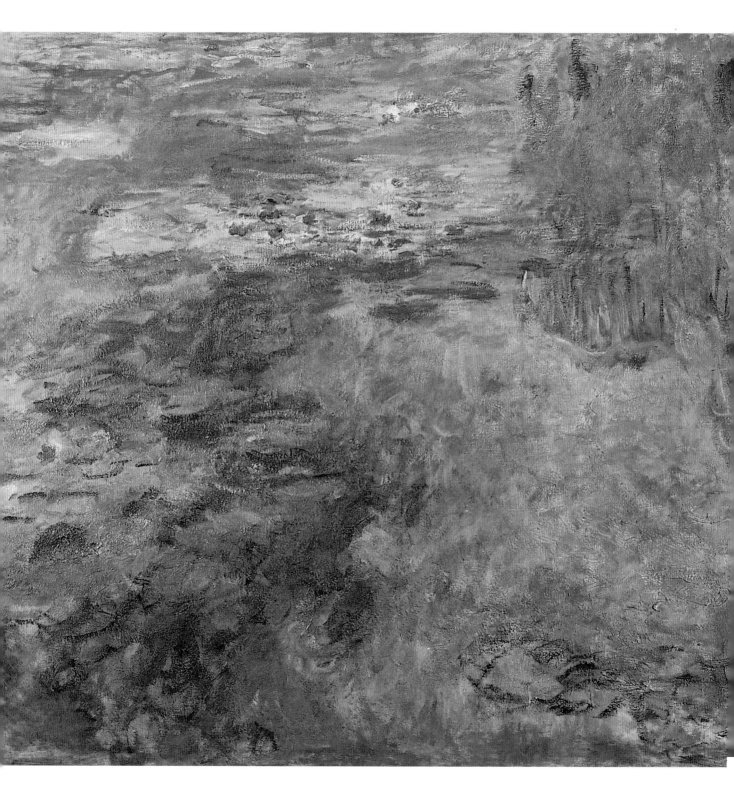

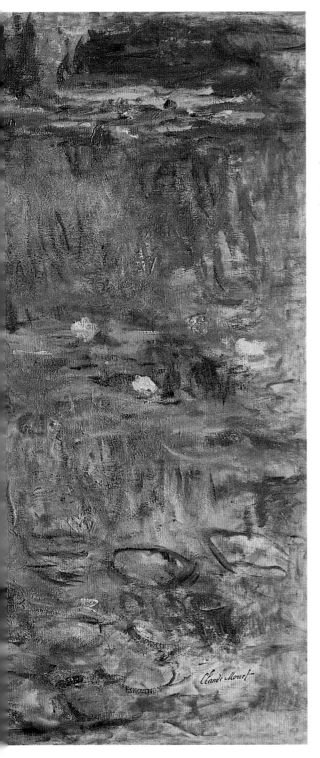

NYMPHÉAS (c. 1919)
WATER LILIES

Courtesy of Christie's Images

MONET returned time and again to his garden for inspiration. Between the years 1903 and 1908 he had painted numerous canvases of water lilies—48 were exhibited by Durand-Ruel in 1909. Contemporary critics exclaimed over the beauty of the paintings. He came back to the subject towards the end of his life.

In all of these paintings, Monet focuses on the surface of the water. He dispenses with any representation of the land or sky, only showing their reflection in the water. This painting is typical, with the willows visible only as a reflection. The sky, with its white clouds, is reflected in the water, so the blue of the sky and the blue of the water are one. Only the presence of the water lilies helps the observer to understand that this is a reflection. The painting is done in such a way that it is difficult to judge depth and it becomes a very flat canvas.

As the sky has clouds in it, the surface of the water is hard to identify. The wispiness of the edges of clouds could be the ripples of the water. The overall effect is of a harmonized world where water and sky have truly become one, and land has almost disappeared.

LES HEMEROCALLES (1914–17)
HERMEROCALLIS
Musée Marmottan. Courtesy of Giraudon

LIKE others in Monet's series of flower paintings, this depicts the plant in isolation. Unlike others, however, this picture has a variety of colors and shadings as background. There is the merest hint that other plants are present, particularly on the left-hand side, where the blue brushstrokes may represent their leaves.

The flowers erupt from the central bush of leaves and are painted without any detail to the flower head. Once again Monet is striving to give an overall impression rather than to represent any specific detail. The brushwork was quickly and roughly applied, and the same technique can be seen in *Nymphéas* also painted in the same time. This technique has the effect of blurring the central image so that the colors merge together. However, in *Les Hemerocalles*, the plant can still be seen in isolation from its surroundings. In *Nymphéas* the flowers were painted on to a background of water which becomes part of the essence of the flowers; the downward strokes on the surface cut across both the water and the flowers.

The colors used in the painting are vibrant, testifying to the problems that Monet was encountering as a result of his cataracts. The strong red and the yellow in the background indicate this in particular.

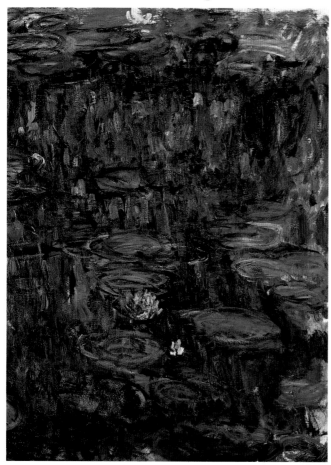

Nymphéas (1914–17)
Water Lilies
Courtesy of Christie's Images.
(See p. 236)

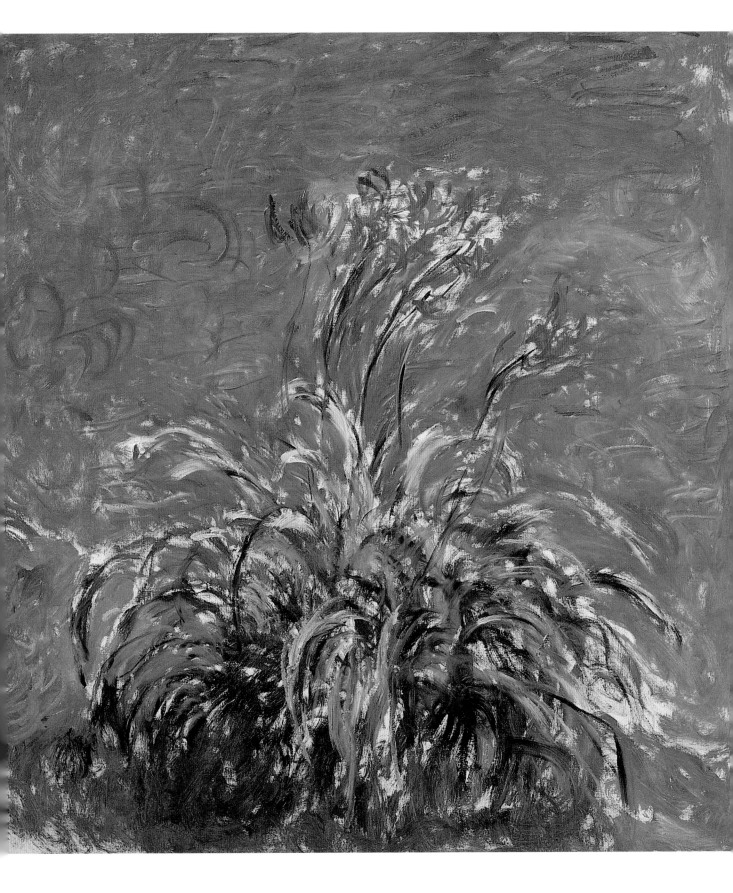

LE PONT JAPONAIS (1918–24)
THE JAPANESE BRIDGE

Musée Marmottan. Courtesy of Giraudon

THE colors and brushstrokes date this picture to the time that Monet was most affected by cataracts. His strong use of yellows and reds had been growing over the years as his sight declined. The effect of the chosen paints is to create a chaos of bright, contrasting colors on the canvas from which the outline of the bridge emerges as a shadowy presence. This is in stark contrast to *Le Bassin aux Nymphéas, Harmonie Verte* (1899), which shows the same bridge harmonized in green and blue. The earlier painting was made before the introduction of the wisteria bower over the bridge, visible in *Le Pont Japonais* as a higher green line. Even when studying the bridge and the foliage above it, Monet still sees some red and yellow so that brushstrokes in these strong colors are present in the greenest part of the painting.

The artist's treatment of the bridge has changed to the point where the structure is not easy to distinguish. This is typical of the Expressionist response to nature that occurs more and more in Monet's work at this time. The angle he painted from is closer to the bridge than in the earlier work and the overall spatial structure still seen there has collapsed here.

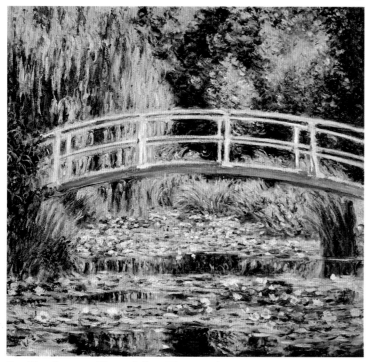

Le Bassin aux Nymphéas, Harmonie Verte (1899)
The Water Lily Pond, Harmony in Green
Pushkin Museum, Moscow. Courtesy of Giraudon. *(See p. 213)*

Le Pont Japonais (1918–19)
The Japanese Bridge
Courtesy of Giraudon

*H*ERE Monet's treatment of the Japanese bridge changes dramatically from the earlier pictures. Following the very green paintings of the late 1890s and early 1900s, Monet has painted the bridge with a blue cast over it. In terms of color, a comparison between this version of the bridge and the later version (1918–24) is striking. Monet moves from a still-harmonious blue and green palette of colors to a riot of red and yellow.

This painting may not indicate the brighter colors that were to appear in Monet's later work, but it does contain some of the Expressionist elements that emerged in force in the later work. The brushstrokes have become wilder and the bridge is merging with its surroundings, making it harder to define than in earlier works. There is still some sense of spatial awareness created by the plant positioned in the foreground, but this is not as strong as in earlier paintings. The flatness that appears in the later work is present in this picture.

Both paintings were created from a similar viewpoint, which makes it easier to appreciate how much Monet's work changed and developed over the intervening years.

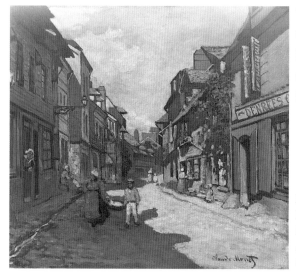

La Rue de la Bavolle, à Honfleur (c. 1864)
Bavolle Street, at Honfleur
Mannheim Stadtische Kunsthalle.
Courtesy of Giraudon. (See p. 22)

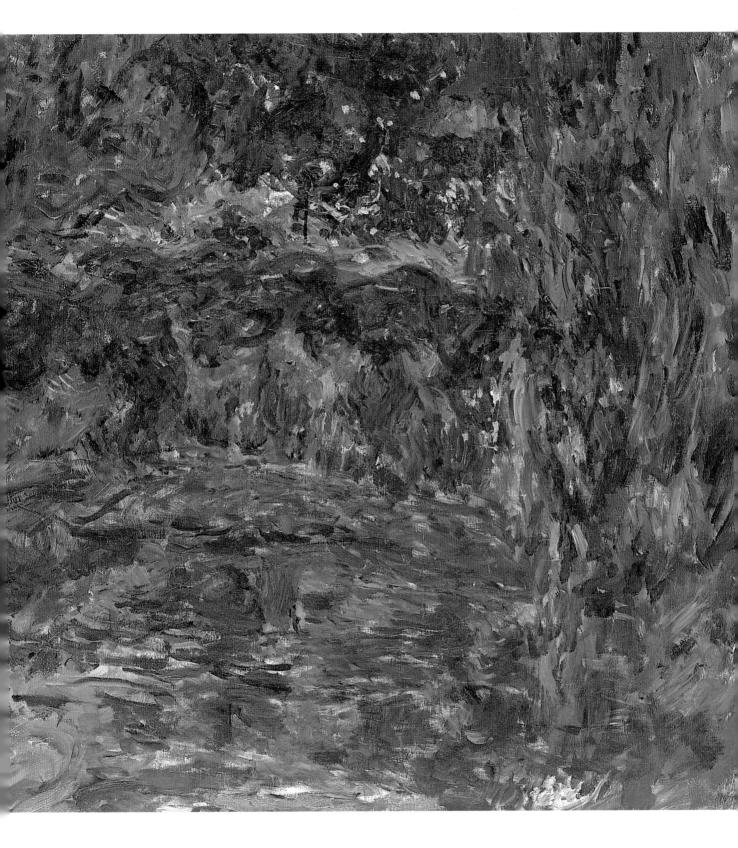

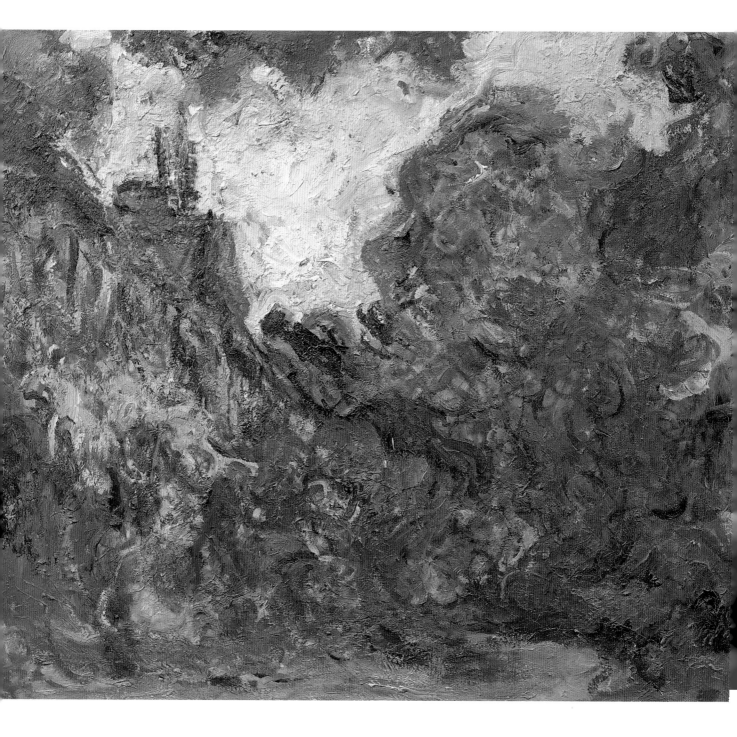

LA MAISON D'ARTIST VUE DE JARDIN AUX ROSES (1922–24)
THE ARTIST'S HOUSE SEEN FROM THE ROSE GARDEN

Bavaria Bildagentur. Courtesy of Giraudon

*I*N 1923, Monet was finally persuaded to have one of the cataracts that were affecting his vision removed. The cataracts had distorted his vision since around 1908, and his sense of color had been disrupted. The effect of the cataracts had made the world appear as if he were looking through a yellow lens. As they grew worse, his vision became browner and browner.

This painting is evidence of that effect. The colors that dominate are yellow and red, with very little blue in the picture. It is not easy to identify any subject in the painting, but the chimney and part of the roof of the house are visible in the left corner, painted in pink. The thick brushstrokes and extremes of color are thought by some to be indicative of the anguish Monet was feeling about his inability to see properly. Paintings like this have been called early examples of Abstract Expressionism rather than Impressionism.

Monet's despair over his vision meant that he suspended work on the Orangerie *Nymphéas* paintings until he was confident he would not ruin them with his poor vision. Prime Minister Clemenceau finally persuaded him to put aside his fear of the operation and have the cataract removed from one of his eyes.

La Maison Vue du Jardin aux Roses (1922–24)
The House Seen from the Rose Garden

Musée Marmottan. Courtesy of Giraudon

HE effects of Monet's eye operation are seen instantly in this painting. The color that virtually screams from the canvas is blue. This is dramatic when compared with the pre-operation painting *La Maison d'Artist Vue du Jardin Aux Roses* (1922–24). The riot of pink and yellow in that painting has completely disappeared.

Although it is easier to identify objects in this later painting, the overall effect is a cacophony of color rather than a concentration on subject matter. Monet found great difficulty in coping with the sudden transformation of his perception of color. He resorted to wearing yellow-tinted glasses to help prevent him from being overwhelmed by blue. However, because only one eye had been operated on, he was struggling to focus properly, so he resorted to wearing a patch over his affected eye. This had the effect of taking away his binocular vision, and as a result he lost an appreciation of depth.

The artist chose to destroy many of his paintings from this period, and he fought hard to return to a style that he desired. Paintings from these years are sometimes referred to as Monet's "blue period;" very few of them remain.

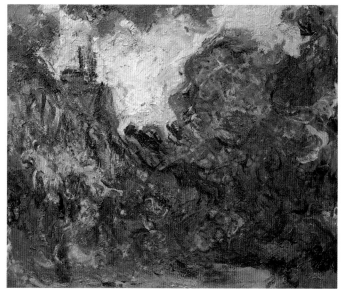

La Maison d'Artist Vue du Jardin aux Roses (1922–24)
The Artist's House Seen from the Rose Garden
Bavaria Bildagentur. Courtesy of Giraudon. (See p. 247)

IRIS JAUNES (1924–25)
YELLOW IRISES
Courtesy of Christie's Images

*T*HIS painting's strength lies in Monet's use of color. The brilliance of the yellow flower is enhanced by being placed against a strong blue background. It is the flower that attracts the eye; unlike the painting *Iris* (1924–25), where the flower itself is secondary to the pattern formed by the leaves.

The straight stems and leaves in *Iris Jaunes* is reminiscent of the poplars in *Peupliers au Bord de l'Epte* (1891). As with those, the heads of the flowers form parallel horizontal lines to counter the vertical green lines. This is an even simpler pattern than that in *Iris*. What both paintings share is not just a common subject but a common treatment of it. Neither is given a background to put it in context; the plant exists entirely in isolation.

The simplicity of *Iris Jaunes* coupled with the grid formation used gives it an oriental tone. By choosing a flower as a subject set against a single-color background, the effects of Monet's interest in Japanese art can be seen. Several of Monet's paintings of flowers have these traditional Japanese elements within them.

Iris (1924-25)
Musée Marmottan. Courtesy of Giraudon. (See p. 252)

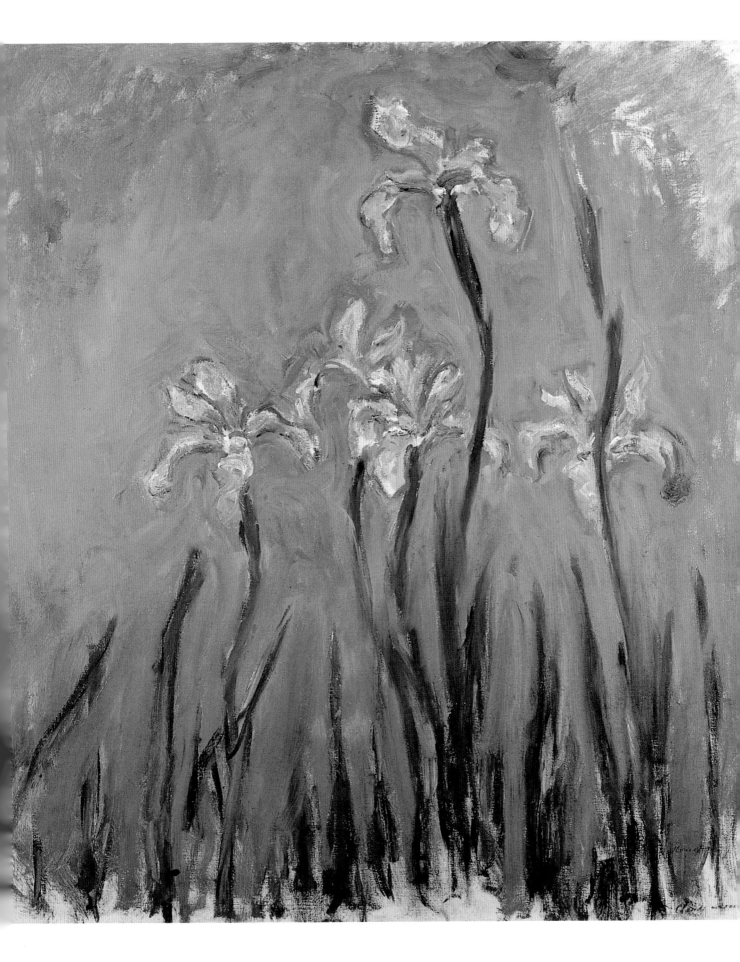

IRIS (1924–25)

Musée Marmottan. Courtesy of Giraudon

*T*HIS painting is among the last that Monet worked on. Even at this late stage in his career he was still developing as an artist and trying new techniques. This is one of the many reasons why he has gained the respect of critics over the years.

With *Iris*, Monet has moved in to give an intimate view of the plant. The background is a swirl of color that is indecipherable as representative of anything in particular, so the plant exists without any distractions to the eye. It is a depiction of an iris in its purist form. Unlike his earlier paintings, it is not the amazing violet and lilac tones of the flowers that have caught Monet's eye. Instead it is the shape of the leaves; their greenness, and even orange on one leaf, that are the focus of the painting.

What interests Monet, as can be seen in work dating back to the beginning of his career, is the grid of horizontal and vertical lines created by the leaves; the sweep of the leaves forming horizontal and vertical lines that cross each other. The informality of the symmetry is further emphasized by the curves of the leaves, ensuring that the whole has a softened and harmonized effect.

LES ROSES (1925–26)
THE ROSES
Courtesy of Giraudon

*L*ES *Roses* has an obvious oriental influence. The tree is painted against a blue background that could represent the sky, although it is so anonymous it would be difficult to state that for certain. The shape of the tree as it curves across the canvas is reminiscent of Japanese art. In particular, an examination of the branches reveals that they are represented by thin black lines that barely connect with each other. This willowy effect, combined with the depiction of flowers by simple touches of color, is synonymous with oriental art.

Water lilies are also a traditional oriental theme. Monet's treatment of them in *Nymphéas* (1914–17) is similar to that of the roses; the main difference between the two being the fact that the tree branches have a defined end, whereas the water lilies float to the edge of the canvas and create the illusion that they continue floating further than the artist (or the viewer) can see.

The colors used here are soft pastels and light blues, creating the effect of color for the sake of it. Monet chose this subject because of the beauty of the combination of colors. The pattern they create together was more important to him than an accurate representation of the tree.

Nympheas (1914–17)
Water Lilies
Courtesy of Christie's Images.
(See p. 234)

AUTHOR BIOGRAPHIES AND ACKNOWLEDGMENTS

To Greg, with love and gratitude.

Vanessa Potts was born in Sunderland in 1971. She completed a B.A. Honours in English and American Literature at Warwick University in 1992. Since then she has completed an M.A. in Literature and the Visual Arts 1840–1940 at Reading University, from where she graduated in 1998. Vanessa currently combines her writing career with her job as a buyer for a major retail company.

For my father, for sharing his love of landscape.
Dr. Claire I. R. O'Mahony has a B.A. from the University of California at Berkeley and an M.A. and PhD from London's Courtauld Institute of Art. Her specialty is nineteenth-century art, in particular mural decoration in Third Republic France and images of the life model in the artist's studio. She is a visiting lecturer at the Courtauld Institute and Curator for the nineteenth-century exhibitions at the Richard Green Gallery, London.

While every endeavor has been made to ensure the accuracy of the reproduction of the images in this book, we would be grateful to receive any comments or suggestions for inclusion in future reprints.

With thanks to Image Select and Christie's Images for assistance with sourcing the pictures for this series of books. Grateful thanks also to Frances Banfield, Lucinda Hawksley, and Sasha Heseltine.